EXTRAORDINARY
DOGS

Kristin Tierney

ALSO BY LIZ STAVRINIDES

Miracle Dogs

ALSO BY JOHN SCHLIMM

Moonshine: A Celebration of America's Original Rebel Spirit

Five Years in Heaven: The Unlikely Friendship That Answered Life's Greatest Questions

The Ultimate Beer Lover's Happy Hour

The Cheesy Vegan

Grilling Vegan Style

The Tipsy Vegan

Stand Up!: 75 Young Activists Who Rock the World, and How You Can Too!

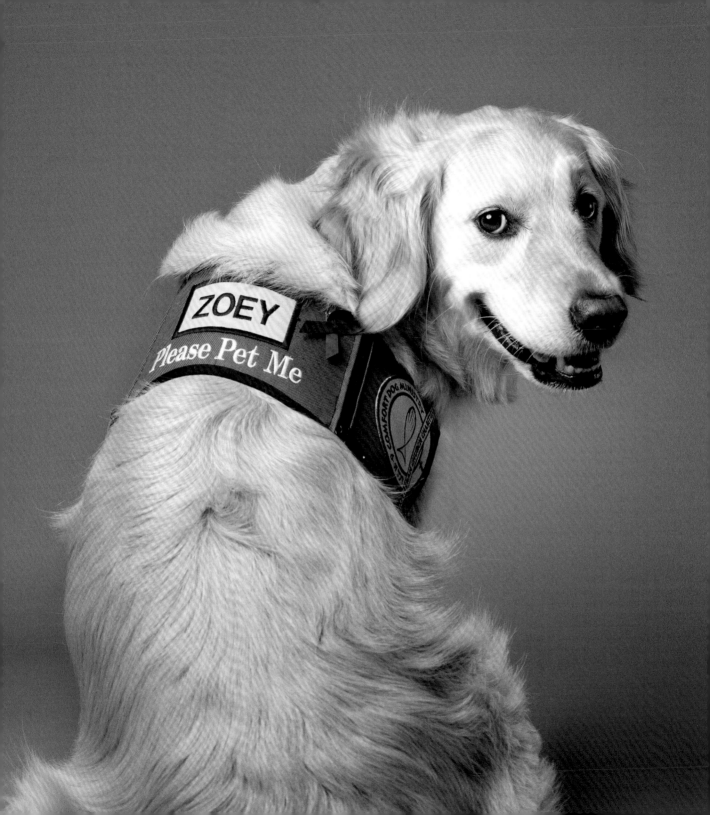

EXTRAORDINARY
DOGS

Stories from Search and Rescue Dogs, Comfort Dogs, and Other Canine Heroes

Photographs by LIZ STAVRINIDES
Essays by JOHN SCHLIMM

St. Martin's Press
New York

First published by St. Martin's Press, an imprint of St. Martin's Publishing Group

EXTRAORDINARY DOGS. Copyright © 2019 by Liz Stavrinides and John E. Schlimm II. All rights reserved. Printed in China. For information, address St. Martin's Publishing Group, 120 Broadway, New York, N.Y. 10271.

www.stmartins.com

The Library of Congress Cataloging-in-Publication Data is available upon request.

ISBN 978-1-250-20140-9 (hardcover)
ISBN 978-1-250-20141-6 (ebook)

Our books may be purchased in bulk for promotional, educational, or business use. Please contact your local book-seller or the Macmillan Corporate and Premium Sales Department at 1-800-221-7945, extension 5442, or by email at MacmillanSpecialMarkets@macmillan.com.

First Edition: October 2019

10 9 8 7 6 5 4 3 2 1

To all the courageous and compassionate dogs and handlers

who are hard at work in the world.

And to all the dogs who are simply the heroes of our own individual hearts.

CONTENTS ★ ★ ★ ★ ★ ★ ★ ★ ★ ★ ★ ★ ★ ★ ★ ★ ★ ★ ★

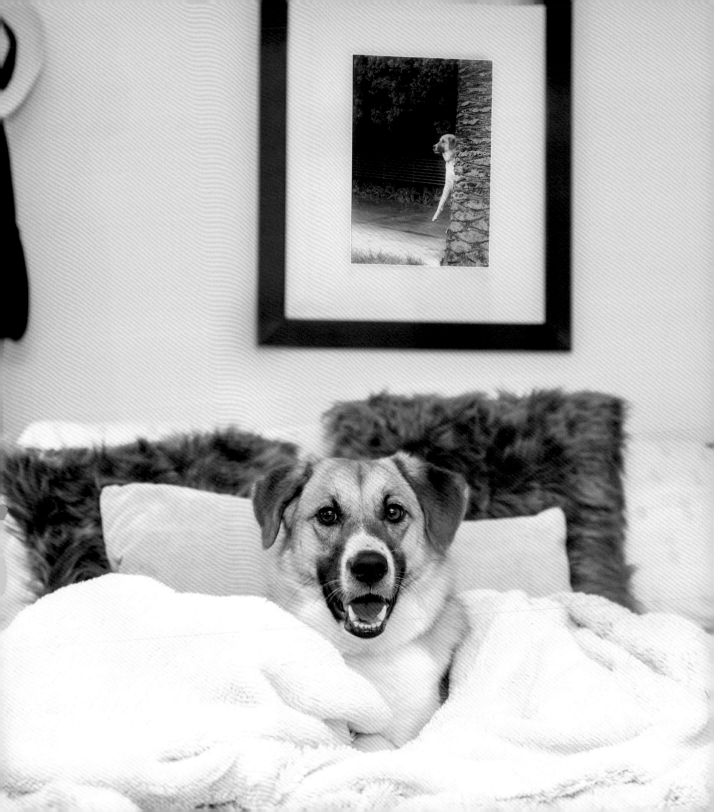

INTRODUCTION

You are about to meet more than fifty of the most courageous, heroic, and compassionate dogs in the world. Along with the police officers, firefighters, veterans, and other trained volunteer handlers who serve side by side with them, these furry beacons of hope will tug at your heartstrings, make you smile, and affirm the steadfast power within every one of us to endure, heal, and triumph over adversity.

The stories and photographs that follow are an unprecedented glimpse through the private lens of comfort dogs and search and rescue dogs, along with bomb-detecting TSA dogs and canine ambassadors from across the United States.

In addition to the first responders and those who are directly affected, most of these K-9 teams are the only other individuals who are allowed into the most guarded, vulnerable, and devastated places on earth to help bring relief, closure, and peace.

Throughout *Extraordinary Dogs*, these teams extend a rare invitation to you to come along for the ride and to see for yourself how even amid the darkest of situations there is always light to be found.

The Lutheran Church Charities K-9 Comfort Dog Ministry will take you behind the scenes of their headlining deployments, such as the Boston Marathon bombing, Superstorm Sandy, and the mass shootings at Marjory Stoneman Douglas High School, Sandy Hook Elementary School, Pulse nightclub, the Route 91 Harvest festival, and First Baptist Church in Sutherland Springs, Texas. You'll meet unforgettable survivors and unsung heroes while discovering the truest meaning of fellowship and of moving forward.

You'll also get to tag along with these comfort dog teams on their daily visits to schools and libraries, churches, hospitals and hospices, courtrooms and prisons, police and fire departments, 911 call centers, military bases and veterans centers, drug and rehab facilities,

summer camps for families of fallen soldiers and police officers, and even a very special pediatric dentist's office.

Search and rescue K-9 teams from the National Disaster Search Dog Foundation and Search and Rescue Dogs of the United States (SARDUS) will reveal what it's really like to travel into the eye of natural disasters, accidents, crime scenes, and the worst terrorist strike in recorded history. You'll join them on the front lines of building explosions, plane crashes, wildfires, the Montecito mudslides, Hurricanes Harvey and Irma, Puerto Rico following the devastation of Hurricane Maria, the search for missing persons, the hunt for criminals on the run, and the smoldering remains of the Twin Towers following the September 11 terrorist attack.

You'll also learn how SARDUS is breaking new ground within the search and rescue world by working with veterans on the next great mission of their lives through the Returning Soldier Initiative.

At Washington Dulles International Airport, you'll be introduced to several of the Department of Homeland Security's TSA dogs whose sole job it is to keep the flying public safe from explosives and other dangers. They give a whole new meaning to traveling the friendly skies.

Rescued by the Vanderpump Dog Foundation, two of the original dogs who survived the annual Yulin Dog Meat Festival in China will warm your heart by showing how they and their new families here in the United States have transformed unspeakable pain and harrowing escapes into platforms for doing good works. They now raise awareness as grassroots ambassadors for many different issues and inspire everyone they meet to embrace the better angels of their nature.

And, get ready to catch the waves in sunny Southern California with an internationally acclaimed champion surf dog named Ricochet, who is changing the lives of veterans with PTSD, as well as children and adults with various disabilities, one surfboard at a time.

Extraordinary Dogs is both a portrait of what love, hope, courage, and heroism look like in their purest forms and a tribute to the eternal and impactful bonds we forge with our furry friends.

—*John Schlimm*

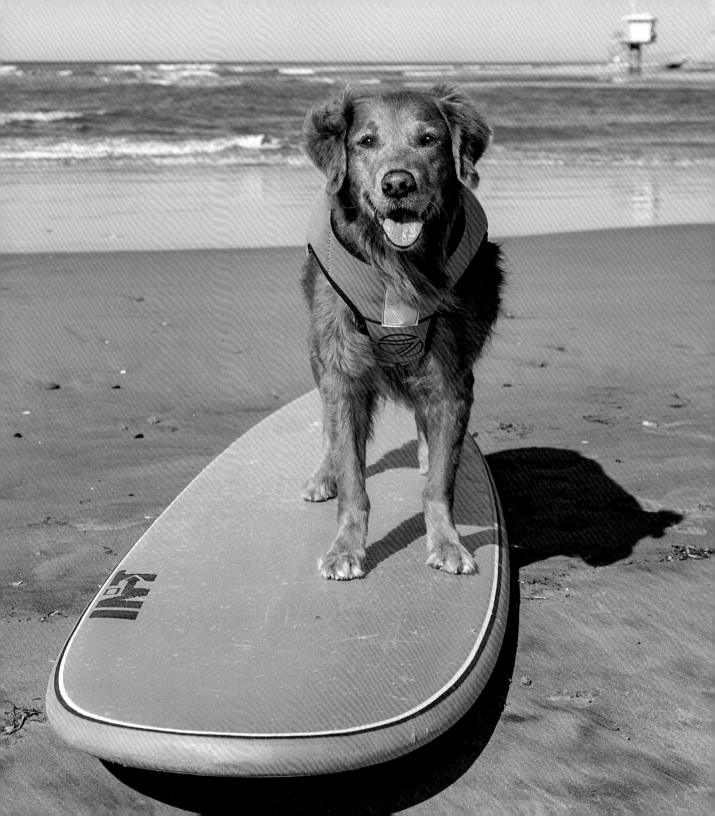

1 RICOCHET

San Diego, California

Talk about multitasking and *pawing* it forward!

The San Diego–based golden retriever known as Surf Dog Ricochet to her millions of fans around the world is not only a champion surfer, but she does so while helping and healing disabled children and adults, veterans with post-traumatic stress disorder (PTSD), and many others, one wave at a time.

"Ricochet was originally training to be a service dog," explains Judy Fridono, a long-time trainer and founder of the nonprofit Puppy Prodigies, "but then life redirected us along the ultimate pathway we were meant to travel."

This energetic duo has been together from the very beginning. "Ricochet was born in my home and took her first breath in my hands," Judy says. "From that moment onward, she chose her life purpose, and I've nurtured it."

While working on her service dog task training at eight weeks old, Ricochet also began balance and coordination training on a boogie board in a kiddie pool. After being in the ocean only a few times, she was invited to compete in 2009's Purina Pro Plan Incredible Dog Challenge in Huntington Beach, where she won third place in the Large Surf Dog category.

"This competition was a pivotal point in Ricochet's destiny," Judy recalls with a smile, "because it was already evident that her interest in chasing birds, bunnies, squirrels, and other small animals was going to prevent her from becoming a traditional service dog.

"When she won third place, suddenly the issue was no longer about what she *couldn't* do, but instead the focus shifted in the new direction of what she *could* do! This was the moment a dead end transformed into a journey of infinite possibilities.

"The idea of Ricochet becoming the world's first SURFice dog was born that day right there on the beach."

Ricochet was one of the original Southern California surf dogs on the dog surfing circuit. She went on to win multiple first-, second-, and third-place awards, while also getting her paws wet as a budding philanthropist. She quickly became the top fund-raiser when the various competitions raised money for charity.

"Ricochet can instantly bond with anyone. She makes a deep heart-to-heart, soul-to-soul connection," Judy explains.

A crucial moment in this journey came when Ricochet demonstrated the unique gifts with which she has been blessed.

"The first person Ricochet ever surfed with was a young man named Patrick, who she met in 2009," Judy says. "At fourteen months old, Patrick had been run over by a car and became a quadriplegic. Ricochet and I met Patrick when he was fourteen years old. His goal at that time was to walk across the stage at his high school graduation.

"One day at the beach, Ricochet jumped on the surfboard with Patrick, and together they rode the waves, in tandem. Patrick lay on the board while Ricochet balanced it. We had a team of people throughout the water in the same path as the board was traveling so if Patrick fell off, someone would get to him immediately. This provided Patrick with the freedom and encouragement he needed to continue healing and working toward his goal.

"Ricochet also put her fund-raising abilities into overdrive, and along with one of her sponsors was able to give Patrick the money he needed for the next three years of rehabilitation."

Patrick—who nicknamed his furry pal "Ricki"—later said, "Ricochet has changed the course of my life. She stepped in and made recovery possible for me at the exact moment when the money was running out. Never in a million years could I have expected the impact Ricki and Judy were going to have on my life. I love them both so much! Ricki is an awesome surf partner, and I have so much fun riding the waves with her. I feel so blessed to have them in my life."

In June 2012, Ricochet was one of the special guests—seated in the front row—as Patrick successfully walked across the stage of his high school auditorium and received his diploma to victorious rounds of applause and cheers.

"Ricochet's adapted surfing work has resulted in amazing triumphs and miraculous transformations in people who never imagined they would ever be on a surfboard," Judy says. "Ricochet is also a member of Team USA for the annual Stance ISA World Adaptive Surfing Championship hosted by the International Surfing Association (ISA). This compe-

tition began in 2015 and brings together surfers from around the world who have physical challenges.

"She's also part of the surf clinic at professional surfer Bethany Hamilton's Beautifully Flawed retreat for young women who have lost a limb. Bethany lost her own arm in a shark attack when she was thirteen years old."

It's the complete and unbreakable bond of trust between Judy and Ricochet that has allowed them to utilize this furry superhero to surf with hundreds of children and adults for more than a decade.

"Ricochet naturally adjusts her surfing style based on each person's disability or emotional challenges," Judy explains. "This includes children and adults who have cerebral palsy, traumatic brain injury, cancer survivors, autism, spina bifida, and other conditions, as well as kids who are victims of things like bullying and social anxiety.

"Ricochet also encourages siblings of kids with special needs and other young people to become what we call Buddy-up Mentors."

While Ricochet was never specifically trained to surf with individuals who have disabilities, Judy describes how this extraordinary dog performs her very special brand of love and compassion. "Ricochet just intuitively knows how to adapt to the person's needs," Judy says. "For example, if the person is lying on the board, Ricochet stands on the back of the surfboard. If the person is sitting, kneeling, or standing, Ricochet stands on the front of the board. And for kids, especially, who may not have physical disabilities, they'll often hold on to Ricochet's back end while they stand up on the board."

Surf Dog Ricochet is also doing important work to help members of the U.S. military, both active duty and veterans. In addition to serving people with disabilities and special needs, through the Waves of Empowerment and other programs at Puppy Prodigies, Ricochet enriches the lives of those service members who are suffering from PTSD, traumatic brain injuries, and military sexual trauma, as well as wounded warriors and many more.

In the past few years, Ricochet's talents have taken her in yet another direction, one that even mystifies the scientific community. "Ricochet can meet a person, such as a veteran with PTSD, and is immediately in tune with that person's triggers, social anxieties, and other issues, and can alert to them," Judy explains. "I believe these are abilities that all dogs have, if nurtured, as I've been doing with Ricochet. Basically, people have to listen to their dogs and learn to interpret their behavior differently.

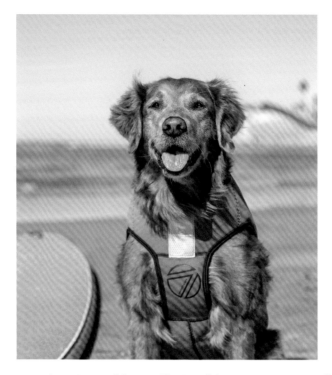

"Some veterans may be triggered by smells. So, if they associate a smell of the war zone with something that resembles it, they could be triggered. If a veteran had killed a child in the war zone, children could be their triggers. If they unexpectedly see a child somewhere, it can result in flashbacks, anxiety, and other reactions. Everyone has their own triggers. I've seen veterans react to trucks, a black vehicle, a metal beam, and alleys—anything that would remind them of a traumatic event. This is the same with anyone who suffers from PTSD or trauma.

"Essentially, Ricochet recognizes the triggers and takes responsibility for the person she's with at the time. She then helps them to avoid the triggers. This is very exciting to me, because it provides a whole new perspective and window into what dogs are capable of doing. It teaches us to listen to our dogs, because they're always communicating with us. We just need to learn how to interpret their communication from a different perspective.

"One time, Ricochet and I were walking down a sidewalk in a very nice neighborhood with a service member. Suddenly, Ricochet planted and alerted. I said to her, 'Show me.' I wanted to see what it was she was alerting to—what the trigger was that she was helping this service member to avoid.

"Ricochet took us down a driveway away from where there was a garbage truck making loud noises. I asked the young woman if that truck was a trigger for her. At first she said no, but then she explained how once when she was crossing a street, a motorcycle flew by and clipped her, followed by a truck that hit her with its mirror. I simply said, 'There you go! Ricochet was trying to protect you from this trigger that you weren't even fully aware of.'

"Amazed, the woman said how her own dog rushes her across street crossings. I told her how that is her dog's way of also helping her to avoid the same trigger, by quickly and safely getting her across the street.

"That experience with Ricochet gave the service member a whole new perspective on herself and on how her own dog was working to assist her."

Judy's firsthand research and work with Ricochet in particular have taught her that "dogs don't listen to our words, they listen to our feelings; and they mirror what we're feeling or experiencing, even if we're not fully aware of those things at the time." And while a dog stopping abruptly and taking other certain actions may come off as stubborn or misbehaving at first, Judy says, "Once you're in tune with what your dog is really trying to communicate, you'll better interpret those actions as helpful and empathetic."

For years, while at surfing competitions and doing adaptive surfing, Ricochet would often plant herself on the beach, but only recently has Judy begun to recognize and cultivate the greater significance of this action.

"This one afternoon, Ricochet was surfing with children suffering from spinal muscular atrophy," Judy recalls. "There was a girl in a wheelchair who went out on a surfboard with Ricochet. Eventually, Ricochet was brought back into shore while the girl remained in the water a little longer. When I started to leave the beach with Ricochet, she planted herself and wouldn't move. Finally, when the girl got out of the water and was pushed past Ricochet in her wheelchair, only then did Ricochet move. Ricochet had felt responsible for that girl and wanted to ensure she got out of the water safely.

"I believe all dogs are capable of doing this, and helping other dog owners to better understand this behavior has become my mission, thanks to Ricochet. I don't even surf, I'm not even really a water person, but it's those things that have led me and Ricochet down these pathways of helping others."

To date, Ricochet has worked one-on-one with hundreds of children and adults and inspired millions around the world—her *From Service Dog to SURFice Dog* video alone on

YouTube and Facebook has a combined fourteen million views—and her ambassadorial and philanthropic work for more than 250 human and animal causes has raised well over $500,000. Ricochet has made numerous media appearances, has a growing roster of celebrity admirers, and is the star of her very own international bestselling book, *Ricochet: Riding a Wave of Hope with the Dog Who Inspires Millions,* which was written by Judy with Kay Pfaltz. She also is in the 2019 IMAX movie *Superpower Dogs.*

It's very easy to see how Ricochet has already impacted the world, with many more miles and waves still left to go. "She's a mystic, healer, and very powerful," Judy says. "She came to this earth with a very specific purpose. It's my job to make sure she's able to fulfill her purpose. I never call her 'my dog.' She belongs to everyone!"

Judy is then quick to once again point out that Surf Dog Ricochet has also helped her to find her own purpose in this life. "My mission in life is to make a difference in at least one person's life before I leave this planet."

Mission completed, *and counting!*

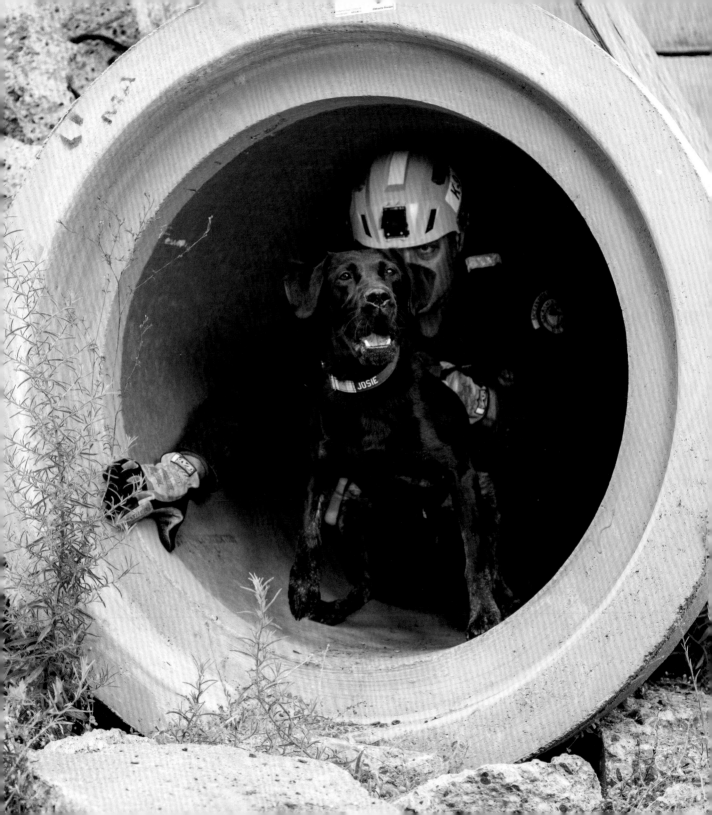

2 JOSIE

Placerville, California

J osie and I were deployed to Puerto Rico in September of 2017 with our FEMA-certified urban search and rescue team to complete recon and search missions after Hurricane Maria devastated the entire island," says Brandon Budd, a firefighter and paramedic with the City of Sacramento Fire Department. "I've never seen nor will I probably ever again see as much devastation as what I saw on that island."

A catastrophic Category 5 hurricane, Maria was the worst natural disaster to ever hit Puerto Rico. After making landfall on September 20, Hurricane Maria left a path of historic destruction, lost and fractured lives, and utter despair in its wake across the 110-mile-long island. As the more than three million residents of Puerto Rico, who are by law citizens of the United States, fought to survive the most extreme circumstances—no water or food, no shelter, no electricity, scorching heat, injuries, and disease—and started to put their lives back together, a wave of welcome aid came in the form of search and rescue dogs.

One of the furry superheroes who arrived in Puerto Rico to assist was Brandon's partner Josie, a forty-seven-pound black Labrador retriever with a "rare mix of yellow fur on all four paws."

"Puerto Rico was my first deployment with Josie," Brandon says from his ranch in Placerville, California. "We got there a few days after the hurricane had hit, arriving in San Juan where we were headquartered. The smell when we got there was of death—a combination of raw sewage, garbage, and dead animals. There wasn't a single power or telephone line left standing. The humidity was insane, and the temperature was close to one hundred degrees. Josie wasn't used to this—the heat, the hot asphalt, even the trip there on a military plane was a first for her, but she did great. Our US&R team was assigned the western side of the island.

"The first impact Josie had was as comfort support for the people who lived there. Many of the residents we met throughout our time there felt abandoned and forgotten. Just seeing Josie and knowing someone cared brought smiles to their faces. For many of these locals, we were the first help of any kind that they had seen. When we visited the distribution centers and neighborhoods, the people petted Josie and took pictures with her. She gave everyone who had suffered through that natural disaster a little positive feeling and a momentary break from what was going on around them.

"On our way to Rincón, a famous old surfing region about four hours from San Juan in the northwestern corner of the island, we stopped in a tiny little town called Aguadilla. We went to the *bomberos*—which is Spanish for 'fire department'—to see if they had any immediate needs we could help with. Again, Josie was able to serve as a comforting sight for very sore and tired eyes—both the residents and first responders.

"During the whole trip, we traveled with security. Because of the desperate conditions, it became dangerous—there were gun battles for gasoline and fights for even simple amenities like water and food. When we went anywhere, law enforcement went along to protect us so we could get our jobs done.

"Once in Rincón, which has historic surfing beaches like Maria's, Domes, and Tres Palmas, Josie undertook her first big search mission. She searched forty-five homes in a beachfront community that was like an RV park or mobile-home development where all the structures had been crushed. Then next door, there were four Victorian-style mansions that had basically pancaked on themselves during the one-hundred-mile-an-hour winds of the hurricane—top floor falling down on the second floor, which then fell onto the first floor, and then all of it mostly crumbled into the ocean. None of these had been searched, so the job fell to Josie.

"As soon as I unhooked Josie's leash, I was nervous for her. I needed to know she'd be safe. But I also knew I had to trust her and the training we had done up to that point. Although I was hesitant to let her go, trust goes both ways. I thought she might be scared and timid since this was her first deployment, but she was awesome. She was agile and determined. She fought through all the obstacles—like crawling and climbing around and through, all the collapsed floors of the houses and the massive piles of debris like furniture, broken windows, and all the other things you normally have in a house. At one point, Josie

navigated around a refrigerator that was on top of a desk that was dangling on a two-by-four threatening to fall over at any minute, but she made it."

Like the residents of Puerto Rico whom she met along the way, Josie herself well understands what it means to beat the odds and triumph over dire circumstances. It's this very combination of an unwavering drive toward resilience and proudly bearing the battle scars of survival that helped make her a beacon of hope amid an otherwise wrecked place.

"Josie is a rescue dog," Brandon says. "She was raised at the cruel hand of a farmer and then sent to a kill shelter."

Known at that time by the name Sequoia, it was at this shelter that a staffer from Lassen County Animal Control Department in Susanville, California, saw her and reached out to a National Disaster Search Dog Foundation (SDF) volunteer named Penny Woodruff. The staffer thought Sequoia might have had what it took to be a disaster search dog and that she deserved the chance to prove herself in order to live a long, productive life. Penny traveled to the shelter, evaluated Sequoia, and determined that she, indeed, had all the traits that SDF looks for in its dogs, such as a hunt drive and a drive to receive a reward, usually a toy.

"Having a strong drive means the dog absolutely will not stop looking for a hidden toy until she or he finds it," Brandon explains about these basic testing requirements. "Also, the dog cannot have any fear of climbing over rubble or into tight spaces. There is an age requirement as well. They have to be over one and less than two years old with no medical problems."

Sequoia was eventually taken to the SDF's national training center in Santa Paula, California, and renamed Josie. "She's named after the ninety-year-old woman who grew up on the ranch that was donated to the National Disaster Search Dog Foundation for its headquarters," Brandon explains.

Josie eventually completed a nine-month boot camp of sorts and acquired Federal Emergency Management Agency (FEMA) certifications to become an official search dog.

"One of my first fire captains was Rick Lee, who was the first dog handler for the Search Dog Foundation," Brandon says. "I was drawn into all of this by seeing the amazing abilities these dogs have and the amount of dedication it requires to be a dog handler. After doing the research and shadowing the dog team, I knew I wanted to be a dog handler.

"To be a handler, you first and foremost have to commit to the required training and

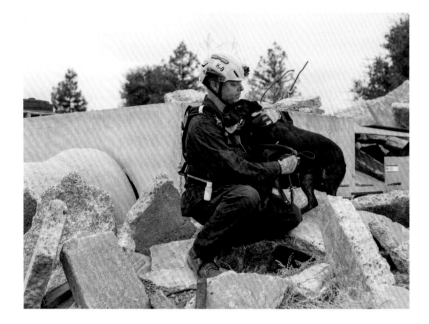

traveling that are necessary. And you have to have the support of your family because being a handler is a 24-7 commitment. Our ultimate mission is to be in a state of readiness at all times to deploy to the next emergency with the most highly trained and physically fit team of handler and canine. Our first mission in Puerto Rico certainly reinforced the importance of this.

"I look at it from the opposite perspective: if I were a victim or my family members were victims in a catastrophic event, I would want to know that the canine team looking for me or them is more than capable. I want to be that sigh of relief for the families who we respond to."

Brandon, who describes himself as "just a blue-collar guy who lives on a small ranch with my family and a bunch of animals," admits that he's constantly amazed by his furry coworker.

"I've had dogs prior to Josie who were family pets," he says, "and who I thought were my best friends. But when I received Josie, it was something I would've never expected. The amount of hours in training and stressful situations naturally forces you and the dog to work as one. Josie cues off the tone of my voice, my body position, the way I carry my hands, the subtle movement of an eye. I'm able to watch her behavior change—whether it's a raising of her nose, the wag of a tail, the whimper in her voice, or the strength or weak-

ness in her bark—and that dictates how I react. This bond was not forced; it became second nature from the fact that we're always together at home and at work. The natural trust that she has in me still baffles me to this day.

"I've also seen Josie injure herself on searches and never slow down. She has a determination and drive that I've not witnessed in other dogs. Teammates and members of the public have shared similar feelings about her. On our deployment to Puerto Rico, the locals' eyes lit up just by seeing Josie, and suddenly they had a small sense of peace and comfort knowing we were there to help them in any capacity possible."

At its core, this classic story of a boy and his dog provides a lasting lesson in how a trusting relationship involves each individual pushing the other to discover untapped potential, through both inevitable sacrifices and shared triumphs.

"Josie has allowed me to test my weaknesses and forced me to come out of my shell," Brandon says with a smile. "Search dogs are high energy and require a lot of interaction to train and maintain throughout their career. If you have a shy personality—like myself—it forces you to be outgoing and assertive. You have to be able to turn off your own pride and become humble. It's natural to make mistakes with your dog, but one needs to be able to own up to those mistakes and take the steps to correct them.

"Having Josie has made me into a stronger person, both mentally and physically. Also, being a career firefighter, I already have a mind-set of dealing with the stress and exposure to emotional situations. One has to understand that no matter what part of the world you're in, there's going to be tragic events—whether caused by humans or Mother Nature—and they're unavoidable. This is why not just anybody can be a firefighter or disaster worker. We have to deal with these situations in a professional manner and have the understanding that we're there for the greater good. When we do see these events and the casualties, we have to push forward and deal with the situation at hand."

Brandon adds that there's one significant way he deals with the burden of what he's seen and experienced on missions as both a firefighter and SDF handler.

"Josie is always there for me and in a good mood regardless of how work or training went," he says. "She's my crutch and puts me in a good mood anytime I'm around her. When I have stressful situations or I'm dealing with a bad call I've made, I know that just by seeing and petting Josie, all is right in the world for that moment."

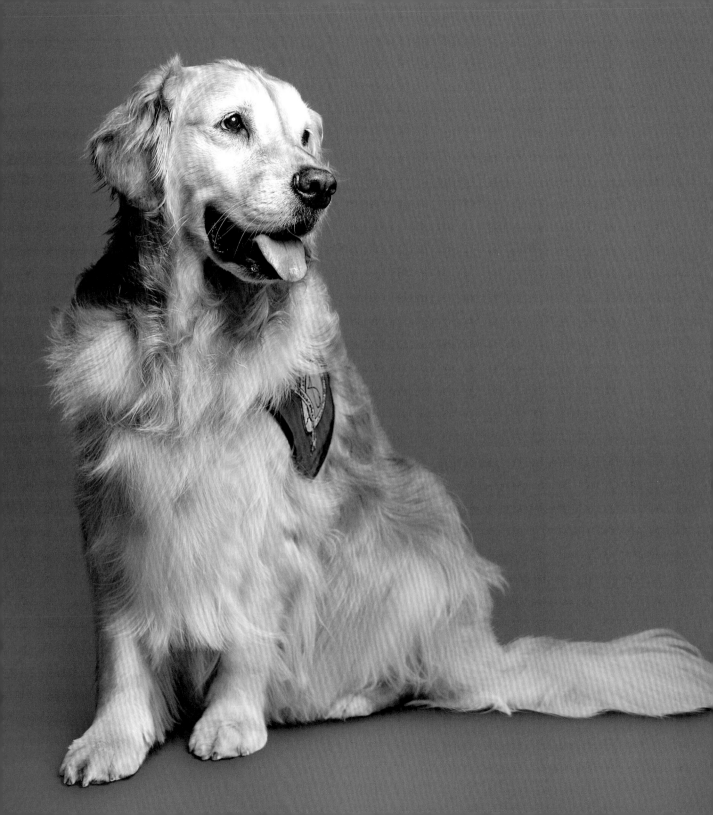

3 ▰ JOJO

Just about everyone can relate to what it's like having cavities filled or teeth pulled out. The pinch of the Novocain needle, the numbness that follows, the sound of the drill—outside *and* inside your mouth—for cavities, or the crunching of a tooth being extracted. It's enough to make you want to run for the hills, and that's if you're an adult!

Now imagine you're a little kid having a tooth pulled.

For sure, one of the least favorite—in fact, scariest—places for most people to go to is the dentist's office. But Lutheran Church Charities (LCC) K-9 Comfort Dog JoJo is working very hard to change that, especially for kids.

"In the dental office, I've witnessed JoJo having a calming influence on very anxious children," says LCC handler Lynne Ryan, a pediatric dental assistant from Arlington Heights, Illinois. "On one occasion, there was a young girl who came to our office after having been to several other dentists who were unable to treat her because of her anxiety. The girl's mother had heard about JoJo, and since she was an animal lover, she was willing to give our office a try.

"The girl immediately took a liking to JoJo, and together they got up on the chair to start her appointment. JoJo lay on the girl's lap the whole time, helping her to pick out a toothbrush and even what flavor toothpaste she should use. The girl not only completed her cleaning and checkup, but she was excited to come back for another appointment. Now all of her dental appointments include JoJo."

JoJo, whose official name is JoJo Psalm 94:19, has become a favorite fixture in this dentist's office. She's proof that the work of the LCC K-9 Comfort Dogs stretches far and wide and into every corner of our society. And this golden retriever is quite hip and fashion forward too, having what Lynne says is a "small Mohawk gently curving down her forehead."

JoJo's home base is Living Christ Lutheran Church, which acquired her from LCC and had her specially trained for work in a dental office.

The LCC K-9 Comfort Dogs receive over two thousand hours of training before being placed in a church, school, or elsewhere. The dogs are chosen by LCC at approximately eight weeks of age and begin their training immediately. Throughout their training, these pups live and work with their volunteer trainers.

Lynne explains, "JoJo's training also included getting her used to the sounds—like drills and suction—and smells inside a dentist's office. She's been trained to get safely onto and off a dental chair, and to be comfortable as the chair moves up and down. While on the chair, JoJo snuggles into the child's lap."

Lynne notes that visits involving JoJo are by appointment only so she doesn't encounter children who may be afraid of dogs or who have allergies. And as Lynne further explains, it's not always the kids who garner JoJo's attention; sometimes it's the moms and dads who most need a furry shoulder to lean on.

"Another visit JoJo had," Lynne recalls, "was with a severely autistic boy who had limited verbal and social skills. His parents were hoping that a comfort dog would help, especially when it came to his dental checkup. They arrived for their initial visit and were greeted by JoJo, but the young boy wanted nothing to do with her. Instead, the dad had to hold the boy on his lap as he struggled through his appointment.

"Meanwhile, the boy's mother was sitting in the corner, helplessly watching her child as he struggled like so many other times. Then along came JoJo, who placed her chin on the mom's lap, leaned in, and let her know that she was there for her. The mom melted and petted JoJo the whole time. For just a little while, the mom's worries and cares seemed to be washed away from her face. At the end, she broke down in tears and thanked us for being there. The little boy made it through his appointment, and with the help of JoJo, so did his parents."

Lynne wasn't surprised by the love JoJo offered to this mother. "JoJo is very intuitive," she says. "She seems to sense who needs her the most and will gravitate to that person. She brings calm into a room." Lynne laughs, then adds, "And at other times, she's very playful and excited to see her friends, and then her silly side comes out."

In other words, JoJo Comfort Dog embodies the best of both worlds—work and play.

Even though Lynne has been with JoJo for a while now, as has a larger team of handlers

and volunteers, she never ceases to be blown away by her furry pal's innate ability to minister to those in need.

"We can't fully understand how these dogs do what they do," Lynne says, "but they're *amazing!* They turn sadness into smiles, grief into gladness. They give us all they've got to give, asking for nothing in return.

"JoJo is a hero to me because she goes out every day and does what I don't always do—she gives unconditional love to everyone she meets! In fact, every day, JoJo continues to teach me how to be more loving and giving, as well as nonjudgmental and forgiving."

In addition to serving in the dentist's office, JoJo has also shared her abounding love, compassion, and comfort with many other folks—both close to home and across the country—such as the survivors of the 2011 tornado in Joplin, Missouri, and families impacted by the Sandy Hook Elementary School shooting in 2012. In both deployments, Lynne says, "JoJo made lifelong friendships."

And talk about *amazing* . . .

Luckily for the visitors to this particular dentist's office, there's always a shining hero who comes to the rescue.

"One time," Lynne remembers, "a little girl was scheduled to have four teeth extracted in preparation for orthodontics. Of course, this would be stressful for anyone, but JoJo was there to save the day. She hopped up on the young girl's lap and stayed the whole time. JoJo wasn't squeamish at all either.

"The girl held on to JoJo's ears, which happen to be the softest things ever, and she went into a happy place until it was all over. She was another happy customer!"

Lynne and JoJo have formed a strong bond and are true friends who watch out for each other in addition to helping so many others.

"JoJo and I have been through a lot together," Lynne says. "Dealing with tragedy, sadness, anxiety, and loss can be very stressful. You can't go into a situation and not be affected in some way. I take time before an event to chat with JoJo. Sometimes I tell her about my day or about what we have lined up. Then afterward, I usually spend time in a big JoJo hug, letting my own cares and worries melt away.

"I think touch is so important for both humans and animals, so I like to end our sessions with a doggy massage, letting JoJo know that she's done a good job and that I appreciate her hard work."

The closeness JoJo shares with Lynne and her other handlers is both ingrained in her DNA—"Golden retrievers are by nature calm, friendly, and intelligent," Lynne says—and it's part of her LCC training.

"One of the commands we give is 'with me,' which is similar to *heel*," Lynne explains. "This command lets the dog know she's to be by your side while walking. JoJo is by my side when facing sadness, and she's by my side when facing grief. *And* she's by my side during happy times as well, when we get to celebrate and be grateful for a successful visit."

Lynne pauses for a moment to reflect on the greater, symbolic significance of this side-by-side walk together through life that she shares with JoJo.

She then adds, "JoJo is a soft, gentle, unspeaking reminder that God is with us always, and that he is also by our side no matter what comes our way."

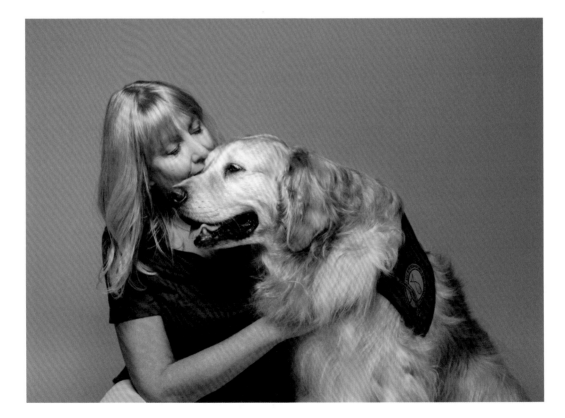

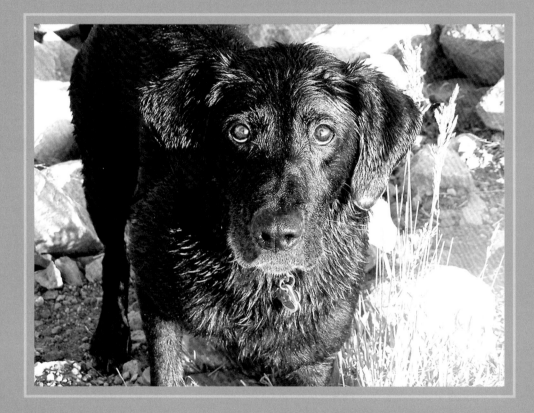

JENNER, MERLYN, AND SKY

Otis, Colorado

Though she's too modest to ever brag on herself, retired park ranger Ann Wichmann is one of the icons of the search and rescue dog world. She has seen it all and done it all with these dogs, from routine missions involving missing persons to searching the smoldering rubble of the fallen World Trade Center buildings following 9/11.

For more than four decades, Ann's love and passion for working with these highly trained animals has impacted the lives of countless individuals, including most significantly her own. To her, they each are hero and friend rolled into one happy ball of fur.

"As a park ranger, I began working with service dogs in 1975 and established a park ranger service dog program in the City of Boulder," Ann says from her home in Otis, Colorado. "My first service dog was Sage, who was a ranger service dog. I was astounded at how much the dogs could help me in my work, in so many ways."

Ann went on to cofound Front Range Rescue Dogs, Search and Rescue Dogs of Colorado, and Search and Rescue Dogs of the United States—to help educate and certify search and rescue teams around the nation.

She also became fascinated with the work that dogs could do in disaster situations and was asked to become a member of the Federal Emergency Management Agency (FEMA) Canine Subcommittee, tasked with writing a curriculum and a standard for a national disaster dog certification. In addition, she began speaking at international rescue dog symposiums in Berlin, Stockholm, Prague, Seoul, and Boulder, when her organization hosted.

During her storied career, Ann has certified multiple dogs and has responded to numerous emergencies, including the World Trade Center after 9/11.

"With my first search and rescue dog named Logan, a black Labrador retriever who was named after a mountain in Canada where my boyfriend died in an avalanche," Ann

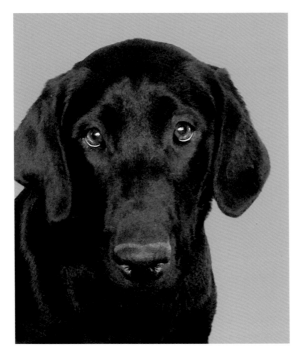

recalls, "I helped to locate the victims of a plane crash in a Boulder neighborhood, find a hiker, and locate a developmentally disabled person.

"Logan and I also worked to locate several people with illegal guns in a park, and we even once found a woman's passport and plane ticket in a huge meadow so she could fly home the next day."

Logan scored a little international star power in 1991 when he demonstrated disaster and water search skills at the international symposium in Berlin. Ann notes that this was an important moment in search and rescue history because it changed—"To the positive!"—the way that Europe viewed search dogs from the United States.

Currently, a fifty-two-pound Lab named Jenner's Prairie Sky—or Sky for short—is one of Ann's newest working search and rescue dogs. "She's named in honor of her great-grandfather Jenner, who helped in the search and rescue efforts at the World Trade Center following 9/11," Ann says. "Her name is also in honor of where we live—in the great blue bowl of the high plains here in the northeastern corner of Colorado."

Sky is a newbie on the search and rescue circuit. However, she's the latest in a long pedigree of dogs with whom Ann has served on many memorable missions great and small. As the great-granddaughter of one of the original September 11 search and rescue dogs, Sky has historic and heroic blood coursing through her veins.

Two of Ann's Labrador retrievers, Sky's great-grandfather Jenner—with black fur and whose full name was Jenner by the Sea—and his son Merlyn—also with black fur and whose full name was Jenner's Merlyn—worked alongside Ann and a friend of hers to search the ruins of the World Trade Center shortly following the September 11 terrorist

attack that claimed 2,606 lives on or near that site alone. The experience of those five days—September 24–28, 2001—spent in New York is seared into Ann's memory forever.

"I'll never forget walking up to the site for the first time," Ann remembers. "Twelve stories high, still burning in areas, twisted steel. I thought, *I can't send Jenner into that!* When we were asked, 'Are you willing to search this site?' I took a really big gulp and a deep breath and then replied with a very subdued yes. Jenner and I were assigned to the day shift for searching.

"As we entered the site over a narrow bridge of debris, I had Jenner on lead to get him a little bit oriented. I then released him to search. It was simply a leap of faith on my part that his training, his courage, and his sense would keep him safe. Jenner was amazing and so thoughtful—nose searching for scent, carefully negotiating the horrendous rubble, ignoring the firefighters who had their own job to do, and focusing on locating the lost. I was stunned by his ability.

"Jenner and I also spent a lot of time waiting on the sidelines to be asked to search specific areas. Once when the New York Fire Department was changing shifts, and huge groups of firefighters were leaving and entering the site, one young firefighter stopped, knelt down by Jenner, and just started talking to him. After a few minutes, the firefighter looked up at me with his arm around Jenner, and with tears streaming down his face, he said, 'I lost thirteen of my best friends here.' I believe that Jenner was the first one to hear of his grief. All of the dogs there were so important as therapy dogs as well as search dogs.

"Another time, a priest came up to us and just asked to hug Jenner, and he did that for a long time. He needed to replenish his energy."

Ann's Merlyn was deployed with her friend Matt Claussen. Born not breathing and then revived, Merlyn was destined to do great things in his life. It's believed that Jenner and Merlyn were the only father-son canine team working at the World Trade Center site.

Matt and Merlyn worked the night shift, opposite Ann and Jenner.

"When we arrived at the site each morning, Merlyn was always so excited to greet both me, his mom, and Jenner, his dad. It was quite a display!" Ann remembers with a laugh. "One morning, though, the search team manager came up to me and said, 'Merlyn was awesome last night!'

"I immediately said, 'What do you mean *was?*' Merlyn wasn't there to greet us that morning, and it gave me quite a scare. But it turned out that Merlyn had located several subjects the night before and at that very moment was on *Good Morning America!* There he was, sound asleep on national TV after a successful, albeit exhausting, night."

Both Jenner and Merlyn had worked with Ann since they were puppies, and she was with them when they each passed away in 2004 and 2015, respectively. "I think Merlyn was the second-longest-living dog who had worked at the World Trade Center," Ann says.

Sky is very special, indeed, to be descended from this line of dogs, who are true American treasures.

"Sky was literally born into my hands," Ann says with a smile. "Since her mother, Rosie, grandmother Torie—whose full name is Jenner's Ebony Tor and alludes to *Tor* as *ruler* in many languages—and great-grandfather Jenner were all search dogs partnered with me, I knew from the time Sky was a puppy that she would carry on her family legacy."

As with her other dogs, it was love at first sight for both Ann and Sky.

"Sky is so much more alive than I am," Ann says. "She's very hard to keep up with—so funny, so inquisitive, so focused, and so quick. It's a little like having your best, most athletic, brightest self waiting for you to do something, looking to you for a decision. She's one of the best partners I've ever had and yet constantly reminds me of how incredible her other family members have been as partners. So she is personally, in the moment, so loved and appreciated and also has a historic admiration and amazement attached to her."

Sky and the illustrious line of dogs that have come before her have given Ann a chance to reflect on the important impact they've all had on her life and career—collectively and each individually—and to look toward the future.

And even after almost forty-five years of serving with search and rescue dogs, Ann still learns something new from them every day.

"Sky is like having a genius attachment to your work," Ann says. "I love her without reserve, love to play and cuddle with her, love to talk to her, and I *love* to see her work in any environment. She teaches me in ways that I haven't even thought of—through her focus, attention, intention, willingness, and courage. Sky has allowed me to continue my commitment to working with and teaching about search and rescue dogs. She continues to amaze and astound with the abilities of this particular family of dogs. I've told people that when you get older, get a faster dog. This is so true of me! I've always joked about starting a new group called Old Farts with Fast Dogs."

Sky is now carrying on her family tradition of courageous and inspiring service in more ways than one.

"Sky has had two litters of puppies, and one litter has several members who are already certified in search at two years of age," Ann says. "All totaled, among the line descending from Sky's great-grandfather Jenner, there are over thirty FEMA-certified disaster dogs and many more who do other aspects of search and rescue work. The legacy goes on!"

Anyone who meets Ann quickly sees that she is someone who lives life to the fullest. Life is much too short and with too much work left to accomplish to approach it any other way.

"The gift of these dogs in my life has been extraordinary," she says. "To learn about such an astonishing species, to try to see and perceive what they're capable of and aware of, and to teach others has been the focus of my life.

"I have used dogs, since they're universally loved, to teach humans about the amazing and intricate world around us, hoping that the bridge of dogs will help humans understand, appreciate, and protect all species. Sky carries on the work of her family—to find, save, protect, inspire, and teach. This is the work of a true hero!"

5 FLEX

For veteran Fred Vanstrom from Rolling Meadows, Illinois, working with a comfort dog is a very personal endeavor on many levels.

"I served in the U.S. Army, Air Defense Artillery, from 1970 to 1972," Fred explains. "Interestingly, the only picture I have of myself while serving is one of me with our unit's mascot—a German shepherd named Dog. In the photo, I'm holding one of his puppies."

With a laugh, Fred adds, "In fact, I was one of only two soldiers in our unit whom Lila, the puppy's mother, would let handle her puppies. Lila wouldn't even let Dog, the father, come near them. So I was destined to be with dogs!"

Enter Flex, a Lutheran Church Charities (LCC) Kare 9 Military Ministry dog—a seventy-eight-pound golden retriever whose official name is Flex 2 Samuel 2:22.

"Flex is one of the original eight Lutheran Church Charities Kare 9 Military Ministry dogs and therefore was named after a military working dog who was killed in action while serving our country," Fred says. "After these first eight, the demand for Military Ministry dogs was so great that we started dual vesting the LCC Comfort Dogs. Now, a Comfort Dog can wear the Kare 9 Military Ministry camo vest only when their handler is a veteran.

"Flex's namesake served with the Second Marine Special Operations Battalion, which has since been redesignated the Second Marine Raider Battalion. The original Flex was killed in an attempt to save his military handler."

On May 4, 2013, the original Flex and his handler, Corporal David M. Sonka, twenty-three, of Parker, Colorado, were both killed in action in Farah Province, Afghanistan. Corporal Sonka and Flex have since been memorialized by the multipurpose canine kennel for the Second Marine Raider Battalion at Camp Lejeune in North Carolina. The kennel is

now named the Corporal David M. Sonka Multi-Purpose Canine Facility, and it features a bronze statue of Flex wearing a full deployment kit.

"We veterans like to honor our fallen comrades," Fred explains, "and this story has become an integral part of my ability to connect with veterans, especially Marines. I've even witnessed this story bringing tears to the eyes of members of a Marine motorcycle club, all of whom served in combat."

Fred first got involved with the Kare 9 Military Ministry at Lutheran Church Charities following a brief encounter with LCC president and CEO Tim Hetzner.

"I was sort of drafted into the Kare 9 Military Ministry when it began in July of 2014," Fred recalls. "On the first day of the 2014 LCC K-9 Ministries National Conference, Tim came up to me during a break and asked me what my dog situation was like. I responded that it was fine and that my wife, Kathy, and I still had a golden retriever named Miriam at home. He then asked, 'You're a veteran, aren't you?' When I responded yes, Tim then said, 'Okay, tomorrow you're getting a puppy.'

"No further explanation was given because I guess very few people knew the Kare 9 Military Ministry was being officially launched the next day."

Like Flex, five other original Kare 9 Military Ministry dogs—all siblings of his—and two others were named after military working dogs who had been killed in action. Unlike the other LCC K-9 Comfort Dogs, the original Military Ministry's Kare 9s have had only one caregiver and handler.

"I've had Flex since he was eight and a half weeks old," Fred says. "I've also gone through a year of training with him. The only time I haven't been with him is when I've gone on vacation.

"Having dogs my whole life, I've had a strong bond and relationship with every one of them. But Flex is extra special. He's a working dog, and I'm amazed how well he does his job of comforting people. I feel a real sense of pride in him when I'm told how wonderful he is, that he's made someone feel better and that he's just what they needed, or how great he is with someone's children.

"Plus, I do feel we have a special bond. Whenever I'm at an event and I have to go somewhere alone, I give the leash to another handler. When I come back, Flex is always sitting up and watching for me to return. The handler typically tells me that Flex was intently watching for me the whole time I was gone."

It's this devoted bond between Fred and Kare 9 Flex that has allowed them to serve others with compassion, as well as with an unflinching sense of duty and purpose. This includes often working with some of Fred's fellow veterans and their families.

"Since the beginning of LCC's Kare 9 Military Ministry," Fred says, "Flex and I have had the honor of being invited to visit a free summer camp called Camp Hometown Heroes, which is for children ages seven to seventeen who have lost a parent or sibling in the military.

"On our very first visit, Flex and a young man made a real connection. Every year since, this young man waits for Flex to arrive. When he sees Flex, he just lights up, runs up, and gives my wife, Kathy, and me a hug and stays by Flex for our whole visit.

"The Kare 9s have made such a nice impact at Camp Hometown Heroes that they're now asked to go to each camp session and to be on hand for the two most difficult days for the campers—the balloon release and the memorial remembrance.

"At our first visit, one of the staff members, who was a Purple Heart recipient, told us that our visit was very special to the children because all us handlers were veterans ourselves."

Flex's kind and cheerful bedside manner has also made him a welcome guest at veterans hospitals.

"Twice each month, Flex visits a VA hospital," Fred explains. "He visits with veterans and staff in both the extended care center that provides rehabilitation, respite, and hospice care, and the spinal cord injury unit.

"One time we met this veteran who was sitting in a wheelchair. Flex did a 'lap,' where the dog keeps their hind legs on the floor and brings their front legs onto the lap of the person sitting down so it's easier to pet him. As the veteran was petting Flex, he began to cry. He said he always had goldens as pets, but no longer could manage owning one and that he missed his goldens tremendously. He thanked me for bringing a golden for him to pet.

"Another time, we came upon a veteran sitting in the hallway in his wheelchair, slouched over and looking at the floor. As we were about to walk past, Flex went up to the gentleman and nudged him. Without looking up, the veteran reached out and began petting Flex. As we left, the volunteer escorting us said that this was the first time that he had seen this particular veteran even move while in his wheelchair.

"And a visit that really made me smile was this one day when Flex was visiting the spinal cord injury unit. We went into the physical therapy room to visit some of the vets. We were greeting one of the guys when out of nowhere a Navy SEAL comes rolling up in his wheelchair, saying he just had to see Flex. We'd previously met him during other visits.

"The SEAL asked if Flex could get up on his wheelchair so he could pet him more easily. So Flex did his 'lap' command and straddled the SEAL's lap. The SEAL then leaned in and asked for a kiss. I told the SEAL that we try to make sure the dogs don't lick. He replied that he'd been in more jungles than he could remember and therefore a lick from a dog was surely not going to hurt him, and besides, he wanted one. The SEAL got his wish, and we all had a good chuckle with that one!

"Flex and the other Kare 9s who visit the hospital are also invited each quarter to attend the Last Roll Call ceremony, which is a memorial service in the chapel for the families and friends of those veterans who passed away at the hospital during the prior three months."

In making their many rounds to brighten the world for those who are suffering, Kare 9 Flex and his furry Kare 9 colleagues have also become popular dinner guests, especially for one very special and moving monthly event.

"On the twenty-second of each month," Fred explains, "the LCC Military Ministry hosts a dinner for veterans, their families, and friends. We call this particular event the Twenty-Two because twenty-two veterans commit suicide every day. The main purpose of the Twenty-Two event is to raise awareness about veteran suicide and to grow and strengthen the larger community of veterans. All the Kare 9s go under the table where their veteran is eating. If a veteran is sitting at the end of the table, the Kare 9 might lie at the end of the table. All LCC K-9 Ministry dogs have been trained to go under the table when we go out to eat—the command is 'under.'

"Also, a part of the Twenty-Two event is the Missing Man Table—a symbolically decorated table with empty chairs to represent American POWs and MIAs.

"After dinner, we handlers all get the biggest kick when leaving a restaurant. As we walk out with seven to twelve dogs, it's so much fun hearing some of the patrons exclaim, 'Where did all those dogs come from?!' All our dogs are so well behaved that people don't even notice them under the tables."

Flex and his fellow LCC Kare 9 Military Ministry dogs can be found lending a friendly

face at other events as well, including those involving the Wall That Heals—a smaller-scale, traveling replica of the Vietnam Veterans Memorial in Washington, D.C. Unveiled on Veterans Day 1996 by the Vietnam Veterans Memorial Fund, the Wall That Heals was designed to travel throughout the United States. To date, it has visited nearly six hundred communities and has touched millions of lives.

"At one event for the Wall That Heals," Fred recalls, "the Kare 9s were invited to be present for anyone who needed to be comforted. One evening, three of us veteran handlers saw a man sitting alone looking at the Wall. We brought our Kare 9s up to him. Flex went right up to the man and put his head on his lap, and the man started to pet him. The man told us that he had served with the Marines in Vietnam and that sixty-six names on the Wall That Heals were from his company. The veteran said he normally likes to come to the traveling Wall alone but that our dogs did make him feel better. Right before we left, we all said a prayer together."

In addition to spreading comfort and joy at larger group events, Kare 9 Flex and the other Kare 9s have also been invited to have more intimate, one-on-one interactions with veterans. These meetings have been among the most memorable for Fred.

"One time, Flex and his siblings Brutus and Brandy were honored to be asked by the daughter of a World War II veteran of Normandy and the Battle of the Bulge to visit her father at his nursing home," Fred remembers with a smile. "Each of these three dogs then made a monthly visit to that veteran for over a year until his passing. At the very end, the man's daughter asked that all three dogs come to visit her dad.

"When Flex arrived, he immediately went to the daughter. She said to Flex, 'You're here to visit my dad.' But I told her that Flex knows who needs the most comforting. The daughter then began crying and hugging Flex. All these Kare 9s, along with several other Military Ministry dogs, later attended the veteran's visitation and funeral.

"But this story doesn't end here! The nursing home asked that Flex, Brutus, and Brandy continue to visit because the residents so enjoyed them. The three dogs make monthly visits to the nursing home to this day."

When a mom or dad is deployed, the absence can be very hard on the family. While nothing and no one can ever completely fill this void, the LCC Kare 9 Military Ministry dogs do their best to bring a little more light into these families' lives.

"The Kare 9s were invited to visit a local military family," Fred says. "The father had been deployed for a year, and his two daughters missed him terribly. The family was so thrilled because we brought three dogs, one for each family member—the two daughters and the mother."

As dedicated as handlers like Fred are, working with the LCC Kare 9 Military Ministry dogs can be highly charged and emotionally draining.

"I tear up, choke up, or simply cry," Fred says. "I usually let the emotions flow. The other LCC handlers completely understand and lend emotional support. For example, at our first visit to Camp Hometown Heroes, a young man came up to me and thanked me for my service. This young man had lost his father while serving in the military, *and he thanks me for my service!* I lost it! I handed Flex's leash to my wife, went outside, and cried like a baby."

True to form, at times like this, Fred's best friend knows exactly what to do. "When I get upset and yell at myself," Fred says, "Flex always comes running and puts his head near me so I can pet him and feel better."

Fred is quick to tell you that Flex and the LCC Kare 9 Military Ministry go hand in hand for him and have changed his life by making him more outgoing.

Now retired, Fred's former business career was in IT. He laughs when he says, "Most ITers don't particularly like being around people who they don't know; give us computers over people any day! But I now find myself saying hello to complete strangers and striking up a small conversation with people I've never met."

Likewise, he adds, "I served in the U.S. Army during the Vietnam War, and veterans from my generation just did not mention that they served. Since having Flex and being a part of the LCC Kare 9 Military Ministry, I've found a sense of pride in my military service."

Fred's and Flex's service has also, at times, extended beyond veteran-related missions. With all of these and many more deployments now behind them, you don't have to ask Fred twice why he thinks Kare 9 Flex is a hero; that's a no-brainer to this handler.

"Flex is always so eager to comfort people," Fred says, "no matter how long he's been at an event. Some of these events are hard on him and all the other dogs; the dogs absorb the feelings of the people they're comforting. That's why it's important for us to give them

plenty of downtime, exercise, and a massage to help them de-stress and relax after every visit."

But at the end of the day, words are insufficient for expressing exactly what Flex means to Fred. This speaks to the unwavering bond of love and friendship they share.

"Every morning when Flex greets me," Fred says, "I'm reminded that God has blessed me my whole life and that he continues to bless me. Flex is my not-so-small reminder of that!"

6 ▰ FINLEY

Manassas, Virginia

What makes Labradors great explosive-detection canines at the airport, besides their great sniffing ability, is that they're not intimidating dogs," says Gerli Flores, a Transportation Security Administration (TSA) specialist and explosive detection canine handler based at Washington Dulles International Airport. "They're floppy-eared dogs who passengers fall in love with as they're being screened."

Gerli's partner, Finley—named after one of the 2,996 victims of the September 11, 2001, terrorist attack—takes this cuddly cuteness to a new level of adorable. "Finley has a special fur color," Gerli explains. "She's known as a Fox Red Labrador; her coat color is a gold-and-red mix. Passengers sometimes think she's a golden retriever because of her fur color. Children especially like her, and she loves to get attention from them.

"Finley is very playful. Whenever she sees small children, she becomes excited, and the kids do too. I've had children try to get on her back and ride her like a horse, but most just want to pet her and play with her. I like to tell children that Finley is looking for cookies. Most kids are surprised by this and ask their parents why we're searching for cookies." Gerli laughs.

"There are times when children are afraid of dogs and begin to scream or cry," Gerli adds, "but I try my best to make the screening process as easy as possible for those kids and their parents. As Finley gets older, she's slowly breaking the habit of being playful with passengers. When she's really focused on working, she ignores everything around her. Overall, Finley is a welcoming sight for visitors, especially those who are nervous about flying. Beneath all that furry charm is a highly trained individual whose ultimate goal is to keep fliers safe."

Finley has been specifically trained to detect explosive odors that are traveling through

air currents—this is known as *vapor wake explosive odor detection*—which is an art form in and of itself that serves a critical purpose for our national security.

"As a passenger-screening canine team, our main focus here at Washington Dulles International Airport is to screen passengers and their belongings as they walk through the checkpoint," Gerli explains. "Our dogs are vapor wake dogs, which means that they follow the trail of odor left behind by explosives. Finley is trained to pick up small scents of explosive odor, and once she encounters it, she begins to follow the trail through the air currents and leads me to the person or bag. As a team, in addition to screening passengers, we're also certified to screen airplanes, luggage, gates, vehicles, and cargo."

Gerli's and Finley's goal is to make sure tragedies of the past never happen again. This is a heavy weight to carry on one's shoulders, which is why having a four-legged pal by your side to share the job helps.

"History is known for repeating itself," Gerli says, "and the events that occurred on 9/11 are something no one in America wants to ever go through again. I'm a fond believer that in order to accomplish your goals and to really master something, you have to be the hardest worker in the room. So I always try to be the hardest worker in the room.

"Being a handler means constantly being on the move. There will be days where you move from one training problem to the other and then get called to screen passengers at the airport, all while you're hungry and tired. At the end of the day, I know that training is the best tool we have for keeping our dogs' detection rate on point. And by me dedicating myself to this position, as well as my team, I know my canine and I are keeping lots of people safe. And if I have to skip lunch or wait to eat my lunch later, it's all worth it."

This level of dedication to serve the public combined with a love of dogs was instilled in Gerli early on.

"I decided to become a handler," Gerli says, "because growing up I would help my next-door neighbor—who worked as a state trooper with my father—train his canine. I was always fascinated by the way canines worked and the challenge behind the job. Working at Dulles, the opportunity to become a handler arose while I was a lead on the checkpoint, which means I was the lead TSA officer. I knew I had the ability to be a handler, as well as the skills to establish a firm foundation and face the new challenge.

"My mission now is to make sure that no explosives get through."

Doing the best job possible like this where there's no room for mistakes takes hard

work, professionalism, and integrity, which are both the guiding workforce expectations of the TSA and three words that are synonymous with Gerli and Finley.

"First, as a handler, I was trained at Lackland Air Force Base in Texas to become comfortable with Finley," Gerli explains. "Once we got back to Dulles Airport, there was a period for acclimation and preparing for our second evaluation, which eventually certified us as a team here at Dulles."

These two partners, who spend much of every waking and sleeping moment together— either on the job or at home in Manassas, Virginia—had a bumpy start at first until they got to know each other better. Now, they're inseparable.

"Even after only a few months, Finley and I have established a very tight bond," Gerli says with a smile. "The first month with Finley—which we spent at the TSA National Canine Training Center at Lackland Air Force Base—was very difficult. She wouldn't listen to me and would prefer to do her own thing. As time went by, though, she began to understand more and more that I was her handler now and that I'm in control. The more we interact and work with each other, even today, the stronger the bond between the two of us becomes.

"I treat Finley as if she's my child; there are frustrating moments when she doesn't want to work, but I know that playing with her and cheering her up will do the trick to getting her motivated once again. Now after being with me for a while, she knows that we have an important task to do.

"I believe that in order to be successful as a handler, it starts with having that special connection with your canine. You need to show your canine love when needed but also be firm and demonstrate dominance in order to get the job done.

"Finley means the world to me. Like I said, there will be frustrating moments as a handler when training problems won't go smoothly and it'll seem like your world is crumbling down because your dog missed something. I look at each training problem as a learning experience, not just for Finley but also for myself. Finley to me is my guide to finding explosives anywhere. I can trust her sniffing abilities to guide me in the correct direction every single day."

Because of the nature of their work, Gerli and Finley are potential lifesavers for the millions of people passing through Washington Dulles International Airport every year. But also because of the nature of their job—behind the scenes, confidential, top secret—most

of those millions of passengers will never know the extent to which these two superheroes and their colleagues go on a daily basis to keep them safe by preventing bad things from happening.

And on a much deeper, more personal level, Finley has played a significant role in Gerli's life as well.

"Finley has completely changed my life around," Gerli says. "Before having her, I knew that owning a dog was a semi-difficult task; I knew that dogs needed love and compassion just like us humans, but having a working dog has made me realize the difficulties behind it all. Now I live my life by a schedule. That means on the weekends I have to feed her early in the morning and take her out to use the bathroom, as well as out for a run. My weekend schedule revolves around her.

"In order for her to come into work with me nice and calm on Monday mornings, I have to make her use her energy by taking her out running or playing on the weekends and not let it build up. To me, Finley is a hero for the hard work she puts in on a daily basis. She isn't your normal dog who gets to enjoy treats and is free to play all the time. The work, as well as some of the environments we encounter, makes me appreciate her more.

"Finley is the one who helps me protect the flying public who comes through Washington Dulles International Airport. Every evening when I go home, I know Finley has done her best to find explosives, and that I've done my best to work beside her in finding them."

7 KODI

When your name literally means "friend to mountain lions," you know you have some heroic and adventurous energy coursing through you!

It also shows just how much Pinewood Springs, Colorado, handler Jayne Zmijewski loves and values her search and rescue dog, Kodi, whose full Native American name is Kodi To Ho.

And at sixty pounds and just under two feet tall, this chocolate-brown Labrador retriever is also fearless, making him ideal for search and rescue work. And with her own nicknames—Calamity Jaynie and Annie Oakley—Jayne is Kodi's perfect match.

"One day in late summer, Kodi and I received a call from our local police department," Jayne remembers. "They asked if Kodi could assist with evidence from two poached black bears in a backyard in a small town in the mountains."

Poaching like this is illegal; it happened out of season, with no hunting license, and within town limits. The two bears were shot and killed by an unknown assailant, leaving behind no substantial evidence, although it was suspected that there had been shell casings left initially since a neighbor reported seeing a stranger looking in the grassy area near the scene.

Kodi's mission was to attempt to backtrail the bears' paths to where they had been shot. One bear's body had been found lying next to a neighbor's front door, and the other bear had been killed a day later, after being shot and then found next to the tree he had been in.

"I told the police this would be very difficult, if not impossible," Jayne says, "because I had never had Kodi locate or follow a blood trail of an animal before."

But true to their free-spirited nature, Jayne and Kodi gave it a try for the good of their community and to hopefully bring the bad guys to justice.

"I scented Kodi on where one of the deceased bears had been lying and asked him, 'Where did the bear come from?'" Jayne explains. "I obviously couldn't give him the search and rescue commands for finding a missing person or human remains in this case." The rest was then up to Kodi.

"Sure enough," Jayne recalls, "Kodi backtrailed the bear scent and minute drops of blood to the backyard of a house."

With a proud smile, Jayne adds, "This effort by Kodi is essentially unheard of in our line of work!"

This dynamic duo volunteers their services as part of Search and Rescue Dogs of the United States, as well as Larimer County Search and Rescue and Rocky Mountain Cat Conservancy.

Based on some of his other experiences, Kodi could easily star in his own prime-time sleuthing show titled *Murder, He Barked*.

One mission involved the search for remains of a missing male—possibly the victim of a drug deal gone bad. The scene: hot, dry, high desert, lots of predator activity, and flooding in the area. The remains were estimated to be three months old by this point. All of this conspired to be one big challenge for law enforcement, who called in the dogs for backup.

"Kodi was one of several dogs working a more than one-hundred-acre pasture area, looking for scattered bone elements," Jayne explains. "I gave Kodi my regular human remains command for him—'Find Napu,' which is Native American for *death*—and off he went."

After a long, arduous search, several items were located by Kodi and the other dogs. "When I took Kodi to a couple of the suspect areas, he found two of the most sought-after clues in the case," Jayne says. "This was a very difficult mission, but Kodi showed remarkable effort and did amazing work."

In another murder case, law enforcement once again called in Kodi to search for clues from the suspect. A scent article—in this case, a sock—from the suspect was provided to Kodi.

The scene this time: old storage buildings and a large outdoor nursery.

"Kodi hit a gold mine," Jayne says. "Not only did he locate several of the items the police were looking for, but he also found multiple stolen items stashed on-site that the police weren't even aware of!"

Experiences like these have inspired Jayne in more ways than she can name or count.

"Kodi has made me more committed to help him attain his highest potential given his talents," she says. "And his desire, intelligence, and intensity have also pushed me to pursue certifications that I haven't had the opportunity to acquire before."

Jayne adds, "I got Kodi from Iowa when he was only seven weeks old, so we've been together a long time. It was love at first sight! In fact, Kodi picked me, not the other way around when I first visited his litter. Ignoring the chaos of his siblings, he immediately came and sat at my boot, and just looked up at me. Ever since then, he's projected only love and devotion. He's my whole life—my best friend and a cherished companion."

To everyone they know, it's obvious how close these two friends are. And no matter what cases come their way, Jayne is very clear on what her purpose is when doing search and rescue work with Kodi.

"My mission as a handler," she says, "is to use my God-given skills and my ability to communicate with animals in order to positively impact others' lives. I believe this is the path I was destined to take in life."

As for her unconditional love for Kodi, that's obvious too. "Kodi is a hero to me because of his commitment to our work together and his radiating love. He has a loving look in his eyes that goes right through a person in the best way possible."

With a smile, Jayne adds, "We were chosen to follow this path together!"

8 JACOB

Prospect Heights, Illinois

The dog officially known as Jacob Colossians 3:17 holds the distinction of being the first Lutheran Church Charities (LCC) K-9 Comfort Dog on the scene following the Valentine's Day 2018 shooting at Marjory Stoneman Douglas High School in Parkland, Florida. At the time, Jacob—a fifty-nine-pound golden retriever that normally lives in Prospect Heights, Illinois—was spending the winter in the Sunshine State with his LCC handlers, Sharon and Mike Flaherty.

"On February 14," recalls Sharon, a retired jeweler, "the news was turned on, and suddenly my husband and I were watching the shooting in Parkland live on TV. We knew immediately that the Comfort Dogs would be deployed. Luckily, we had deployment supplies—our shirts, dog vest, and other things—with us. We spoke with our LCC leaders in Illinois and they told us to go.

"LCC had been invited by the local Lutheran church in the Parkland community to bring the dogs. Otherwise, we never just show up. We only go where and when we're invited.

"We arrived in Parkland in time for the first prayer vigil. For those initial twenty-four hours, Jacob was the first and only Comfort Dog there. As a result, Jacob quickly became the face of the Comfort Dogs during this time, with media, students, teachers, and the community.

"After the Parkland schools reopened following the shooting, Jacob spent a full day in one classroom, visiting with several classes that were passing through. We were with the same teacher all day. She had been fairly subdued and quiet for the first part of the day. Eventually, she joined the students on the floor petting Jacob. In the afternoon, the teacher encouraged students to share their experiences and feelings. Jacob went from student to

student, snuggling on their laps as they each told their story of what happened to them during the shooting.

"At the end of the day after students were dismissed, the teacher finally relaxed onto Jacob and shared her story with us. She talked about helping students during the incident, both to hide them and then eventually to get them out of the building. It was obvious that once again Jacob's presence was the catalyst for emotional release and sharing.

"In the very beginning of this visit, it was difficult sometimes to accommodate everyone, as Jacob was very busy comforting those dealing with a very fresh horrific situation. But his calm, highly social, snuggly demeanor pulled us through until more Comfort Dogs arrived.

"We drove back and forth every day from our home just an hour away, our days often started at 3:00 a.m. and ended at 11:00 p.m. Luckily, Jacob could use drive time as sleep time."

After the LCC K-9 Comfort Dog teams finished their deployment at Marjory Stoneman Douglas High School and went home, Sharon and Mike remained in Florida to finish their vacation. However, they soon learned that their work in Parkland wasn't finished just yet.

"We received word that a particular student was having trouble speaking about the event and wouldn't return to school," Sharon remembers. "We were sent to his home for a visit. The student met us at the door unaware that we were coming. He took one look at Jacob and exclaimed, 'The Comfort Dog!' The student immediately began talking about dogs—how he wanted one and how he would train it. His younger sister and family were also very affected by the shooting, each burying their heads into the golden comfort that Jacob offered. Before leaving, we spent time praying with the family and shared many smiles and hugs. I believe God planned for us to be in Florida at that time like we normally would be so that we would be instantly available for this tragedy, and I thank him for that."

Sharon cites Jacob's "grace, calm, and natural ability to be a bridge for compassionate ministry." These traits have enabled him to be one of the many furry faces who communicate unconditional love and offer a welcoming sanctuary from hurt and pain.

At every step of the way, the work of the LCC K-9 Comfort Dogs like Jacob is a grassroots, volunteer effort. "The major deployments of our dogs—the ones that receive the most press, accolades, and community thanks are made possible because of the smaller-scale, less tragic, daily visits in and near our communities," Sharon says. "Those local visits,

which are often out of camera range or public view, prepare handlers like me and our dogs for the major deployments. Our dogs, including Jacob, visit nursing homes, schools, firehouses, hospitals, funerals, reading programs in schools, and so many other places. And, I might add, Jacob's funny attitude and cute face due to his short nose make him a favorite at most all visits, big or small."

Before the Parkland tragedy, Jacob's peaceful and soothing demeanor was called upon at two of the United States' worst mass shootings—at Pulse nightclub in 2016 and the Route 91 Harvest festival in 2017.

The trip to Las Vegas was a particularly poignant reminder to Sharon that you never know exactly when or how you and your Comfort Dog may be called upon to minister.

"This one day, Jacob and I were with one of the teams visiting victims and families in the hospital in Las Vegas," Sharon recalls. "While Jacob and I were in the restroom—yes, you never know when or where duty will call—a woman in great distress asked me to pray for her son. Right then and there, she sat down hugging Jacob while I prayed.

"Just as we finished praying, a young girl burst into the room, asking, 'Can you please pray for someone even if they weren't shot?'

"I said, 'Of course!' and asked what her need was.

"The young woman asked Jacob and me to come quickly to her grandmother's room. She told us that her grandmother was imminently being removed from life support.

"We arrived in the room to greet a family of dog lovers shortly before they were to say goodbye to the woman, who was also a lifelong dog person. They hugged Jacob and me, thanking us profusely for coming to them at that time. Then the family members prayed, the pastor prayed, and I prayed, while Jacob stood close by.

"Just as the life support was being removed, Jacob did a rise-up, putting his front paws on the grandmother's bed as if also saying goodbye. I was truly amazed at what his presence meant to that family. That event was an example of how we never know who will need the comfort of our dog, or who we will be called to serve next."

Comfort Dogs like Jacob are soft and cuddly on the outside, but as these major deployments and the work involved demonstrate, they're tough as steel—as well as tolerant and intelligent—on the inside. This isn't by accident.

"We de-stress the dogs with daily brushing and a massage at the end of their work," Sharon explains. "Jacob also thrives on after-work exercise time in the backyard."

Still, the resilience that Comfort Dogs exude is impressive, and it sets a model for their handlers to follow as well.

"Jacob's ability to remain calm in most all situations—like amid joyfully screaming children, twenty-one-gun salutes, motorcycles revving engines, marching bands, flying on airplanes—gives me confidence, trust, and peace of mind as we share the comfort of our ministry together," Sharon says with a smile. Because of this unique service with Jacob, she adds that she has become "more patient, aware, fearless, prayerful, and capable of sharing in God's love."

And that's not all. Sharon could easily gush about her best furry pal all day—a testament to their unbreakable bond.

"Jacob provides me a way to remain physically active and socially active, with compassion and humor," she says. "Most importantly, he provides me involvement in a ministry that easily shares the love of God." And, Sharon adds with a laugh, "Jacob's silly, laid-back personality is a joy to witness every day!"

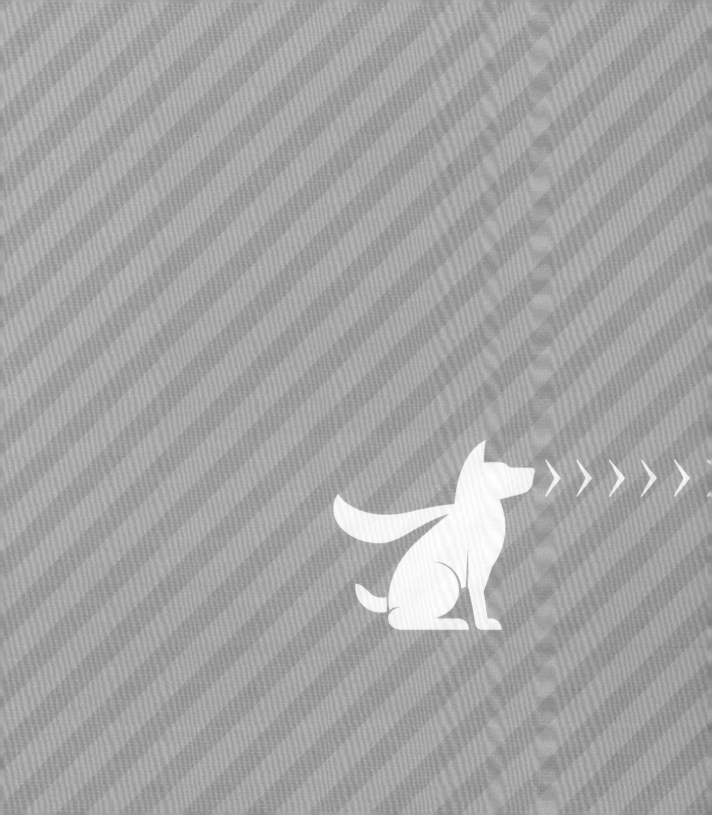

JAKE

Folsom, California

Around 3:00 a.m. on January 9, 2018, torrential rainfall jolted the Santa Ynez Mountains, dislodging boulders and mud and launching them and other debris into Montecito, California, which not even a month before had been impacted by the Thomas Fire.

Debris flows twelve to fifteen feet high rushed mercilessly at speeds of up to twenty miles per hour into the unsuspecting enclave—the wealthiest community in Santa Barbara County and home to celebrities such as Oprah Winfrey, Rob Lowe, Ellen DeGeneres, and Portia de Rossi.

A thirty-mile stretch of U.S. Route 101—from Santa Barbara to Ventura—was closed after being covered in several feet of debris and mud; tens of thousands of people lost power; more than one hundred homes were destroyed and several hundred more were damaged; and twenty-one people were killed. Mass evacuations and chaos ensued, as did the courageous search and recovery mission.

This area is also the former hometown to Eric Lieuwen, a CA-TF7 Sacramento FEMA-certified search and rescue specialist and National Disaster Search Dog Foundation (SDF) handler. He was raised less than five miles away in adjacent Santa Barbara.

"Santa Barbara and its surrounding areas, including Montecito, are very well known to me since I grew up there," says Eric, a U.S. Air Force veteran who served during the Iraq War. "My wife, Paige, also spent the bulk of her life in Montecito. Throughout the first day following the mudslide, the regional task force leaders were trying to both manage the situation and work on additional resources to assist as they were quickly task-saturated with the resources that were in place. The order was placed for what's called a mission ready package, or MRP—handlers with two live-find dogs, meaning they search for living victims, and two human-remains-detection dogs."

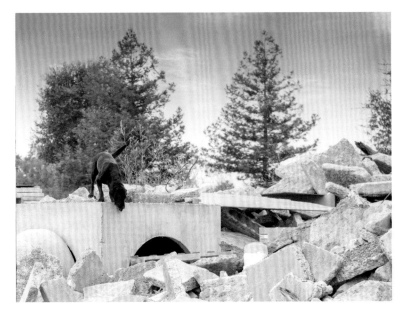

Currently a fire captain living in Folsom, California—the same Folsom where Johnny Cash's iconic *At Folsom Prison* album originated—Eric's furry partner is Jake, a black Labrador retriever with black and hazel eyes, who has gone from being a rescue dog in a shelter to a hero as a live-find dog on the front lines of the search and rescue circuit. Together, Eric and Jake are part of California Task Force 7 (CA-TF7) and work out of the fire department known as Sacramento Airport Fire.

"We assembled at the CA-TF7 US&R cache in Sacramento and were deployed to Santa Barbara in record time," Eric recalls. "I had seen aerial photos of the destruction on the way down, and I didn't sleep well that first night with what I knew loomed ahead of me and Jake the next day in my old hometown.

"The first morning, we were up before dawn. We made sure we had a hearty breakfast before the morning briefing where we would receive our assignments for the day. We met in a huge hall at the Earl Warren Showgrounds in Santa Barbara, where officials went over the incident, the current resources, and what the plan was for the day.

"My MRP was assigned to the Olive Group, which ran from the ocean to East Valley Road, and San Ysidro to the Montecito Country Club. Our forward base of operations, or BOO, was in front of the Biltmore Santa Barbara, a Four Seasons Resort on Channel Drive, just across the street from Butterfly Beach.

"After the briefing, we had a meeting at the Vons supermarket on Coast Village Road to go over the map that detailed the mudflow's path and to start the process of formulating a search strategy. Once we had our orders, we loaded up our dogs and equipment and headed into the hot zone.

"As we drove down Coast Village Road, I was trying to push childhood memories out of my mind as best I could. It's so much easier to compartmentalize when the area and people are unfamiliar to you, but not when it's your own hometown. I needed to focus on the mission at hand, and these memories were a huge distraction."

Still, work is work, and a serious mission like this demands an intense level of professional concentration and focus—traits that Eric and Jake have trained long and hard to master.

"We arrived at the intersection of Olive Mill and Coast Village Road," Eric remembers. "The mudflow had barreled down this intersection and flooded the 101 Freeway with plenty of debris. By the time the flow had reached the Montecito Inn on the corner, it had spread out and was only a few feet high, but anything at ground level or below was wiped out or destroyed.

"Jake and I did a quick search of the area and then reported back to the Long Beach regional US&R task force that we were paired with for most of the deployment. We were then assigned a few areas to search as a team. For Jake and me, that was the Coral Casino Beach and Cabana Club area from the beach up to the railroad tracks just west of the 101. We were spread out quickly because as soon as the fatigued firefighters learned that more canines had arrived, they knew that they could take a much-needed break from their exhausting search. They seemed more than happy to let the dogs rotate in and search. The dogs cover many times the area and in a fraction of the time.

"Jake and I were dropped off with what I could carry in my pack for water, food, and supplies for the both of us. Jake had been cooped up for two days and was beyond ready to work. They gave us a small area to work initially, but I knew Jake, and he wanted nothing to do with the bushes along the roadway. As if shot out of a cannon, Jake was gone, blowing over the area I wanted him to search and heading for structures like a heat-seeking missile trying to acquire its next target.

"I had never seen Jake work so frantically. I asked myself why, and then I realized that the answer was all around me. I was stressed, as I had just started my first real search for live victims. They say the emotions travel down the leash, and I can confirm that to be true.

"Jake was ready to work as hard as ever, but both of us were trying to stay focused amid all the other rescue personnel, tractors, trucks, and chain saws. He started to clear the building area and then hit the parking area that included carports. These carports were six-plus feet deep in mud, and Jake went swim searching. His huge front paws cannonballed

into the mud with his head held high and his nose even higher, trying to catch the scent of a person. Soon after starting, Jake must have been fifteen pounds heavier and was brown from all the mud that had adhered to his coat. I was worried that I was going to have to go get him because the mud was so thick, and he had been searching vigorously for some time. He eventually cleared the area and returned, ready for more.

"We train a lot, and we always keep it safe, but this environment was anything but secure.

"After lunch, Jake and I headed up Olive Mill Road to the area of Hot Springs and Olive Mill. This was where we saw the beginning of some of the worst destruction. It started with vehicles shoved into corners of lots and driveways, and as we drove closer, we saw the heavier concentration of mudflow. The mud lines on the houses started to rise. As we drove up Olive Mill Road, we saw the two-tone paint on the houses many times before realizing that this was the high-water mark of the mudslide. It didn't stand out because it looked like a painter had taped off a section at about the seven-foot mark on the outside of the homes and painted the bottom half a deep brown. The line was so straight, it was eerie. And the side of the foothills had become so liquefied that where a house once stood, it was now replaced by a city of boulders, some larger than a full-sized elephant. They were so big they were immovable, and no worker could get on top to start jackhammering. So the crews started drilling holes in the boulders and putting dynamite in them, and even that didn't always work.

"Soon we saw houses that were slanted, and you could see through the first stories where the mud went through and had removed the contents, turning these homes into tunnels. I took some photos for training purposes and thought we had seen the pinnacle of the damage. Not even close! We saw cars crushed and mangled into unrecognizable pieces of metal and open areas where houses used to be. They were gone. All that was left were the pools covered in so much mud that a first responder walked over one of them and fell in, and he needed to be rescued himself.

"As the mud had slid down, there was one of two options for whatever was in its deadly path: float with the mud all the way to the ocean or get caught in a snag somewhere on the way. The mudflow decided if it would rip the tree up from its roots or start to stockpile its contents in the snag.

"Until the mud started to solidify, Jake and I used whatever we could to stay on top of it and not get stuck, or swallowed whole, ourselves. We used doors, lounge chairs, surf-

boards, and whatever else we could find to walk on. And as if this wasn't enough, there were small fires to be avoided from the natural gas lines that we were unable to shut off at the source, along with huge boulders that hadn't settled and live wires that could easily electrocute us.

"Jake and the other dogs had no idea what these hazards were. They were there to do a job, period. Heck, Jake even thought searching in the mud was *fun!* It was my job to keep him safe.

"By day three of the deployment, the mission switched from search and rescue to recovery—as in, recovering the deceased. Since Jake isn't trained to find human remains, he, instead, received a well-deserved decontamination bath, a big dinner, and some rest. I even treated Jake to a rewarding swim in the ocean waves at Butterfly Beach."

Listening to Eric talk about this deployment—his and Jake's *very first* deployment together, by the way—is nothing short of breathtaking. Every word is swaddled in emotion and dedication, and it paints the beginning of a lifelong bond between these two.

As with all the handlers and their canines who brave harrowing and even unspeakable conditions to conduct search and rescue missions, Eric and Jake are true heroes. But it's Jake's backstory that makes his current tour of duty even more remarkable because it very easily could have never happened.

Jake was once an abandoned dog, a stray wandering the streets of Omaha. Fortunately, he was rescued and brought into the Nebraska Humane Society shelter there.

As luck would have it, Wilma Melville, founder of the National Disaster Search Dog Foundation, and Tim Matthews, from the South Dakota Canine Center, were in the area scouting shelters for potential dogs to recruit. As soon as they met Jake—who was named Jessie at the time—his future as a furry superhero was sealed! He first went to the South Dakota Canine Center for further evaluation and passed with flying colors.

Next, Jake was sent to the SDF headquarters in Santa Paula, California, where he began his formal training.

Eric laughs as he recalls, "The staff's initial notes about Jake were that he was a 'wild man' and that 'he is goofy and lovable. . . . He searches very fast . . . and will be very easy to train.' Jake was indeed easy to train, just as they said, because of his phenomenal intelligence. In fact, he's so smart that he kept me on my toes—still does—and I found out quickly that he was trying to train *me!*"

Exhausting as the process can be, Eric has no doubt that it has all been totally worth every minute of it. Plus, this has been the unique fulfillment of a childhood dream for him.

"As a child growing up in Santa Barbara," he recalls, "I always wanted to be one of the boys on *Flipper,* and eventually, I wanted to grow up to be like the father on the show. Working in public safety with an animal was all I wanted to do. I know that seems silly, but we all dreamed as children, right? So, when I was given the chance to train with one of the most elite and unique canine disciplines in the world, I leaped at the chance. After a few trainings, I was hooked. This is one reason Jake and I were paired—we both have an insatiable drive for the search!"

As for the bond they share, it's unbreakable. *And* comical, especially at the very beginning when they were initially getting to know each other.

"When I first met Jake," Eric remembers, "I was very intimidated. He was *a lot* of dog. Keep in mind that the trainers only work with dogs who have that insatiable drive and super-high energy, so when they called Jake a 'wild man,' maybe that sheds some light on just how driven he is, and what I had brought home with me.

"When I first took him home, he only understood work; he was either in the crate resting or out of the crate working at one hundred miles per hour. As soon as the crate opened, I had to develop a process just to get the collar on him and get him out of the crate without the crate flying in one direction and me the other. This required a monumental amount of patience and consistency. There were times when I wanted to use four-letter words, but I soon learned to love him for what he was. My bond with him now is deeper than anything I could've ever predicted when I first met him."

Eric and Jake's friendship is one that instantly tugs at the heartstrings, not least of which because this handler so sincerely and lovingly speaks of his furry best friend as if this endearing "wild man" is poetry in motion.

"Jake means the world to me," Eric says with a smile. "Every day with him is a gift, and we make the most of it. Now that he's grown up some and we have a mutual *understanding*—as I call it—we can do more things together. He goes on the family boat. I take him to the river and on my paddleboard. He's the best! He gives hugs to me when I need them; it's awesome. He takes a look at me—or anybody else, for that matter—and determines I need a hug, then he wraps his front legs around my neck like a human and puts his head on my shoulder."

This affection runs very deeply—as do the connection and understanding that these

two have for each other's life journeys that eventually brought them together.

"The whole is greater than the sum of its parts," Eric reflects. "Both Jake and I were—at one point in each of our lives—talented but underachieving and lost individuals without a purpose. During adolescence, we both were unwanted and moved from home to home until someone scooped us up and pointed us in the right direction. And then we each found our calling. He's my hero because—and forgive the corny cliché, but—who rescued whom here? Plus, Jake is a hero to so many others for a few reasons. For starters, he's a physical ensign of hope."

In what was a full-circle moment from the first experience they shared in Santa Barbara, Eric says, "Jake and I were at a fund-raiser in Summerland, California, in March of 2018 for the victims of the Thomas Fire and the Montecito mudslide. We met a woman who told us how she had cheated death on the freeway that fateful morning. Visibly shaken by the memory that was resurfacing after seeing all the first responders gathered at this event, she willingly shared her story with me.

"She told me that she had been driving on the 101 Freeway in Montecito when a wall of mud appeared in front of her, rising rapidly. She tried to turn around and barely escaped death. Although her vehicle was destroyed, she was able to get just far enough away so as not to be completely encased in the mud.

"When you do what I do, you must learn to compartmentalize and focus on the task at hand. You can never make it personal; you just have to concentrate on the Xs and Os, not the faces of the victims. Hearing this woman's story, there was no way out of this one, so I tried to not look into her teary eyes. But as if on cue, Jake stood up and nuzzled her. I told her that Jake's second job is as a therapy dog and that he loves hugs. Without hesitation, she latched onto him and let loose an extremely cathartic burst of tears. Jake once again saved the day!"

Looking ahead to the future, Eric says, "Friends and family have asked if I'll partner with another dog someday to continue the search when Jake retires—spending his days riding shotgun in the truck everywhere I go. In a perfect world where we always get what we want, the answer is yes. But life doesn't work that way. I wouldn't just be losing a partner but a purpose. Jake and I were given a gift, and for now, we live out that gift every day, but a gift like we've been given is not something in all likelihood that can ever be replicated."

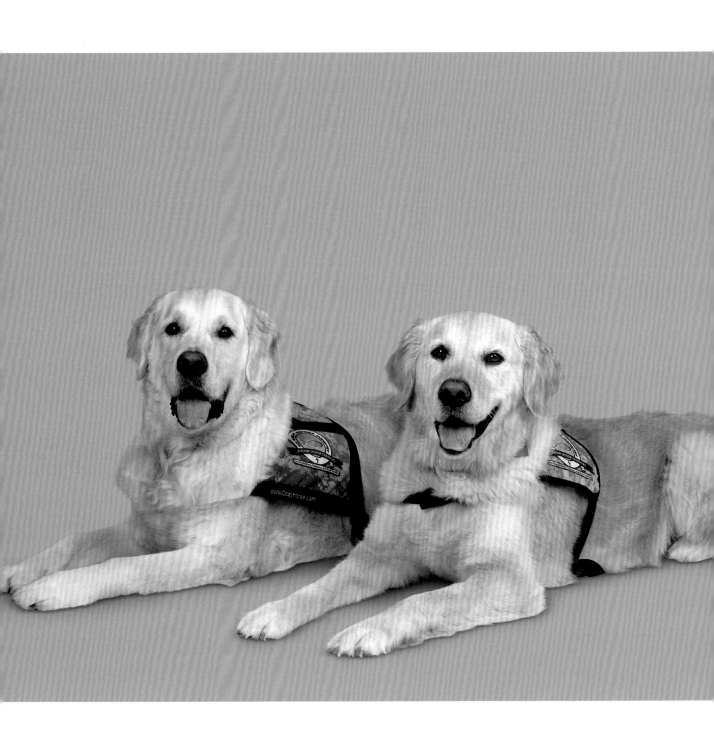

10 PHOEBE AND PAX

Fort Worth, Texas, and Willow Park, Texas

The old adage that opposites attract is even true in the comfort dog world!

Meet LCC K-9 Comfort Dog Phoebe—a golden retriever from Fort Worth, Texas, whose Lutheran Church Charities (LCC) top dog handler, Janice Marut, describes as having "a quiet approach to life that makes her ideal to serve as a comfort to those who are hurting, tired, scared, ill, or in pain. She'll calmly rest her head on a person's knee or hospital bed when she's told to visit."

And now meet LCC K-9 Comfort Dog Pax—a golden retriever from Willow Park, Texas, whose LCC top dog handler, Rhonda Hampton, says is "Phoebe's polar opposite. He has almost an extroverted personality by comparison. You can tell he doesn't want to miss out on anything. If there's the sound of a party, he wants to be right there!"

Joking aside, these furry pals serve as perfect complements to one another. With her official name being Phoebe Matthew 11:29, Phoebe's biblical namesake was best known for her kindness, and Pax—whose official name is Pax John 14:27—in Latin translates to peace. Both are dual vested, serving as LCC K-9 Comfort Dogs when they're with Janice and Rhonda or the other civilian LCC handlers on their team and as LCC Kare 9 Military Ministry dogs when serving alongside a veteran who is an LCC handler.

In addition, Janice and Rhonda believe these two are a match made in heaven because "goldens, in general, are known for being gentle giants. They're a patient breed that is especially good with young children. Probing hands and fingers aren't a problem for them."

So when it comes to comfort work, this pair is a bona fide win-win!

Phoebe and Pax have become an ultimate comfort dog duo. They hail from two worship locations that are both part of St. Paul Lutheran Church headquartered in Fort Worth,

Texas. Along with their handlers, this canine team has become a force to be reckoned with when it comes to spreading love and cheer wherever they go.

This has been a true team effort that begins at the top.

"To both Rhonda and me, being top dog is a job that we take very seriously," Janice says. "The way we structured the ministry from the beginning meant the job encompassed all things Phoebe and now all things Pax. For us, it's a full-time job that includes team management for up to fifty people who serve in various roles. In addition, we take care of the social media presence, scheduling, and interfacing in the community to add new locations to our schedule."

Rhonda, who, like Janice, was initially inspired by watching the LCC Comfort Dogs who visited Newtown, Connecticut, after the Sandy Hook Elementary School shooting on December 14, 2012, says, "To do one-on-one ministry with a dog sounded almost too good to be true. Once I saw the ministry working, I realized it was more than I had imagined. Unlike us, dogs don't see differences in people. They love unconditionally. They're ready to load up and go wherever we're called to serve."

"In all honesty, I'm not an animal person," Janice confesses with a laugh. "But following the coverage of the LCC K-9 Comfort Dogs at Sandy Hook, I guess you could say the stars aligned in terms of information and people contacting a young pastor at St. Paul about the possibility of us having a comfort dog here.

"At first, I was going to do the administrative end of our LCC K-9 Comfort Dog Ministry. My family never even had an animal living in our home before. But after watching the training and going out on a few visits to get the team of handlers up and running, I realized there was something of great value of which I wanted to be a greater part. To watch the effect these dogs have on people who are in pain, whose blood pressure is high, who seem hopeless from loss, who are grieving, and to see how the mere presence of a dog can change their hurt and loss because Jesus comes into the scene through prayer, that's life-changing on both sides of the leash. We say the dogs have done their job if we leave a person with a smile. A frown becomes a smile. A heartache turns into a smile. These dogs are a true bridge to Christ."

Rhonda concurs wholeheartedly. "It's about sharing Jesus with those we don't know and may never meet again," she says, "but the seed is planted, and we leave it to the Holy Spirit to cultivate it further."

The pilgrimage upon which Phoebe and Pax—along with Janice, Rhonda, and their larger congregational team—have embarked led them nearly three hundred miles south of their hometowns to aid another worship community in rural Sutherland Springs—population around six hundred—in 2017. During the November 5 Sunday service at First Baptist Church, a gunman entered the church and opened fire, killing twenty-six parishioners and injuring twenty others.

"Sutherland Springs is a tight-knit community that was rapidly plunged into a world of hurt," Janice recalls. "The town itself is very small, and the number of media trucks and tents, I believe, outnumbered the number of homes in the immediate town. I was very impressed by the number of law enforcement agencies that were represented. I guess I figured in a small town there would be fewer agencies involved, but that wasn't the case. And they did a brilliant job of protecting the townspeople from prying eyes.

"We spent most of our time with first responders and law enforcement officers. They explained to us the process of cleaning up a crime scene so those who wanted to return for closure could do so without fear. They also explained the process of cleaning up personal belongings and boxing them so families could claim some or all of the belongings if they wanted to.

"We met a fire chief who asked if we would go visit one of his crew. We told him yes and asked him where he wanted us to go. He explained how to get to a coffee shop and who to ask for. We went with six dogs. I went inside and asked if they had a firefighter who worked there. The cashier answered yes. I told her the chief sent us to say hello and I had a few friends with me.

"A young woman, maybe in her early twenties, came out from the back, and when she saw the dogs, she hardly knew what to do. We moved away from the register to a more private area where the dogs could surround her and we could pray with her. We asked if we could stay for lunch with the dogs, and they gave us a small private room. Soon, our new young firefighter friend was back at our table and told us she was on break. This time, we got the dogs down on the floor with her, and the picture-taking began. She couldn't get enough of them, and they couldn't get enough of her.

"That night, we went to a prayer vigil at an area high school. We went early so we could greet the crowd as they arrived. A woman walked up to us and asked who was in charge. We located the president and CEO of LCC, Tim Hetzner, and had no idea what she wanted

with him. She began to cry as she thanked us for giving her daughter a reason to smile. Her daughter was the young firefighter we had met earlier in the day. This mother was so appreciative of us finding her daughter and spending time with her. She hugged us and loved on our dogs.

"We also met a woman with the Austin Police Department who has since further reached out to us and even came to our regional meeting in Austin to talk about self-care following a deployment. She started her presentation by describing what it was like being inside of the church after the shooting and working with family members and feeling a sense of needing to get outside and just breathe some fresh air. She went on to say that as she stepped out of the church and looked up at the trees and across the church lawn, she spotted us heading her way with beautiful golden retrievers. She explained how she had smiled and walked toward us."

As this encounter with the young firefighter and others demonstrates, Phoebe and Pax have proven to be especially compassionate when comforting the courageous first responders and other trained professionals whose job it is to run toward a tragedy, not away from it, no matter how emotional or stressful the situation may be on them.

This particularly special gift that these two comfort dogs have for spreading warmth and inspiration was on full display during an unforgettable journey to Dallas. On July 7, 2016, a shooter opened fire on a group of Dallas police officers, killing five and injuring nine. It was the deadliest attack on U.S. law enforcement since the terrorist attack on September 11, 2001. Soon after, Phoebe and Pax were on their way.

"Two of our St. Paul church members serve in the Dallas Police Department," Rhonda explains. "When the shootings occurred, one of them—Debbie, who also happens to be a ministry assistant with our team—reached out to us. Upon our accepting the invitation to be in Dallas, Debbie met us in the parking lot of her precinct in tears. She opened the door to her unit, and they all welcomed us with open arms.

"We spent a good portion of the morning with them, visiting with the police officers and praying with many of them, as they had suffered the loss of three fellow officers in the shooting. We then left and were police escorted to the main police station.

"In Plano at another station, we spent a great deal of time with an officer who had lost his partner and another officer—retired military—who had no family living close by. Both of these officers were drawn to the dogs. Neither of them wanted to go home and be alone.

We sat with the dogs and let them talk. They needed someone to talk to and for someone to listen. We were able to do that for them with our dogs.

"We also visited the memorials, one of which was located in front of the main Dallas Police Department headquarters. There we met and prayed with family members of active-duty police officers who expressed their fear of the same thing happening to their loved ones."

While this LCC K-9 Comfort Dogs team is away from their home base in Fort Worth, they try to end each day by collectively talking through the day and sharing their feelings with one another. This is sometimes very difficult to do, as a lot depends on the circumstances of each deployment.

"After the vigil at Sutherland Springs," Janice says, "I asked everyone to go to dinner. It was cold and wet and late, but I wanted us to process the day. I asked each person to share something from the day, but once something was shared by one person, I told them it couldn't be repeated. We then started going around the table. Of course, everyone wanted to share our firefighter story, but it was amazing how much more we learned from each other, as we had all heard and seen different things during the day and now sharing—with the caveat that it couldn't be a repeat—forced us to think back over the day more carefully and mindfully."

When not traveling outside of their home region, Phoebe Comfort Dog and Pax Comfort Dog keep very busy schedules all the same. They regularly visit eight hospitals and five independent school districts that surround Fort Worth, as well as several nursing homes, rehab centers, cancer centers, and Alzheimer's facilities. They also visit a home for unwed mothers waiting for birth and adoption, a Ronald McDonald house, and the Salvation Army. Plus, they partner with United Airlines at George Bush Intercontinental Airport for the Fantasy Flight each December and Burlington Northern Santa Fe Railway for the Make-A-Wish train every October in Fort Worth.

Since Phoebe and Pax are also vested as LCC Kare 9 Military Ministry dogs, their work with the military takes them to Fort Hood and Central Texas Veterans Health Care System facilities in Waco and Temple. For these visits, a veteran who is also an LCC-trained handler accompanies Phoebe and Pax. Along with other dogs in the region, they visit these locations three times annually to spend time with the soldiers or veterans, listen to their stories, and pray with them.

"Our veteran visits are especially poignant," Janice, who often goes along, says. "For me, watching a veteran visit with a veteran is often a history lesson for me. I can follow some of the conversations but find that afterward I get a real history lesson when our veteran handler explains all they were talking about. This includes major world events that I actually lived through. I then realize that during those historic times, I never fully comprehended what was actually taking place in the life of our military heroes.

"One time, at the state veteran home, we visited a World War II veteran who was a delight. More and more handlers and dogs gravitated toward his room, as we stayed in there for a while. He was presented with a quilt, which he appreciated, and then a handler asked if we could pray with him. He was quick with his answer of 'Oh yes! *If* you let me sing to you when you're finished.'

"After the prayer, this gentleman broke into a perfectly pitched rendition of 'Amazing Grace.' There were no dry eyes left in that room when he finished. I cherish the video I made of this man singing.

"When we returned to the veteran center the following year, I had the video on my phone. We asked if he was still there. The nurse immediately recognized the veteran on the video and told us where to find him. He remembered the dogs and thanked us for seeing him a second time. Before we left, he sang for us again."

Phoebe and Pax, along with Janice and Rhonda, have traveled countless miles together. This has given the two humans in this unique foursome a lot of time to mentally process the missions they've experienced and to consider what these two dogs mean to them.

For starters, Phoebe and Pax have turned out to be conduits to lessons and skills Janice and Rhonda never anticipated learning before becoming a part of the LCC K-9 Comfort Dogs family.

"I'm still not an animal person," Janice says with a laugh. "People who hear me say this ask if that's still true, and it is, but I can't imagine doing cold-call ministry without Phoebe. She breaks down any barriers with her quiet presence and totally takes the spotlight, which allows me to share Jesus in a quiet, nonthreatening way. Talking to people, and especially before large groups, has never been something I sought to do, but now I have to ask for time constraints so I'm sure not to speak too long."

Rhonda explains, "I knew after my first appointment that what I thought this ministry was about had been turned on its ear. It was an in-home hospice visit. We were there on the

patient's rally day—this is a period of time when a patient appears to be getting better when actually they are getting closer to the time of their death. This was a term I wasn't familiar with at the time.

"This ministry has changed the direction of my life. I find that I've grown in areas dealing with social media perception and the sharing of our dogs. From photography to website development and many steps in between, I've acquired new life skills I hadn't previously thought I would be doing. Speaking to individuals or before groups, I'm now never at a loss for words. Sharing about the ministry is a joy I welcome. From a personal-spiritual standpoint, simple things for some people—like openly praying with strangers—were not part of my wheelhouse. Now with the dogs, I don't even think about it; it just naturally happens."

Of the many journeys they've traveled together—handlers and dogs in perfect union—Janice and Rhonda each eloquently sum up their work.

"The joy of us having two dogs is very much a team effort," Janice explains. "Every day the places we visit and the people we meet are very humbling. People let us into their lives for the happy, joyous moments as well as the personal and sad times. They trust us enough to know we'll handle their situations with mercy and grace. It's our honor to represent our churches and to share this LCC ministry freely in our community and beyond."

Rhonda adds, "You never forget the stories, with many of them claiming pieces of your heart. Most of us exist in a bubble with people just like us. But this ministry puts you in places and situations that you never imagined entering. You rethink your politics, your beliefs, and your purpose here on this earth, all because of these dogs."

11 HONEY

West Hollywood, California

With sandy-blond fur, white paws, a black-and-white snout, and honey-brown eyes, Honey Vanderpump Herits Presant is just as sweet as her name suggests! Especially in the eyes of her mom, Lauren Presant, and dad, Thom Herits, from West Hollywood.

From the moment they met her, Lauren and Thom were profoundly moved by Honey's story of survival, which was so horrific that most people can't bear to even hear it, let alone see the images. Today, this forty-pound ball of love and energy has become an inspiring ambassador and role model to millions, both humans and her fellow canines.

"Dr. John Sessa from the Vanderpump Dog Foundation personally rescued Honey from a huge truck that was delivering over eight hundred dogs to be brutally murdered at the annual dog meat festival in Yulin, China," Lauren explains. "The dogs are then sold for meat for humans to eat in order to garner what they think will be good luck. Honey was stuffed into a barbed-wire cage with several other dogs—this cage was big enough for maybe two dogs maximum, yet her captors managed to shove at least seven dogs in there—and transported on this truck for three days with no food or water. She was in such bad condition when John saved her.

"Honey was then rehabilitated and quarantined for a few months. She was one of the only dogs that became healthy enough to pass the strict regulations that are required for a dog to enter the United States. Honey received a passport and finally made it to the USA, where John and the Vanderpump Dogs family took care of her and fostered her until she met the right match and perfect home."

Thanks to the Vanderpump Dog Foundation cofounders and stars of Bravo's *The Real Housewives of Beverly Hills,* Lisa Vanderpump and Ken Todd, the dogs like Honey who are

brought to the shelter, whether from faraway places like China or the streets of LA, are offered a massive platform to transform their rescue stories into powerful advocacy work. In Honey's case, she is one of the iconic first faces to emerge alive in the anti-Yulin movement. Her service as a canine activist also allows her to be the barking voice for thousands of other dogs who have been abused and neglected throughout the country and around the world.

The years 2017 and 2018 collectively marked Honey's new beginning as a grassroots volunteer advocate serving on the national stage. In October 2017, as the newest survivor to escape from the Yulin Dog Meat Festival, Honey attended the star-studded world premiere for the critically acclaimed documentary *The Road to Yulin and Beyond,* where she walked the red carpet. The event was held during the Awareness Film Festival and was located at the Regal LA LIVE Stadium 14 in downtown Los Angeles. During the film's showing, while Lauren watched, Honey was in a green room with a couple of other Yulin survivors.

"The documentary was extremely difficult to watch," Lauren remembers, "and we often found ourselves covering our eyes and ears to tune out the horrific mistreatment of these animals. Honey and her furry friends got to relax in the green room so they didn't have to relive the unkindness and torture they were once subjected to.

"After the film, John, along with Lisa, Ken, and their daughter, Pandora, did a Q&A, during which Lisa recognized Honey as the latest survivor. And then I picked up Honey, and she greeted everyone when they came out of the screening. Singer-songwriter Leona Lewis asked to take a picture with Honey. Lance Bass and Michael Turchin, along with the cast of *The Real Housewives of Beverly Hills,* including Kyle Richards, Erika Girardi, Lisa Rinna, Dorit Kemsley, and Camille Grammer, all greeted Honey after the Q&A, and they all gave her so much love! Members of the *Vanderpump Rules* cast, including Kristen Doute, Katie Maloney-Schwartz, and Tom Schwartz, were also all there, and they also came up to pet Honey and congratulated me on being her mom."

One potentially embarrassing moment in particular at the premiere drove home the fact that Honey had indeed secured A-list status as a superstar ambassador with friends in high places.

"Erika from *The Real Housewives of Beverly Hills* actually stood up and defended Honey at one point," Lauren recalls. "There was a security guard who said Honey had to go out-

side because she accidentally peed on the floor from all of the excitement. But Erika told the guard, 'No, Honey is a part of this event and will not be going outside; she's staying right here!' After the guard backed down, Erika proceeded to tell Honey and me, 'You guys aren't going anywhere, you understand? Honey is so precious!'"

With a laugh, Lauren adds, "Honey was the star of the show that night, and it was very moving to see everyone commend her and congratulate and thank me for adopting her!"

A month later at the Vanderpump Dogs Gala in Los Angeles, Honey was the recipient of the first annual Dog of the Year Award. Once again, she got to walk the red carpet, do interviews alongside Lauren and Thom, enjoy cocktail hour, and then head into the main ballroom for the dinner and awards ceremony.

"A couple of weeks prior to the event," Thom explains, "the Vanderpump Dogs family reached out to us asking if they could film Honey at home and interview us on how she was adjusting to her new, cruelty-free, fabulous life. Without reservation, we agreed. Sarah, the VP of operations at Vanderpump Dogs, came to meet with us at home and asked us questions while filming Honey as she played with her toys and ran around."

"When we got to the gala," Lauren says, "we were told there was a surprise for us. Once seated, we ate dinner, and the awards ceremony started. There was a huge warm welcome from Mario Lopez, who was emceeing, followed by presentations from Lisa and John, a performance by Billy Gilman, and then Lance Bass walked onstage to announce Honey as the recipient of the first annual Dog of the Year Award. This was a complete surprise to us.

"But that wasn't the only surprise! Right before Lance announced Honey as the recipient, our Honey-at-home video started playing on the big screen. We instantly got chills as the entire room watched. It captured the essence of true joy that a dog brings to a home—especially our home—and spoke as a testament to how hard Honey fought to stay alive in the hardest conditions, as well as gaining trust again and learning to love for the first time ever. Her story, along with the photos we submitted, were also printed onto a one-page spread featuring Honey within the gala's pamphlet."

These two high-profile events establishing Honey as an extraordinary hero for our times were made possible not only because of her dramatic rescue from China but also because of a touching love story—this one between a precious little dog from a distant land and the two human hearts she captured at first sight. Like all soul mates, Honey's meeting Lauren and Thom was clearly a destiny written in the stars.

"Thom and I had gone to Vanderpump Dogs a few times in the past," Lauren says, "just to see if there would be any dogs that we'd love. I never truly felt a connection with any of the dogs, which Honey's dad always made fun of me for. Joke's on him, because when his friend came into town to visit, I took her to lunch at Joan's on Third, down the street from Vanderpump Dogs, and then we walked over to see the puppies. I saw Honey, a Shepherd mix, from outside and immediately needed to meet her. She came right over to me and jumped on my chair, and I knew I was in trouble. I wasn't expecting to get a dog anytime soon. I was on the fence, but as soon as they told me she was a Yulin rescue, I felt *awful* that this incredible dog had been through something so horrible. I needed to have her! I asked for the adoption application right then and there. I lifted her up after I filled out the application, and we looked into each other's eyes and immediately fell in love.

"John had turned down a few families before meeting me, which is a true testament to his character and love for the animals he saves. He wasn't going to let Honey go to just anyone; it had to be the perfect match, and he saw the connection we had as soon as he met me.

"Our little fighter has endured two blood transfusions, multiple surgeries, months of recovery, and tons of wounds and scars—including one on her leg from the barbed-wire cage she was jammed into while on her way to the Yulin Dog Meat Festival to be eaten— that took several weeks and even months to properly heal, and some scars are still visible.

"She also had severe PTSD when we first fostered her. The second night we were fostering her, a garbage truck drove by at 4:00 a.m. while we were sleeping, and she screamed and trembled in fear. I've never heard anything like this from any animal, and it broke my heart. We cuddled her and brought her on the bed and assured her she was safe and that nobody was going to hurt her. She fell asleep in our arms, and we formed a bond I never thought was possible."

Thom adds that Lauren meeting Honey couldn't have happened at a better time. "Honey came at a very difficult time in our lives," he explains, "when Lauren's brother passed away suddenly. You could even say this was perfect timing or that the universe works in mysterious ways. Honey could sense when we needed a cuddle or a good laugh. Honey is love, she is light, and she is everything you could ever want in a companion— always happy to see you with a smile and her tail wagging, a cuddle buddy, no judgment, and ready to go on any and all adventures!"

Since being rescued by Vanderpump Dogs and adopted by Lauren and Thom, Honey has cemented her new status—which, according to Lauren, is as a "symbol of hope."

"Honey has shown us what strength and courage are," Lauren says. "She continues to attend events to raise awareness for the cruelty of animals, and she proves day in and day out that love is learned and that love is possible, regardless of your circumstances."

With the help of Lauren and Thom, Honey bears the torch of hope and love as she leads by example to inspire action in others.

"Aside from attending events, including the annual World Dog Day festivities started by the Vanderpump Dog Foundation in 2016, and being an active advocate on social media, Honey has a presence in the neighborhood and community, raising awareness through her story every day," Lauren says. "Our neighbors have taken to Honey, in addition to all of our friends at the park. One neighbor in particular met Honey while we were fostering her for seventy-two hours before finalizing her adoption. He's always in complete awe of her demeanor and thanks us daily and tells us how incredible it is to watch her grow and adjust.

"During our daily walk with Honey one morning, we were across the street from our home and someone in a Prius waiting in traffic on our street rolled his window down and asked if we had adopted her from Vanderpump Dogs. When we said yes, he immediately screamed, 'OMG! *Is that Honey?*'

"He told us that he had almost adopted her, but it wasn't the right fit at the time. Still, he recognized her and almost cried he was so happy for her. I told him to follow her on Instagram at @HoneyFromYulin, and he immediately did, and he messaged us saying again he was so happy for her."

As for the social media extension of Honey's work as an ambassador, Thom explains, "We've chosen to use Honey's online presence as a platform to raise awareness about animal cruelty, but more importantly to also focus on the positive outcome for these dogs once rescued by their owners. It's incredible to watch these dogs find love and give love after all of the adversity they endure. We post videos of Honey learning new tricks, photos of her lounging and smiling, enjoying life, and just showing how amazing it is to be able to have a second chance at life."

"We've even had a few friends looking to find their perfect furry soul mate who have adopted rescue dogs as well because of seeing firsthand how precious Honey is," Lauren adds. "We've always been advocates for the 'Adopt, don't shop!' movement. When people

ask where Honey is from, and we explain, it resonates with them, and we always, without pause, receive a 'Thank you.'"

While counting their blessings with Honey, Lauren and Thom also enumerate the many lessons she has taught them. "For us, Honey is a true testament to overcoming life's obstacles and facing adversity. It seems ironic, and sometimes comical, learning from a dog, but she has taught us so many lessons: how to love unconditionally, to get fresh air, play, relax—she's very mellow—and most importantly, to trust. Honey is the perfect representation of having a second chance at life and duly embracing it. All these dogs need is some TLC, and they'll give you an abundance of love in return.

"Knowing about Honey's history and the fragility of life itself through what she endured gave us a new outlook on life and taught us how to hold our loved ones even closer. It's about forgiveness. It's about understanding. It's about being kind—as a dog rescuer and as a human being. We could all use more of that! Honey's background is an opportunity to educate people. And to us, she is our world."

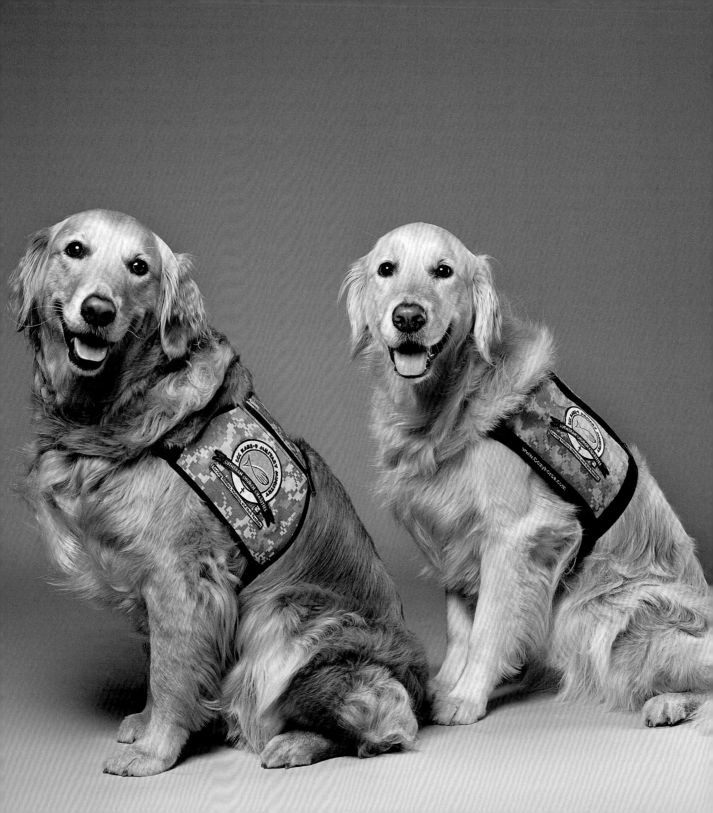

12 ADDIE AND LEAH

Danbury, Connecticut

A golden retriever with fluffy and wavy fur named Addie—her full name is Addison Psalm 18:30—went as a Comfort Dog in training with the first group of Lutheran Church Charities (LCC) dogs and their teams that responded directly after the Sandy Hook Elementary School shooting on December 14, 2012.

"Those handlers and dogs remained in the town for weeks following the tragedy, responding to the needs of the traumatized community," says Mary Perry, a resident of Sandy Hook, Connecticut. "Immediately following the shooting, LCC was invited and responded that weekend with dogs and handlers. Teams remained and ministered in town, then went home for Christmas, and some came back for several weeks after New Year's.

"Addie came out in January and was placed at Immanuel Lutheran Church in Danbury. Along with other LCC K-9 Comfort Dogs, she went to the temporarily relocated Sandy Hook Elementary School every day to console students, staff, and parents. Addie and other Comfort Dogs were at that site until the new school opened. Maggie, a Comfort Dog from Christ the King Lutheran Church in Newtown, continues visiting students in the Newtown schools to this day.

"About a year after Addie's placement, and as requests for her time grew, Immanuel applied for another Comfort Dog from LCC. In the fall of 2015, Leah, whose official name is Leah 2 Corinthians 4:7, joined our team, and our team of handlers grew too! The reach and coverage of our service has grown to the point where today Addie and Leah go to hospices, schools, preschools, drug and alcohol rehab facilities, veterans' programs, police and family service programs, stress relief sessions at colleges and universities, workplaces, nursing homes, rehab facilities, in-home visits, church programs, and more. We also sit on two

crisis response teams—one in Putnam/Westchester, New York, and the other in western Connecticut—and are deployed as needed as part of the standard school-crisis response protocol."

Witnessing the work that the LCC K-9 Comfort Dogs were doing in her own community is what inspired Mary to initially get involved with them.

"Since I live in Sandy Hook, I saw firsthand the amazing work the dogs and handlers did in a traumatized community," she says. "I originally got to know them when I'd see them in town or at the local mall, and I just loved them from afar, not wanting to interrupt the work they were doing for others. On social media, I liked the dogs' pages and followed their activities. Then one day in the late summer of 2015, only by the grace of God did I reach out to Addie's top dog handler at the time, Jen, just to see if they needed any help—maybe in marketing or something. But I never thought I would become a handler, *and* later a top dog.

"Jen more or less swept me onto the team, and I was thrilled to later be at Leah's welcoming party and at her passing of the leash. I thought I was in heaven. I felt so humbled and privileged to be just a small part. I then heard myself saying to Jen that if they ever needed me, I would consider becoming a handler. Next thing I knew, I'm at handler training in Chicago, where I passed and received my badge. I was officially then a handler for the Comfort Dogs. It was a total feeling of *wow!*

"My mission is to now take Addie or Leah wherever we're needed, to keep them safe, and allow and encourage the love of Jesus to be felt by whoever is in need. I step out of my own hesitation and uncertainty every time I walk in somewhere because Addie and Leah need me to do my job. And so does God. I consider it a true and honest privilege to be part of this ministry team and to be used by God to be present with someone and to share love with them. I still to this day think it's such a powerful moment when you see a line of LCC K-9 Comfort Dogs walking into a difficult situation; they represent the best of true love and comfort coming to the rescue."

Currently, Mary also serves as the LCC top dog for Comfort Dog Ministry Team Addie and Leah. The memory of the Comfort Dogs at work during those days, weeks, and months following the Sandy Hook shooting have stayed with Mary and continue to inspire her.

"Addie's job when she first came to Connecticut was to help get the Sandy Hook Ele-

mentary School kids back to school," Mary remembers. "She helped them to get off the buses and to let go of their parents' firm grip, and to walk in the door and to go to their classes. Some kids came to school only because they had the job of giving Addie water or brushing her. Parents would say to their children, 'Addie needs you to brush her today, so let's go to school.' And the children would agree to go. And for her part, Addie fulfilled this extraordinary mission beautifully."

Addie has repeatedly demonstrated the gift she has for drawing people out of their grief and fear and welcoming them back to a happier, safer place. "Addie was once called to deploy to a local high school after three students were killed over a single weekend—all in different accidents," Mary says. "There was one student at the school who had lost both her friends in one of the accidents and also her grandmother on the same day. This student literally laid on Addie, hugging her for hours, until she regained the strength to move."

At a hospice, Addie had her handler, Cynthia, stay for an extra-long visit. The patient they were visiting was too weak to sit up, so Addie placed her head on the end of the bed. "The patient petted her ever so softly," Mary says, "and a small smile came to the woman's face. Addie left and the woman passed away peacefully that evening."

Likewise, Mary and her entire dedicated LCC K-9 Comfort Dog team, which numbers twenty-five total handlers, also adore Leah, a seventy-five-pound-golden retriever with a smooth, long, light golden coat.

"Leah is a sweet, loving dog," Mary says with a smile. "Although she's younger than Addie, Leah is an old soul. She's calm and levelheaded as she works. We can always count on her to listen to commands and to do her work to comfort and love people beautifully. I think she genuinely likes her work and loves to love. She keeps her eye out for her handler when she's in a crowd of people and wants to know that you're there for her. And when her work is done, it's done. Leah leaves it at the door behind her and moves on. I love how sweet and confident she is, and when I or her other handlers love on her, I know she feels our love for her."

One time, her LCC Kare 9 Military Ministry veteran handler and co–top dog Joel took Leah to a drug and rehab facility and met with the veterans who were clients there. It's truly a special bond that exists among veterans.

"Veterans have a tendency to talk openly with Joel when seeing Leah in her camouflage Kare 9 vest, along with her unique cards," Mary explains. "To them, those things mean

that Joel and Leah understand and get them. We're proud to also have two other veteran handlers, Tom and Heidi, on our team."

Leah has also become a furry advocate for literacy. "Leah loves to be read to!" Mary says with a laugh. "Joel takes her to libraries and a local elementary school, and the kids lean on her while they're reading to her. One little girl didn't want to read out loud, because she didn't think she was good enough. But then Leah put her head on the girl's knee as she was sitting close to her. The girl saw and felt that touch of encouragement and began to read out loud to Leah. We take pride in the fact that Leah's reading program was recognized as the best reading program in the school system by the local school board."

For this team of more than two dozen handlers and the other volunteers, this journey of service with Addie and Leah is deeply personal.

"Bad stuff happens in this world," Mary reflects. "Really bad stuff. No one should experience what some people experience, see, and remember. But through this ministry, people's lives are changed, people do smile for the first time, people do start talking while petting the dogs, people do want someone—human or K-9—to love them back. And as a result, people do experience hope."

13 JESSIE AND OLLIE

Arvada, Colorado

What's in a name?

Well, if you're one of deputy sheriff Kelly Fosler's search and rescue bloodhounds in Arvada, Colorado, then the answer is: a lot of love and heartwarming significance.

Davidson's Jessica Ridgeway by Al, or Jessie for short, is named in part after Jessica Ridgeway—a girl who was kidnapped and murdered in Westminster, Colorado, in October 2012.

"My original trainer, Al, had used his bloodhound to do some work on Jessica's case," Kelly explains. "I didn't have a bloodhound at the time, but I had helped search for Jessica. I later met with Jessica's mom and got her permission to name my first dog after her daughter. We've kept in touch since, and K-9 Jessie wears a purple collar and a purple leather swatch that says *Faith* on the back of her badge."

Kelly's younger dog is Oliver Tom Johner Loves Mama Jeannie. He's certified but not yet working for the sheriff's office.

"I like the name Oliver, so we call him Ollie," Kelly says. "And Tom Johner was a friend and coworker at the sheriff's office. He was in charge of most of our canine cars and loved each of our dogs as if they were his own. He passed away unexpectedly just prior to me getting Ollie. And Mama Jeannie Bondio is one of my mentors who's been there from the beginning. I speak to her frequently about cases and my hounds."

The love and care that went into naming each of these dogs is only the tip of the iceberg when it comes to the sheer affection Kelly has for her search and rescue dogs and the work they do with her. Both dogs are certified through Search and Rescue Dogs of the United

States, which bases its standards of certification on Federal Emergency Management Agency (FEMA) requirements.

"I've always been a dog lover," Kelly says, "and at one time, I wanted to be a veterinarian, but once I got out of high school, I got into law enforcement and have been doing something in that realm ever since. Now I have the best of both worlds!

"Initially, I was interested in how the search and rescue dogs worked and why they do what they do, so I went to observe the bloodhounds work and our shepherds as well. To see the power a dog has by using his or her nose is an amazing thing to me. Each dog has a phenomenal sense of smell. They use this trait to please us and never ask for much. They never complain about going to work or what they're working for while using the special innate skills they have.

"I now do this work because I want to help in any way I can by using my dogs. Whether it's to find a lost child or elderly person, locate a car thief or any criminal, or even find the remains of someone whose family wants to lay them to rest. I also love taking Jessie to events for kids and adults. Citizens enjoy being able to personally ask questions of a police officer, and the dogs often serve as icebreakers. They show that we cops are human too and can love animals as well as be friendly."

To date, Jessie has had more experience on missions than Ollie, who is three years younger. For one mission, Jessie and Kelly were sent to help search for a homicide victim in a forest of a neighboring county.

"It was a needle-in-a-haystack situation," Kelly explains, "and no one was really sure that the victim's body was even in the area. The suspect had been arrested in another state with the victim's belongings.

"We divided up the area—about three-fourths of a square mile—into sections with three other dog teams. Jessie and I got teamed up with the county coroner. We drove to our section, and Jessie didn't appear to have much interest. She was smelling things, slowly moving along, eating grass, and trying to get in the water. The brush and shrubs were so thick that sometimes I couldn't see her, just the thirty-foot green leash I use.

"She headed west slowly but surely, and I assumed that she wasn't going to find anything, but she kept pulling west and then wanted to cross the railroad tracks north, into another dog's section. At that point, I decided to let her go where she wanted. Again in thick brush, I couldn't see where she was taking me, but it ended up being in the camp area

we had met and started in. It felt like we were just walking in circles. I was not happy.

"As I rounded her up to head south to our section, she pulled me quickly south and west. Again I couldn't see her, but once I got sight of her, I could see her creeping low and slow. I looked in front of her and could see human feet sticking out of the ground. She had found our homicide victim!"

When working in law enforcement, and especially with search and rescue dogs, life is never dull, nor is it ever the same routine from one day to the next. "Being on call has changed my life the most," Kelly says. "I'm on call 24-7, being the only bloodhound handler in the county. I also get called out for other agencies when needed. That means missing birthdays, dinners, movies, and more."

But this line of work is a labor of love for Kelly. It has to be.

"I also do things differently at work because of Jessie," Kelly adds. "I drive smoother and am tasked with making sure my partner is okay in the car while I'm away from it and that she doesn't get hurt by anyone while working. I don't just have me to look out for; there is always two of us."

And on a lighter note, Kelly says with a laugh, "I never had large dogs before, so there's a lot more hair and slobber than I ever dreamed of!"

Jessie's very first mission in trailing a person was from a car crash involving a stolen vehicle, and she demonstrated just how on point she is when it comes to this unique line of detective work.

"It was snowing and extremely cold, and the officers couldn't locate the driver," Kelly remembers. "We started the trail from the car, and Jessie followed the sole footprints from the car, looping back around and eventually crossing the highway. She started south but had a change of direction and went north, all the while the highway was shut down—dur-

ing rush hour—because we were walking it. We went about one and a half miles, and she stopped. I also heard over the radio that someone possibly had gotten the suspect in custody. However, he was *south* of us. I wondered, *How could that be?*

"Talk about embarrassing! So Jessie and I walked back to where the crash was. I started talking to one of the deputies while he sat in his car. Jessie kept nosing the car and jumping up on it. The alleged male suspect was in the back. Perplexed, I opened the door, and Jessie jumped up on him with her front paws, identifying him as the subject she was looking for. Still perplexed, I asked again where he had been picked up. The deputy told me south of us and that he had been driven past us, northbound as we were crossing the cement barrier on the highway. That's when I realized Jessie had gotten the odor from the patrol vehicle driving north!"

Both Jessie and Ollie mean the world to Kelly. Not only are these three a mutual admiration society when it comes to the work they do together but that shared love extends into their personal lives at home as well.

"My dogs are both tools to help the citizens *and* pets," Kelly says. "They're bonded to me and rely on me for everything from food, play, and shelter to guidance and instruction. We three give and take when it comes to learning. They mean enough to me that I have their first initials engraved on two of my gold crowns. Not to mention many, many pictures of them, including selfies and their own Instagram account.

"As for the bonds we share, Jessie and I are together every workday in a patrol car for almost twelve hours. I talk to her, and since she can't answer in words, I answer for her. She's not what you'd call very lovey or cuddly, but she's very independent, and she always protects me. And she's a hard worker. Jessie doesn't let anyone near our patrol car, she smells the driver's license of everyone I contact, and if I'm on a traffic stop, she watches them with intent. If the person moves around a lot or gets out, she starts whining at me. Throughout the day, she goes to briefings with me inside schools, to the dog park, into the lieutenant's office to get food, and, yes, usually to the bathroom at headquarters with me.

"Ollie, on the other hand, only comes to work with me once in a while, but to training every week so I don't spend as much time with him. He's at the very beginning of his journey in this field. But he does like to be with me when I'm home. He's a bit more lovey and cuddly than Jessie and is always underfoot, just wanting to be with me and my husband, Aaron, who is also a deputy sheriff. He watches TV with us and on occasion sleeps in the

bedroom with us. He really wants to please me, and I really think he understands what I'm saying when I talk to him."

Today, search and rescue has become a true family affair for Kelly and Aaron and their brood of hero dogs. Aaron is also a handler; he's had three search and rescue dogs over the years, including Rocky, Sabre, and currently a shepherd from Germany named Thrie.

"In 2017, Aaron and I started working our dogs together," Kelly says, "as in tracking and trailing at the same time. This serves a good purpose, as a bloodhound is literally a man-trailing machine, and a shepherd is a very good tracker too. We started doing this so we would have the protection of the shepherd and also his trailing ability along with the nose of the bloodhound."

At its core, search and rescue work is hard, taxing both mind and body of handler and dog, which means it takes a very special person and an extraordinary dog to form these partnerships.

"I love what I do," Kelly says, "but it comes with a cost: the misery of not finding what we're looking for; the possibilities that go through your head about a certain case where a subject wasn't located; and the questions like *What if?* and *What could I have changed or done better?* really eat at me. Sometimes I feel like I have to justify why Jessie did what she did or didn't do, most commonly to deputies or officers who aren't and have never been a handler. When almost always, Jessie has been right.

"Outside of my mentor, Jeannie, and my original trainer, Al Nelson, I lean on other handlers and a wonderful captain whom I train or work with for guidance and support. Those people are the best, and I don't know where I'd be without all of them. But my husband, with his twenty years of handling, has been my biggest support. He gives me confidence, guidance, and lifts me up when I feel as though Jessie and I have failed. I owe him a lot.

"The one thing he has drilled into my head—'*Always trust your dog!*'—rings true to this day. I finally got it tattooed on my left leash hand, because my gun hand is my right. In French—which is one of the main languages spoken in Belgium, where bloodhounds originated—it reads, *Toujours confiance à votre chien.* I see it when I work my dogs and say it to myself many times over. And that is the best advice I would give to anyone who works with a dog."

14 ▷ DORA

Milwaukee, Wisconsin

Explaining why LCC K-9 Comfort Dog Dora is special is the easiest question in the world for Lutheran Church Charities (LCC) top dog handler Jill Zempel from Wisconsin to answer.

"Because she loves unconditionally," Jill says with a smile. "Her ability to love and listen means that she can go anywhere and provide comfort, and we can go alongside her."

Jill and the larger team that works with Dora—whose full name is Dora Psalm 13:5—through the Lutheran High School Association of Greater Milwaukee split their time working between suburban and urban schools and communities.

"Milwaukee is one of the most segregated cities in America," Jill explains, "but Dora doesn't know that, and Dora doesn't see people for the color of their skin. Dora is special because through her training and her personality, she feels for people. She feels people's emotions, and they respond. There have been countless times that for reasons I can't understand, Dora chooses to sit or lie down next to someone and provide comfort. And it isn't always the person whom we would assume needs love at that moment."

As a mom and full-time volunteer, Jill describes herself as a "connector." Much of her life is now dedicated to Dora Comfort Dog and the journeys they enjoy together. "I'm a sharing-of-ideas person," Jill says, "so I initially met with LCC to ask permission to go to St. Paul Lutheran Church in Fort Worth, Texas, to convince them to consider starting a Comfort Dog ministry at their church. My daughter was a freshman at Texas Christian University in Fort Worth, and I thought it would be a great match.

"At the time, Tim Hetzner—the president and CEO of LCC—told me, 'You can share the ministry idea in Texas, but where we really need another dog is in Milwaukee.' I was serving on the board of the Lutheran High School Association of Greater Milwaukee, and

a fellow board member donated the funds for us to get a Comfort Dog. As a result, Dora now has a meaningful ministry in Milwaukee. And there are currently several Comfort Dogs in Texas—I have a special relationship with those first teams in Texas.

"My mission now is to go wherever God is leading me on any particular day. There's always someone who needs comfort, and my job is to seek out those who are in my path and listen and love. I don't know what my life would look like without Dora, the ministry, and the incredible team of volunteers I work alongside and consider my dear friends. Before starting this ministry, I was working part-time. Within six months of having Dora, I quit my job to focus on volunteering."

Dora and her team hit the ground running and have never looked back. Theirs is a pathway of love, comfort, and hope wherever the day leads.

Less than a month after Dora arrived in Milwaukee, Jill received a call from the principal at a local elementary school. A boy in kindergarten had become seriously ill over Thanksgiving break and was in an induced coma at Children's Hospital of Wisconsin. He asked if Jill would bring Dora to meet with the sick child's kindergarten friends and spend some time with his two older sisters, who were also students there.

"We immediately said yes, that we would go that afternoon," Jill recalls. "The time we spent with the child's classmates was wonderful. All the kindergarteners got on the floor with Dora and were comforted. We prayed that the young boy would be completely healed, and we talked about how God comforts us when we're hurting and sad. We also spent at least thirty minutes with the little boy's sisters, who sat next to Dora and petted her and talked the entire time. They were so sweet. I left the school building thinking, *That's exactly what a Comfort Dog is supposed to do!*

"I then took Dora's vest off to let her run around on the playground a bit before we went home. A school employee was working near the park, and he asked me about Dora. We talked for a while, and he took a few turns throwing the ball to her. I told him why we were visiting school that day. He then told me that he had been estranged from his adult son for years. The holidays were always tough, and he didn't know if he would ever see his son again. So Dora and I sat there on the playground and prayed with this man.

"You never know who needs comfort. And you always have to be prepared to listen. Also, on a very happy note: the young kindergartener made a full recovery and is back in school with all of his fellow classmates. We have a standing two-hour visit every other

Monday at that school, and Dora is possibly the most popular student of them all."

So much about Dora makes her a perfect fit for working as a Comfort Dog. "Golden retrievers like Dora are smart, loving, playful, and very approachable, which make the breed a great choice for being comfort dogs," Jill says. "Even if people are initially scared of dogs, they usually end up petting her. Specifically with Dora, LCC knew that she was going to spend most of her time with kids, and she absolutely thrives on working with children. Naturally, many of the young kids who meet her like to call her Dora the Explorer."

Some of Dora's most memorable moments have occurred at Milwaukee Rescue Mission, which is the largest homeless shelter in Milwaukee. On any given night, hundreds of people wait to see if there's a bed for them. The mission has separate floors for men and for women and children, as well as a program for men who are recovering addicts.

"One of the most humbling experiences we had," Jill remembers, "was when we were meeting with a mom and her kids on a Monday evening. They loved Dora and asked when we were coming back. The next few times we visited, the same mom and her kids came to see Dora. The oldest daughter was in high school and said she loved coming to see Dora because when they moved into the homeless shelter they had to surrender their dog—a Labrador—to the humane society. We had never thought about that reality before, and it was very difficult to hear and to process."

Dora has also spent time involved with the men's twelve-month in-house recovery program. These men live—dormitory-style—on a separate floor of the mission.

"We visit these men just before their group Bible study," Jill explains. "We realized pretty quickly from the first visit onward that they weren't as interested in petting Dora as much as they wanted to play with her. So we would take Dora's vest off and bring a tennis ball for them to throw to her. The more they played, the more they talked to us. It was different, but it worked. The residents were being comforted by playing with Dora.

"We always asked what we could pray about for them. One night, one of the residents told us he had reached his six-month goal and knew he could complete the program. Then he asked if he could say the prayer that night. He thanked God for being with all of us, and he thanked God for Dora and asked that God continue to be with him. We left feeling like we were the ones being comforted that night."

In spring 2017, a police officer was killed in the line of duty in Wisconsin. Dora, who is also vested with the LCC Police K-9 Ministry, attended the officer's funeral with another

one of her handlers named Dave, who is a law enforcement officer.

"During the service, Dora and Dave sat in front with other LCC K-9 Police Ministry dogs," Jill says. "Dora was lying down on the floor being calm when the formal police procession began. Dora then sat up and barked—she's actually trained *not* to bark—as the loud clicking of the processional scared her. The handler immediately had her lie down, and she was quiet the rest of the service.

"We work closely with C.O.P.S.—which stands for Concerns of Police Survivors—welcoming families who have lost a parent in the line of duty to summer camp. We spend time with them when they arrive, when they depart, and last year we got to attend camp for a full day. Dora was with her handlers at this camp when a mom came up and said, 'I know you; you're Dora, and you barked at my husband's funeral. But when you barked, you made my little girls laugh, and they hadn't laughed in a few days. So thank you!' Even when Dora isn't perfect, she somehow finds a way to bring joy to people."

Since Dora is owned by the Lutheran High School Association of Greater Milwaukee, a great deal of her service is spent working with students. On a weekly basis, she visits three Lutheran high schools and numerous other schools in both the city and suburbs.

"Often, students and teachers just love giving Dora a quick pet to say hi, and that brings them joy," Jill says. "Other times we work with students one-on-one along with a counselor, because kids start petting Dora and then they open up about other things in their life."

Modesty and humility are ingrained into the work handlers do with their respective Comfort Dogs. This is an ever-evolving journey that leads the handlers themselves to further embrace the better angels of their nature. This has truly been the case for Jill.

"I always considered myself to be a kind person," she reflects, "but working with Dora has changed the way I look at people. Dogs don't judge. They listen and give unconditional love. After working with Dora for several years now, it's impossible to look at people in the same way. Even when I'm not with her, I find myself really looking at people rather than looking past them."

Ultimately, Jill adds, "At the end of the day, Dora is just a dog. This ministry is about people. But here's the thing: without Dora, we wouldn't have the opportunity to meet the people we do every day or to go places we wouldn't normally go. Dora as a working dog allows us to spread joy, comfort people, and be present. She is the gateway to enabling us to

be the hands and feet of Jesus. So Dora means the world to me because she gives us access to people."

And seeing them all together, there's no doubt that Jill and the other handlers also mean the world to Dora. "Simply put, seeing the world through Dora's eyes makes all of us better people," Jill says.

15　ELCHA

Silt, Colorado

In 2014, Search and Rescue Dogs of the United States (SARDUS) launched the Returning Soldier Initiative, which pairs returning veterans and dogs. Within their communities, these courageous duos are then trained by SARDUS to volunteer for their local search and rescue organizations.

This important program allows veterans assimilating back into civilian life to continue using their vital skills and expertise in new and crucial ways. With renewed purpose, members of the military are then able to serve in their communities in what becomes the next great mission of their lives.

"My dog Elcha is a hero to me because she provided me with something that I didn't know I needed at first," Sergeant Greg Yost says. Greg is currently a helicopter crew chief at High-Altitude Army National Guard Aviation Training Site (HAATS) in Gypsum, Colorado, near Vail. "She gave me companionship that I didn't realize I missed so much, and when I get home after a ten-hour workday and I see her energy and know her purpose, it gives me the motivation to load her up and go train."

A black Czech-line German shepherd, Elcha became the newest addition to the Yost family at age four months when the Returning Soldier Initiative presented her to Greg and his wife, Brandie. "Her name translates to *Ella* in English," Greg explains, "and this really spoke to me since my last dog, who was named Ellie, was killed in a tragic accident."

Elcha marked the start of a whole new life journey for Greg. "This is my first search and rescue dog," he says.

But long before Greg met Elcha and had committed himself to search and rescue missions, he was already a hero who was serving our country. "I began my military career as a Marine in 1997," Greg says. "I was a machine gunner in a weapons company. A deployment

overseas with them was enough to teach me that I needed to be doing something else—helping to save lives, rather than taking them. Fast-forward to 2011 and I was sent back overseas to Afghanistan as a medevac helicopter crew chief with the Arizona Army National Guard. I felt as if there was no other place I'd rather be. Unlike any other job in the military, you never asked the question, 'Why are we doing this?' As medevac, you knew there was no greater job.

"Helmand Province in Afghanistan during this time was a busy, bloody place, and it took its toll on our unit. We lost our share of pilots, crew chiefs, and medics for various reasons. It was during this time that I became sick. I told myself, 'These people are dying and getting blown up; you're just sick, you have to keep going.'

"It took four months, but I finally collapsed on duty and was admitted to the tent hospital on base. I foolishly lied to get released, and I nearly collapsed again. A pilot I greatly respected visited me in the hospital and talked some sense into me. I finally told the doctors the truth about how I was feeling, and I was on a medevac plane myself to Germany that night.

"Things took a turn for the worse once I got back to the United States, and I was in emergency surgery within twenty-four hours. Overall, I spent six weeks in ICU, underwent two major abdominal surgeries, and was in the Warrior Transition Unit at William Beaumont Army Medical Center in El Paso, Texas, for nine months."

One of the few bright spots during this time was the comfort dogs who would periodically visit Greg in the hospital. "While I was in the hospital at Fort Bliss, a few comfort dogs made their rounds," Greg recalls with a smile. "I especially remember a white Lab who came to visit. It was always nice to pet the dogs. They were a welcome break from the mundane, even if only briefly."

Fast-forward again past lots of paperwork, doctor exams, evaluations, and waivers, and Greg found himself back on flight status with the Colorado National Guard's High-Altitude Aviation Training Site.

"HAATS is considered the top gun of the military helicopter world and conducts a large number of search and rescue/hoist missions every year," he explains. "These rescue missions were a key factor in my seeking employment there. It's been my great honor to have conducted a number of lifesaving hoists since being stationed there. At HAATS, we work with civilian search and rescue teams on all these missions. We have twelve highly trained

civilian volunteers who fly in with us and ride the hoist down to secure and ensure the patient is safely prepared to be extracted by our hoist. It was meeting and talking to these fine citizens that led me to seek a volunteer membership with a team myself. I'm proud to say I'm a member of Garfield County Search and Rescue.

"Currently, I'm having some complications as a result of the surgeries I've undergone. This will require another surgery to correct these issues. The doctor is very optimistic that I'll be nearly good as new. However, this has opened my eyes to the fact that I may not be indestructible, and I may need to step it down a notch. I view becoming a dog handler as a way to still continue to serve the local community and my team without the rigors some of the other duties require.

"I know that I have a lot of work and hours of training ahead of me, but it's my belief that these dogs are destined to return people to their loved ones, and I want to help them."

It was also during his military service overseas that Greg met his first military working dogs, who each made an inspiring impression on him, planting the seed for the future work he would do with search and rescue dogs. "I ended up medevacing out three or four military working dogs who got injured in various ways," he recalls. "While in an assault unit, I also flew special operators who had military working dogs. I always enjoyed flying them and was envious they had a job where they used dogs."

One military working dog in particular with whom he crossed paths still brings a smile to Greg's face. "While I was stationed at the medevac compound on Forward Operating Base Payne in Afghanistan," he remembers, "I met a black Lab named Gambler. He was an improvised explosive devices dog, and he had some swelling that needed treatment. The weather was bad that day, and we weren't able to fly him out right away. Since he didn't appear to be in too much discomfort, we all got to hang around him for a bit while the weather improved. My dog at home at the time was a chocolate Lab, and it was nice to be able to pet Gambler and remember her. I often heard military dog handlers say, 'If it weren't for my dog, war would be hell.' I agree, because while petting Gambler, my war wasn't hell."

While HAATS has no military working dogs, Greg says, "Soldiers there sometimes bring their personal dogs. I also bring Elcha in to familiarize her with helicopters and hope to have her taking familiarization rides soon."

So far, even though Greg and Elcha are only at the beginning of their partnership, it's

proven to be a perfect match. For starters, Greg believes, as a German shepherd, Elcha is custom-made for search and rescue work because of the breed's "high prey drive, endurance, fearless nature, and sturdy and athletic build."

These characteristics fit the bill for what Greg was looking for from the start when he joined the Returning Soldier Initiative. "I applied for the program seeking a dog who was special," he says, "and one that was destined for great things." That part of this new mission was easily fulfilled.

"Elcha is also an integral part of our family," Greg adds. "She especially loves Aviana, my young daughter, and nothing makes her tail wag harder than seeing my little girl. Plus, she goes everywhere I go while in the house. It's impossible to have a moment away from her. In fact, we do everything together and go everywhere together."

Greg and Elcha are destined for a long road ahead together, which marks a new beginning and life mission for both of them, all thanks to the Returning Soldier Initiative. With fierce dedication and a goal of bringing out the best in each other, this pair gives new meaning to the traditional U.S. Marine motto *semper fi—always faithful.*

"Elcha has helped to give me more of a purpose with my free time," Greg says with a smile, "and she has encouraged me to remain in peak physical condition to the best of my abilities."

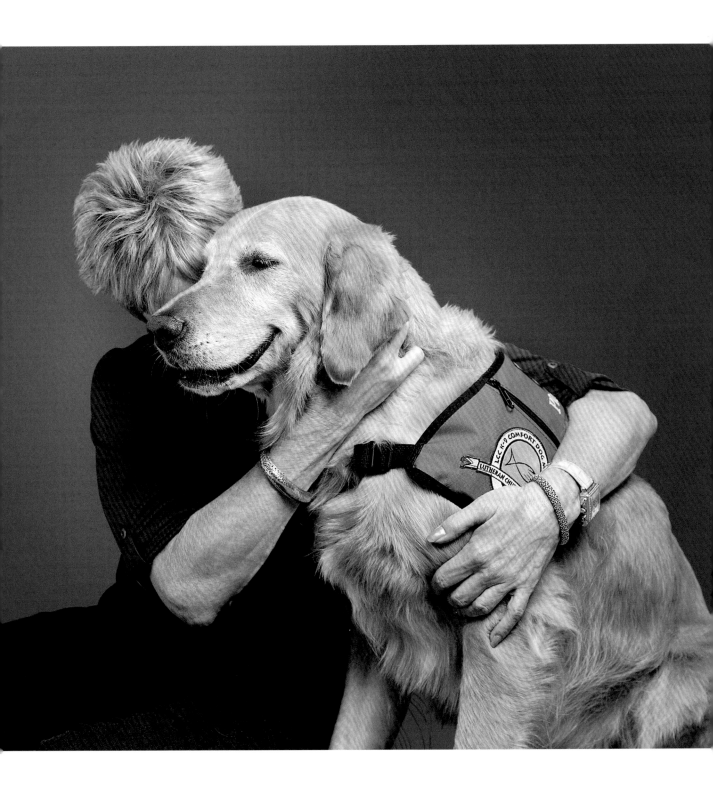

16 HANNAH

Arlington Heights, Illinois

2:49 p.m.—April 15, 2013.

In the span of fifteen seconds, two homemade bombs detonated at the iconic Boston Marathon. Three people were killed, hundreds were injured—more than a dozen lost limbs—and a city and nation were left stricken with grief.

In the days that would follow, Lutheran Church Charities (LCC) K-9 Comfort Dog handler Barb Granado from Arlington Heights, Illinois, would travel to Boston along with LCC K-9 Comfort Dog Hannah and others to offer their unique brand of unconditional comfort and love.

"Boston has more colleges than any other city in America," Barb says. "The kids were scattered everywhere in the days following the bombing when we were there. Young people, especially, were frightened. They wanted to be home with their parents and family and friends. The day of the bombing, the city was in shutdown and stayed that way until the bombers were caught. The pastor and parishioners at First Lutheran Church opened their doors to anyone who wanted to come and just be together. Tears flowed freely. Kids huddled together.

"When we arrived with the Comfort Dogs, word spread quickly, and we had dozens and dozens of people come to the church just to hug our dogs. Out of the sadness and fear from the previous days, laughter and joy slowly emerged from these visits. There's just something about petting a dog. It offers a moment of reprieve from the pain one is experiencing. It may last for only a few moments, but we can see it. We can feel it.

"Those affected by the bombing arrived at the church in tears and left with a smile. Then they came back again and again and again just to hug on Hannah and all the other LCC K-9 Comfort Dogs who were there. They felt safe. They felt love from us and from the

dogs. I can't explain it to anyone other than to say we call these experiences *God Moments.* God uses us and our Comfort Dogs as instruments of his love. The dogs are the bridge. We are a presence, and it's very special. We don't preach, and we pray if people want to, but what we are more than anything else is a presence. And in those moments, God reveals his love and compassion. I've seen this happen every time I've gone somewhere with Hannah."

Bearing witness to the divine power channeled through the LCC K-9 Comfort Dogs like Hannah—whose official name is Hannah 1 Peter 3:15—is a journey Barb and her furry partner began in 2012 when two of the United States' greatest tragedies—one natural, one manmade—struck the very heart and core of who we are as a nation in the span of two months.

In the aftermath of October 2012's Hurricane Sandy, also known as Superstorm Sandy, a swath of destruction stretched across the entire Eastern Seaboard and impacted twenty-four states.

"This was just a sad situation," Barb recalls. "Hannah and I went to a school in New York that was filled with homeless kids. Many were Hispanic and were very grateful to be sheltered there because there was heat and food. Their homes had lost heat during the storm, and repairs had not even begun yet. We were specifically asked to visit these young-sters because it seemed like no one else cared about them; somehow they had become for-gotten victims in this disaster. Their sadness was palpable.

"Most of the kids didn't have pet dogs, and if they did, the pets were gone—also victims of the storm. The only memory of dogs most of these kids had were the pit bulls protecting their houses in rough and dangerous neighborhoods. At first, they didn't have much inter-est in getting close to our Comfort Dogs and actually feared them. They had never loved on a dog before, and they certainly had never had a dog love on them. It took an hour or more for me to coax one little boy to pet Hannah. When we had first arrived, he quickly communicated that there was no way he was getting close to her or any other dog. He was that terrified!

"Hannah looked at him with that golden retriever love and refused to give up on him as many others had. Finally, after at least an hour, he came over, and I gently took his hand to touch Hannah's soft fur on her back far away from her face. Over time, I gradually drew his hands to her soft ears. The biggest smile spread across his face! Well, twenty minutes later, that kid was on top of Hannah, hugging her and kissing her and having a great time.

He asked if she could stay with him so she could keep him warm. This was another very powerful God Moment."

Moments like these impact Barb very deeply, and she's not shy about admitting that. In fact, fully embracing the emotions of these missions with the LCC K-9 Comfort Dogs is part of what ultimately motivates handlers like Barb onward with the knowledge that they and their canine companions are helping to make the world a better place one person at a time.

"I carry my emotions on my shirtsleeve," Barb says as she recalls visiting Newtown with Hannah in the days following the December 14, 2012, mass shooting of twenty first graders and six adult administrators at Sandy Hook Elementary School. "I was very concerned I might cry or be emotional to the point of doing more harm than good. My friend and I prayed and asked God to give us the strength, courage, and whatever else I needed to serve him in Newtown. I prayed for the ability to serve as an instrument of his love, and he gave me that strength and courage. I didn't cry on the job at all.

"The night Hannah and I arrived, along with some of LCC's other Comfort Dogs, we went to the town square, where the memorials were placed under the town Christmas tree. People came from all over the country to pay their respects. Hannah and I just stood back and observed the grief. Some people gently petted our Comfort Dogs and thanked us for coming, but these were usually brief visits.

"At one point, Hannah started leading me in the direction of a young man who was kitty-corner from us on the other side of the street. I resisted at first, but Hannah was determined to cross the street. When I decided to trust her instinct and follow her lead, she went directly to the man, who was just standing there. His eyes were open, but they were totally blank. I thought perhaps he was in shock. But when he looked down at Hannah, he smiled. He then knelt next to her and grabbed her close and just sobbed into her fur. When he got back up after several minutes, he said, 'Thank you, thank you so much.'

"I later learned that he was a first responder who was inside Sandy Hook Elementary School right after the shooting occurred and surely witnessed a horror no one should ever see. Hannah knew he was hurting and that he needed her. I'm sure that's why she had kept guiding me toward him."

Time and again, Barb's experiences with Hannah Comfort Dog following tragedies—which also include the shootings at Arapahoe High School in Arapahoe County, Colorado,

where one student died and countless others were traumatized, Marjory Stoneman Douglas High School, and Pulse nightclub; the tornadoes in Oklahoma, floods in Colorado, and wildfires in California—have shown this handler the redemptive healing that can happen when one person reaches out to another, especially with the help of one of these specially trained dogs.

In these God Moments, unthinkable beauty and love can also rise from unthinkable tragedy and evil. Barb believes that golden retrievers like Hannah are especially ideal for this type of service because "they're people pleasers and perfect for a comfort ministry in that they love to be loved themselves."

This was true of Barb and Hannah's trip to Roseburg, Oregon, shortly after a professor and eight students were fatally shot at Umpqua Community College. This was the deadliest mass shooting in Oregon's history.

"A mom who had witnessed the shooting of this professor and students came to sit with Hannah," Barb remembers. "She then left but came back four more times and just petted the dog. She didn't speak, and we don't generally force conversations. If people want to talk, they will. But when I saw tears running down her cheek, I put my hand on her shoulder and said, 'I'm so sorry.' Then she just sobbed. She eventually told me that her seven-year-old son had taught her about forgiveness when they were saying their nightly prayers. He asked her why they weren't praying for the shooter.

"The mom told me that she didn't know how to respond and simply kissed her son good night and went to living room to sit down. She was numb. Sitting alone in her living room, she told me how she had become very angry. She questioned, *Why would anybody pray for the shooter?* But then a peace came over her, she said, and she just sobbed and sobbed, thinking about what her young son had taught her.

"After hearing this mom's story, I hugged her and told her what a great mom she is and how proud she should be of her little guy. I told her how he had shown her God's unending love and grace, which is available to everyone no matter what, including the shooter. I'm a firm believer that those who we may think deserve love and forgiveness the least need our prayers the most. And I told her that. It was a very special encounter, and we prayed together. Then she gave Hannah a hug and me a big smile."

These many roads traveled together have forged a lasting friendship between Barb and Hannah. "She's my bud, a loving loyal friend," Barb says with a smile. "Hannah and I are

very close. She's a momma's girl, and while she also works well with her other handlers, if I'm around, she really only wants to be with me. She follows me around the house no matter where I go."

And Hannah is also one of Barb's primary comforters. "She comes and puts her head on my lap if she sees me in tears or being sad," Barb explains. "She looks up at me with those big brown eyes, and whatever bad things I'm dealing with at that moment kind of melt away. We share an unconditional love for one another."

Ultimately, Hannah represents a calling for Barb, a second act in life that she never anticipated. All proof that sometimes God's greatest gifts come wrapped in soft fur and a wagging tail.

"I was looking for something to keep me busy after I retired, but never in a million years did I ever think of something like being a dog handler!" Barb says with a laugh. "God found it for me, and it's changed my life. I learned early on that when God calls you to do something, he equips you with the tools you need, including courage, strength, patience, kindness, and a love only he can give. Because of my work with Hannah and the others involved with the LCC K-9 Comfort Dog ministry, I'm more grateful. I have a greater understanding of purpose. Even in all the sadness, I've witnessed God's love, mercy, and compassion. It shines through in ways I can't explain, but I can feel it. It's a beautiful ministry."

For Barb and her fellow Comfort Dog handlers, modesty is a hallmark of their service. This selfless and humble approach to their work shines brightly amid every visit they make. "I'm not in it for accolades," Barb says. "I'm in it to give back, and with Hannah at my side, that's just what I get to do."

17 ■ TAFFEY

Arlington, Virginia

Here's to second acts in life!

Taffey—a fifty-eight-pound, yellow-and-white golden retriever—has literally traveled across the world and back in order to serve the United States and to keep people safe.

"Taffey is a hero," Kelly Cooper says, "because she served four years for the Marines and even deployed to Afghanistan for a year before meeting me, and then she moved forward in our new job together just like it was any other day."

Kelly is a TSA explosive detection canine handler from Arlington, Virginia.

"I've learned more from Taffey in four years than she has from me," Kelly adds. "To this day, I trust her with my life, and she's always keeping me on my toes, literally."

During her time as an off-leash mine-detection dog for the U.S. Marines, Taffey worked as a trained explosive detection canine. She was trained as an IDD, also known as an IED—or improvised explosive device—detector dog. Taffey was deployed in 2012 to Afghanistan, where she spent a year searching for hidden explosives in vehicles or buried on roadside locations.

When her tour of duty with the Marines was finished, Taffey returned to the United States and was identified as an ideal candidate for work with the TSA, which is part of the Department of Homeland Security and whose mission it is to "protect the nation's transportation systems to ensure freedom of movement for people and commerce."

That's when she met Kelly, or rather when a twist of fate in both their respective pathways had a hand in finally bringing them together.

"My unit attended canine school at Lackland Air Force Base in San Antonio, Texas, for twelve weeks," Kelly explains. "In 2015, I was paired with a red Lab named Ben. Ben was

eighty-eight pounds and only one and a half years old at the time. He worked out for eleven weeks of the program, but he didn't have a high drive to work and was aggressive toward other dogs. So during my last week of canine school, Ben was sent back to the trainers to work on some issues he had.

"At that same time, another student failed out of canine school with Taffey. This gave me the opportunity to be paired with Taffey and complete the course with her. She had recently returned from working with the Marines for four years, including most recently in Afghanistan for a year."

Kelly and Taffey serve as part of the TSA team at Washington Dulles International Airport, located in Loudon and Fairfax Counties, about twenty-five miles from our nation's capital. Their job is to find any bombs that may be concealed in luggage or other packages passing through the airport. This is a crucial job that takes them all over the airport, from curbside and baggage claim to boarding gates and even the aircrafts.

As high pressure as the job is—since, after all, there's zero room for screwing this one up—it helps that Kelly gets to do it with one of her best friends.

"The working relationship I have with Taffey is remarkable," Kelly says. "Being able to read her in regard to knowing what she wants in every scenario is amazing. She's so focused when she's at work to find and hunt for what she's working for, but at home, she's a different dog. She always wants to lay with me when I take naps on the couch. Sometimes when she's a good dog, I'll allow it. If I allow her to lay on me, she'll jump up, face my head, lay down, and she'll fall right to sleep. I love how relaxed she always looks."

Working with a dog like Taffey has been a lifelong dream of Kelly's. It was just a question of what direction this dream would take to be fulfilled. "Since I was little and growing up in New Hartford, New York, I always wanted to work with animals," she explains. "At first, I wanted to be a veterinarian, but I didn't want to put animals down or see them sick, so my next option was working a canine for a police department. My family has a background in law enforcement and protecting others, so it seemed like a great fit. After I graduated from college at SUNY Oswego with a bachelor's degree in psychology, I put in for a position with the state police, but there was a hiring freeze. After a few years of waiting for that to maybe happen, someone suggested that I look into the federal government to see what agencies have canine handler positions. That's when I found out about TSA. I soon moved from New York to Virginia, and I started out as a TSA screener at Dulles.

"When I first started with TSA, the biggest challenge was customer service. Passengers are often running late and just want to get through security. They forget why screening is so important; they don't understand why they have to follow the rules. The biggest reward, though, is helping people to feel safe. I loved when a passenger would approach me, thanking me for what I do and for allowing them not to be worried when they board the plane."

Starting out, though, Kelly always had one ambition in mind, from which she never wavered. "I came to TSA to reach a career goal as a canine handler," she says. "I idolized the handlers every time I saw them. I most likely was annoying to them because I would always be excited to see them and their dogs and go out of my way to say hello. I always helped participate in any volunteer work they needed, just to be closer to them and their dogs and to learn as much as I could.

"Dulles offered a shadowing program, where I was able to shadow the handlers and see what they did throughout the day, and it was a lot of work! There was one canine who I became very fond of, a yellow Labrador named Cooper. Maybe I'm biased because that's my last name, but he was always so happy to be at work, and his drive to find his toy was amazing to see.

"When I became a canine handler at Dulles, Cooper was still working there. Taffey was then named Cooper's girlfriend because they both were yellow Labs.

"Being able to protect and deter harm from getting into our airports means a lot to me. I enjoy going to work every day knowing I make a difference. A big mission of mine as a handler is to work with other agencies in my region and share knowledge and to further encourage myself and others to always be better. Working with other federal, state, or local agencies is always a useful tool; each team has the same mission but goes about it a little differently depending upon their environment. To be able to watch another unit work in their home environment is a great opportunity and expands my knowledge. You're able to see different canines working and how the handler is able to overcome obstacles. For example, if I'm trying to advance Taffey in her search methods, I'm able to reach out and observe other units to see how they work. Growing as a canine team and always advancing is a must, and it makes it easier to be able to learn from others."

As an explosive detection canine—not a job for the faint of heart *or bark*—Kelly believes Taffey embodies the perfect blend of traits: intelligent, trusting, loyal, and playful. Not to

mention, Kelly adds that her sidekick is "my partner. She's always there for me, either ready to work or ready to play!" Plus, Taffey having a résumé that includes courageous service with the Marines both at home and abroad is a nice bonus.

In their time together at Dulles, their duties have even included searching ground objects for Air Force One.

"Taffey and I were requested to search static ground equipment in a specific area prior to Air Force One arriving," Kelly remembers. "Once the plane arrived, we were requested to search any vehicles, lights, generators, and other ground equipment that were needed to transport passengers or were in the immediate vicinity of the plane itself."

Personally, this was a pinch-yourself moment for Kelly and Taffey. And professionally, duties don't get much higher level than this. "When I received a phone call regarding a request to conduct a search," Kelly says with a laugh, "I thought it was just another ordinary day in my life as a canine handler. Then the pilot in charge approached me and informed me that this was no ordinary plane search. Rather, it was the aircraft of the president of the United States. *It was Air Force One!* I was honored and excited to be a part of this unusual request and be able to help secure this one-of-a-kind plane."

When it comes to the exciting work that Kelly and Taffey get to do, it's all about location, location, location. "We conduct all of our daily operations and training at Dulles Airport," Kelly explains. "However, occasionally we work off-site at different facilities to conduct training to expose the canine teams to different environments so they'll always be prepared in a real scenario event. Being in the D.C./Virginia area, we have the opportunity to work with the airport police, the CIA, FBI, Defense Intelligence Agency, National Security Agency, Pentagon Police, United States Secret Service, and several other agencies, training in different environments to stay exposed to different scenarios. Taffey and I are always training harder to be better, and a big part of this is learning from other canine units.

"Taffey is very obedient to me. She stares at me all the time waiting for a command or to go search something. Taffey can stay in a down position and wait for a command, I can walk around, tell her to heel away from the object, walk around more, then give her a command, and she's on it."

In thinking about their time together, Kelly happily reflects on how much Taffey has changed her life. "More than four years ago when I was driving back from Texas with

Taffey, this new partner of mine whom I had only known for one week," Kelly remembers, "I knew my life was going to be different. Taffey was a four-year-old, hardworking dog who acted like she was a one-year-old. She wanted to play with everything and jump on me all the time. But when it came to working and finding what she was looking for, Taffey was a new dog. Taffey has a true, dedicated passion for her job every day, just like I have. We both can't wait to get to work and train even harder than we did the day before. And she is such a loving and sweet dog,"

Kelly pauses, then adds with a smile, "I'm the lucky one in this relationship!"

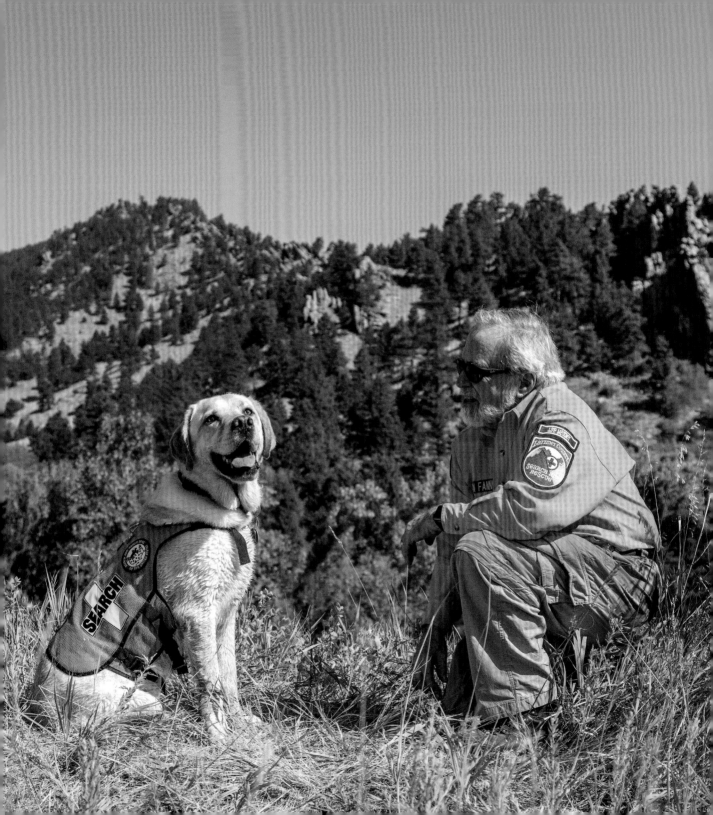

Fort Collins, Colorado

It's very easy for retired elementary school teacher and principal Dan Fanning to express why his English yellow Lab named Tripp is a hero on the search and rescue circuit.

"He saves lives and only asks that you play with him in return," Dan says.

This Fort Collins duo has been actively helping to save lives since 2014 when they certified in wilderness air scent with Search and Rescue Dogs of Colorado. In 2018, they added a human remains detection certification to their growing résumé via Search and Rescue Dogs of the United States.

"To do both of these jobs," Dan explains, "Tripp must have the ability to follow the target scent to the source, return to me as his handler, and give me a trained behavior, such as a bark or jump up." This is then followed by Tripp leading Dan to the missing person or other scent source.

Dan and Tripp have undergone eleven different evaluations and tests to become a certified team. And together, they log around nine thousand miles per year in Dan's truck doing search and rescue missions.

"My first search dog was a gift from my wife, Cynthia," Dan explains. "She came to my classroom in June of 1997, on the last day of school, with a ten-week-old chocolate Lab puppy who needed a new home. She said, 'Here, happy birthday!'"

Dan laughs as he recalls the memory now. "Of course, the second graders in my class went as nuts as did I," he says. "I had mentioned in passing to my wife that I thought chocolate Labs were pretty special, and she picked up on it. It was a really great day! That dog, who I named Bear, was one of the sweetest guys you'll ever meet. He was very sensitive and loved everyone he met. On New Year's Day 2001, Bear and I certified as a trailing dog

team. From that point on, anytime Bear knew he was going to be working, he would jump three feet off the ground in anticipation."

For Dan, like most handlers, this work is also grounded in the unbreakable trust that is forged with the dogs. "This special relationship has been described as a dance that the handler and dog do together," Dan says. "We need each other."

In addition to Bear, Dan soon added an English yellow Lab named Trace to the family. Unfortunately, after four years of training and a year after certifying as an air scent dog, Trace developed lymphoma and passed away at age six.

"Like Bear, Trace was very special to me," Dan recalls, "and shortly after losing both him and Bear, I sought out another Lab."

As fate would have it, a litter from Trace's line had recently been born, and a puppy who would soon be named Tripp went home with Dan.

Tripp's registered name is Long Strange Tripp—after the Grateful Dead's song "Truckin'."

"When I named Tripp," Dan says, "I guess I was trying to sum up thirty-five years of doing search and rescue."

Dan has especially relished experiencing the indelible bond that develops between a dog and his or her handler. "I enjoy being able to spend time with Tripp in the wilderness, and he enjoys it too," he says. "I love seeing Tripp run freely through the hills doing something very natural for him, and I'm continually amazed at what these dogs can do."

Dan describes watching Tripp perform his search and rescue duties as "the closest thing I've ever seen to real magic."

That pure magic was on full display during a mission that took place near the scenic Inlet Bay—extending from the southern part of Horsetooth Reservoir near this team's hometown of Fort Collins—where Tripp shone brightly as a hero one April day.

Along the shoreline and up in the Rocky Mountain foothills bordering the bay and reservoir, homes and campgrounds are situated along a tapestry of roads. Early one morning, a twenty-seven-year-old man was reported missing from this otherwise calm and quiet community. The man had wandered off, suspected of being disoriented from using an unknown substance.

"We got the call around 8:00 a.m.," Dan recalls. "The young guy had fallen the evening before from a deck at his house, and so it was unknown what kind of shape he might be in."

Dan's friend Jake and his search and rescue dog—a white German shepherd named Abby—were the first to arrive on the scene. Dan and Tripp arrived soon after.

"Jake and Abby started up the road to begin working near the house," Dan says. "Since there were gentle upslope winds, I was going to go up the main county road and get up on the ridge above the house and see if I could clear the hillside."

The rugged terrain there is covered in rabbit brush and small pines at the base, then upturned sandstone hills called hogbacks that run parallel to the mountains. Someone lost in this area could easily fall prey to both the environment and the wild animals like mountain lions and rattlesnakes that are native to the region.

Dan explains, "Tripp and I started up the road, and when we were about halfway up, we got some nice wind coming up from the reservoir along the road and the ditch beside it. Tripp started showing a little interest in the ditch, so I took him to it and decided we could be clearing it as we went up. Suddenly, he showed a strong alert down the ditch. We followed the scent, and Tripp became very excited, running off through the weeds and brush."

Dan then tells how he soon lost sight of Tripp in the thick, four-foot-tall wild brown grasses. But he trusted his partner's instincts even though he couldn't see him.

Sure enough, the hunch paid off.

"A minute later, one of our foot teams that was on a hill above us saw a young man walking across the road and up toward the house in question," Dan remembers. "It turned out to be our subject. Tripp had flushed him out from where the guy had fallen asleep. The man was in good shape, and we all went home."

Mission completed!

As Dan reflects on this and other successful missions with Tripp, he says, "Almost any dog will be your friend and enjoy being with you, especially if you're the one who feeds him!" He laughs. "But a search dog and handler share something extra, something much deeper."

Dan believes this close professional bond is easily formed because search and rescue dogs are asked to do something that is already part of their nature. However, he admits that the "emotional side" of this friendship is harder to put into words.

"When Tripp makes a find and takes me to the person, I can only describe his body language and face in one way: ecstatic," Dan explains. "His mouth is open in a huge smile,

and his golden-brown eyes are sparkling. He also exudes a sense of satisfaction and pride. When he has completed his job, Tripp is at his happiest."

Back in Fort Collins, Tripp is simply man's best friend again.

"When we get home," Dan says, "Tripp is nearly always at my side. When I sit and read a book, he's right there nearby with his eyes glued on me. He's warm and fuzzy and has a face that can melt your heart. And if he's sleeping and I stir in any way, his eyes pop open and he watches whatever I do."

Simply put, Dan adds, "A dog's unconditional love is wonderful! Tripp is my partner, and I'm his."

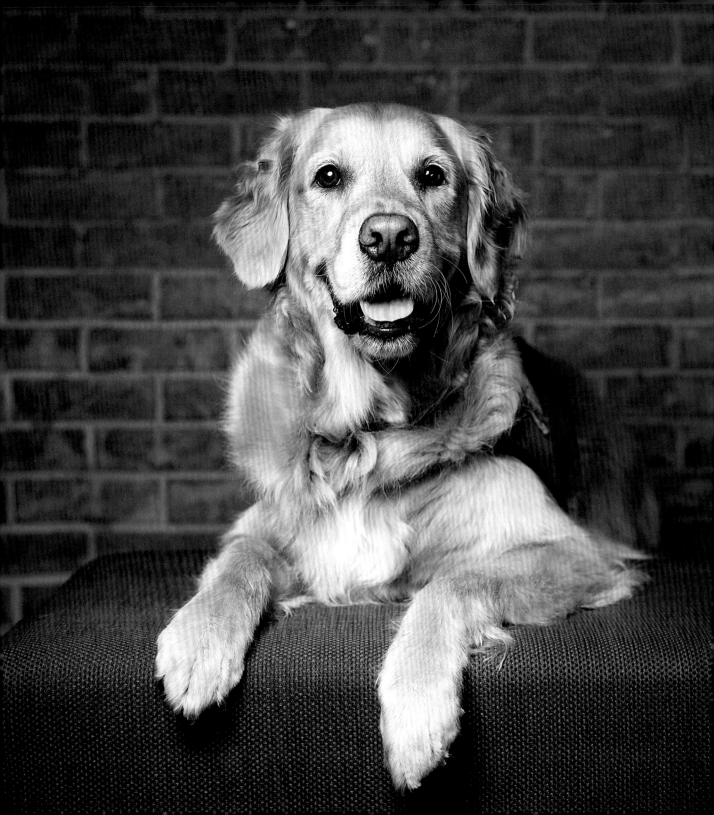

19 KYE

Belvidere, Illinois

Our very first deployment together was to Sandy Hook Elementary School," Lutheran Church Charities (LCC) handler Libby Robertson—a retired patient care technician—says about her LCC K-9 Comfort Dog named Kye. "I had no idea what to expect. We were assigned to greet the children as they returned to their first day back at school at a middle school that had been temporarily refurbished for the elementary students.

"Arriving at the school, I was even more anxious when I saw the heavy security, but once inside waiting in the hallway as the kids arrived—many of them arriving with smiles and laughter—I thought, *I can do this; Kye and I can do this.* Then the final bell rang, and we started walking to the small room just off the entrance where the kids could come at any time of day, always accompanied by an adult, to visit with the Comfort Dogs.

"In the distance, I heard 'Happy Birthday' being sung to a child, just like it's done in schools all across the world every day. But as I listened, I felt like everything and everyone were moving in slow motion as these sweet children sang. All I could think of was the twenty children who would never celebrate another birthday, and the heartache of their parents and siblings. And when we got to the small room, there were no kids there yet, and I burst into tears. I then thought, *I don't think I can do this.* It was a roller coaster of emotions. I was comforted by one of our team leaders, Dona, who told me I was doing fine, and then I just followed her beautiful lead.

"Finally, the kids started coming in, going right to the dogs on the floor, sitting or lying next to them. One little boy came in and went right to Kye, sat down, and as he pet her, he told me an animated story about how he wanted a German shepherd and how he and his sister loved dogs, and how their old dog always wanted to sleep in his sister's room so they

had to put up a gate. And he told me how their old dog had died. It was a nice story, and he talked more about wanting a German shepherd. Then he said, 'I like to think our dog and my sister are together now in heaven.'

"That's when I realized his sister was one of the first graders who had been killed. It was a sweet memory to share, and I'm humbled to think he shared it with Kye and me.

"The following day, we started out greeting all the students at Newtown High School and then stayed there in the huge lobby. The kids and staff could come and be with the dogs. Some of these kids had lost siblings and former teachers and friends in the shooting. It was such a tough time for them; everything as they had once known it had now changed forever.

"Sandy Hook and the other nearby schools received many gifts of sympathy and encouragement from all over the world, and that day they got a huge shipment of stress balls. As the kids were leaving that day, they were bouncing these stress balls *in front of a group of golden retrievers!* The dogs were showing as much interest as they were allowed when it was decided that we unvest them and let them play!

"So here is this huge high school, and we're in this big lobby with all these kids and they're throwing the balls and the dogs were having a blast, chasing and fetching them. It was such a joyous thing to witness. Everyone—hundreds of kids who had just endured an awful tragedy—were laughing! And we were laughing along with them. It's a moment I'll always treasure."

Kye, whose official name is Kye John 10:10, is especially gifted when comforting young people, something that is sadly becoming more and more necessary.

"We were once deployed to Toledo," Libby recalls, "to an elementary school there where a beloved teacher had taken his life. There were several Comfort Dogs in addition to Kye there. Most of us started our visit by meeting with the third- and fourth-grade classes, and the deceased teacher's son was there. He was nine years old.

"We met in a cold-tiled room, the children sitting on cold aluminum folding chairs, and we were sitting on the front side of the room with our dogs. The counselor asked the children to tell of how they heard of the teacher's death, and she asked his son to go first. That young little guy bravely stood up, said his name, and then told us, 'I'm his son, and I'm the one that found him!' Then he burst into tears.

"Because we weren't the professionals—we're only invited volunteers with our Com-

fort Dogs—we just sat there. It was physically painful not to go to that child who had lost his father in such a tragic way. I was sitting practically right next to him, and he sat there crying.

"I eventually got on the floor, with Kye next to me, and we inched our way closer to the boy. I think he was waiting for permission to go to Kye, and all the while, he was listening to his classmates talk about where they were when they heard the news about his dad. It was torture for all of us.

"Then, it just finally kind of organically happened. By this point, Kye was at the young boy's feet, and the boy got down on the floor with her. While the other kids spoke, I know the boy was able to tune them out because we were whispering together—me telling him Kye's name and how she loved to be scratched behind her ears and underneath her vest. Kye leaned back for him to rub her belly, and he smiled.

"And then the session was over, and the boy was able to meet all the Comfort Dogs and collect their cards. For this, we had moved to a carpeted room, where he could come and go to class as he wished, just as any of the kids could. They came and went as they needed. We spent the day at the school and then went to our motel overnight. The next day, we heard of a big snowstorm approaching, and we had a four-hour drive ahead of us, so our plan was to go to the school in the morning and then get on the road as soon as we could.

"Back at the school, we saw a lot of kids, and the deceased teacher's son again spent time with us. Before we knew it, it was late morning and the kids were eating lunch, so we thought it would be a good time to leave in order to beat the storm.

"We gathered our bags and had them slung over our shoulders when the school door opened and the deceased teacher's parents and sister came in. They had just arrived from out of town that morning and were coming straight from the funeral home. His wife and her parents came in as well, as did other relatives.

"We knew what we had to do, snowstorm or not. We put down our bags and introduced our dogs and spent two and a half hours with the family. They talked about their husband, son, brother, and brother-in-law. It was all so good; they talked and cried and pet the dogs. That experience was a gift for us as well."

When she's asked how she personally deals with sad and traumatic experiences like these, Libby is brutally honest in a way everyone can surely relate to.

"Cry," she says. "I cry into Kye's fur. Her fur has absorbed a lot of my tears."

Libby and her larger LCC K-9 Comfort Dogs team at Immanuel Lutheran Church in Belvidere, Illinois, debrief frequently, which Libby says is a "huge help, because we can share our stories and cry together."

She then adds, "But mostly you have to understand, by doing what we do with the LCC K-9 Comfort Dogs, we're able to see the very best in humanity. After the horrors and evil, we respond with comfort, yes, but we also see so many other helpers—the kindness and goodness and generosity of so many people. And oh, what I've learned about grief—especially from the people who've been horribly hurt and still they say, 'We won't let hate define who we are! We're going to let love win.' And you see it in their eyes—the sincerity of what they're saying. I'm repeatedly humbled to see this over and over. These people are proof that love does win in the end."

A few weeks after the April 15, 2013, Boston Marathon bombing that killed three people and injured hundreds of others, Libby found herself sitting in the courtyard of First Lutheran Church of Boston.

"It was a beautiful setting," Libby remembers, "and we would watch people come up the steps and smile at all the goldens and then a police or fire truck siren would sound and their faces would turn to terror. I could actually see their hearts pounding and then watch them slow as they pet Kye. One woman talked about how she was living in constant fear. She didn't think she could take much more—*First Sandy Hook, now Boston, and the bomber wasn't found for days, surely the world is coming to an end.* She thought she would never sleep again.

"But as she talked and pet Kye, Kye decided to roll on her back for a belly scratch. The woman was so delighted that she laughed and spent a lot of time that morning with us. We hugged when she eventually left us. She said she'd be back the next day, and she did come back. She came right to us, and she said that the night before she had slept the best she had since the bombing. I also remember how some of the nurses who cared for the bombing victims stopped by to pet the dogs. They were teary, arriving and leaving quietly, and never saying much."

Many times over, Libby has learned that kindness is a gracious and blessed two-way street when it comes to the inspiring outreach performed by the LCC K-9 Comfort Dogs.

"When I think back to our time in Orlando following the Pulse nightclub shootings,"

she says, "I think of the kindness and generosity of the LGBT community. I'll never forget the way we were welcomed by this community that isn't always treated well by Christians.

"In the hospital, I remember visiting a severely injured woman, who wasn't speaking at all. Kye went right up to her bedside and put her head on the woman's hand. The woman immediately started to weep, petting Kye, and finally she said, 'My roommate would have loved her.' Her roommate had not survived the shooting.

"I remember being in the hospital lobby and suddenly Kye turned and led me to a man—an orthopedic trauma surgeon. He was a young man, but he looked so tired, and I knew he must have not been home for days. He knelt down and pet Kye, only for maybe ninety seconds, and said, 'Thank you.' He told me how he really missed his dog at home, and then he went back to work.

"We also visited the medical examiner's office. We visited with the clerical staff first, and they spoke of having to see the police photographs of the dead where they lay fallen, and of a mother's bullet wounds in her back as she tried to shield her son and his friend, and the number of young dead—all of this would be shared as they pet Kye or another Comfort Dog, each dog leading us to someone.

"And then we walked into the room where other staff members—mostly physicians and technicians who performed the autopsies—were. They were so quiet—so horribly, uncomfortably quiet—and then all of these goldens walked in, and the dogs all ended up kind of in a big pile in the middle of the room. The staffers followed, and everyone was soon on the floor, each nearby a particular dog. I remember consciously telling myself, *Take this in, Libby; something amazing is happening here.* I watched as slowly I saw smiles, and then talking, and then laughter. I just sat there, teary, thinking, *This is such a wonderful gift.*"

At the core of Libby's work with Kye Comfort Dog is humility and an open mind and the faith in knowing that they're being led to wherever they're meant to be at any given moment. From this humble and responsive grounding grows the love, hope, peace, grace, joy, and healing that are the fruit of this team's labors.

"With Kye and the other LCC K-9 Comfort Dogs, we can do great things in small ways. We can make a difference in this world—planting one seed at a time. Being able to witness courage and love and kindness every day, and seeing that, for the most part, people really are good, is a huge gift. I'm grateful and blessed."

This belief, rooted in gratitude and hope, is tested often, from one tragedy to the next. Still, Libby and Kye persevere and take what comes one step at a time.

"When we arrived in Las Vegas after the shooting there," Libby remembers, "we visited the hospital where most of the victims were being treated. I was admittedly overwhelmed by the eagerness—in fact, the *need*—for the survivors' families to describe their loved ones' wounds, in great detail, as they pet Kye. They'd say things like, 'The bullet went through her brain, and she lost her eye'; 'The doctors said he won't walk again because the bullet severed his spine'; and 'She was shot in the head and then the bullet exploded and we want her to wake up, but she probably will always be in a coma.' We also heard stories about the x-rays that lit up like hundreds of shiny stars from all the bullet fragments. But these people needed to talk and to say these things while petting Kye. I asked if I could pray with them, and always the answer was yes."

Libby and Kye have glimpsed the worst this world can throw at us and also the best and most miraculous moments. Theirs is a bond that grows stronger daily as they continue to connect with each other, with their larger LCC K-9 Comfort Dogs team, and with their neighbors across the country.

"This is the hardest thing for me to explain, so I'm just going for it," Libby says with a smile. "My husband and I have dogs that we love very much, but with Kye, it's as if we understand each other. Scratch that, we *do* understand each other, and not just her signal for 'I need to go out.' For example, Kye instinctively knew what to do when we met an elderly blind man versus when we met an autistic child. She knew when I was anxious and unsure of myself—I was constantly checking her to make sure she was okay, and safe, and watered, and comfortable, and she looked to me to see if I thought she was doing good. We learned the ropes together. We're in tune with each other, always!"

This reliance on each other was especially important when Libby and Kye were called into action following the murder of two brothers—ages twelve and fifteen—by their father, who then took his own life. Kye and another Comfort Dog named Bekah, also from Immanuel Belvidere, were invited to the boys' school on a Sunday afternoon when classmates and their families would be together with grief counselors and pastors.

"There was one little boy, he was a friend of the youngest victim," Libby recalls, "and he spent a lot of time with Kye on that Sunday. He talked a little bit about his friend, but

mostly he was just quiet, just petting Kye. He would also go and pet Bekah, and then come back to Kye, making the rounds.

"On Monday, several of the LCC K-9 Comfort Dogs came, and we stood outside the school as a show of support as the kids came in to school. We then were stationed inside. I would watch as the kids came in crying, escorted by a counselor, and picked a dog to sit with. There would be six or seven kids around one dog, and they would start telling stories about the two victims—their friends, both of whom were musically gifted, one was quite a musical prodigy, especially with the guitar, and the other was a drummer. And every so often, you'd hear a little laughter.

"The little boy I had met the day before—he was eleven years old—came back to Kye right away. I asked him if he got some sleep the night before.

"Completely guileless, he replied, 'Sleeping is easy. It's being awake that's hard.'

"We were invited to be at the visitation for the two boys—*just* the visitation at first— and several of the LCC K-9 Comfort Dogs teams came, as did many of the LCC Kare 9 Military Ministry teams. After seeing the response to the dogs, the family asked us to come back for the funeral the next day.

"The boys' mother gave a very moving eulogy for her sons. She spoke of their love of adventure, and their love for their Lord, and their love for each other. She said, 'How blessed I was to be selected by God to be their mother . . . I see now they were never meant to be apart . . . Do not let the evil that brought death to these sweet boys consume you or harden your heart.'

"There was a large photograph of the boys in front of the church of them walking on the beach at sunset, their backs to the camera, the oldest brother in the lead, and the youngest brother just a step behind.

"Their mother said, 'Walking off into the sunset fits perfectly. It represents how they walked through this life, through the valley of the shadow of death, into the next life in heaven.' She ended the service by saying, 'Let this be a call out to you to assess yourself— what have you done and what are you doing to leave this world a better place?'"

This story embodies love. A mother's love, which is translatable to the unbreakable bond shared between Libby and Kye.

"I love Kye," Libby says. "I love her happy personality, her intuitiveness, her gentleness,

the way she can be a clown when she knows people need to laugh, and how she seems to know that together we can share Jesus—his mercy and compassion. Sharing with someone in their grief, and to be a part of that with Kye, *because of Kye,* is so humbling.

"Kye has changed my life in that I feel we can make a little difference in this world. She loves to work, to comfort people, to lighten their load, to share in their grief, and to make them smile. She's shown how we can be Christ to others. She's nonjudgmental. She changes her work style depending on who we're serving. She's very gentle with children and the elderly and more playful with teens and adults.

"Kye has taught me that kindness truly matters, that every day we can make a difference, and that everyone you meet is fighting a battle of some kind and in need of healing. And she's taught me that every step of this journey is directed by God's time, not my own. Kye is one of a kind, but then probably most handlers feel that way about their dog, *and they should.*"

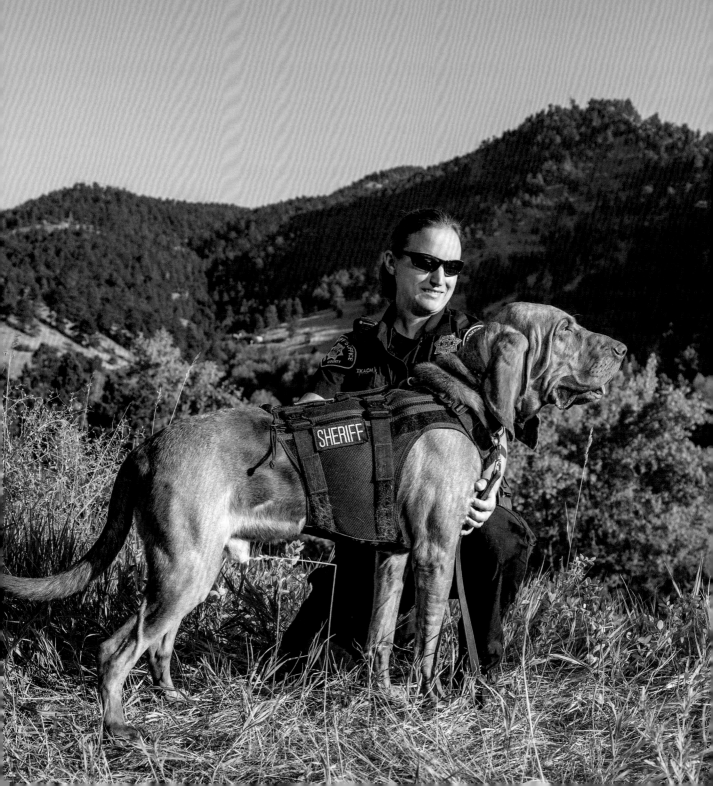

20 ⬢ SCOUT

Boulder, Colorado

I became a handler because I love dogs and love helping people," says Katie Tkach, a sheriff's deputy with the Boulder County Sheriff's Department. "I knew the only way to make my job even more fun was to have a dog riding around with me all day."

For Katie, this service is a family tradition. Her father was also a police officer who handled three K-9s during his forty-year career. "I grew up with working dogs my entire life and was fascinated by what they were capable of," she says. "Two of my dad's dogs were single-purpose narcotics dogs, and one was dual-purpose narcotics and patrol. The patrol dog, Cicco, was a large, black German shepherd with a huge head. He was our first, so I was pretty young when he had him. Most people found him scary due to his size, bark, *and* bite at work. However, he was the sweetest dog we ever had at home.

"My memories of Cicco are of him getting me out of bed every morning for school. I was a stubborn sleeper, and he would climb up into my bed and use his huge head to roll me out of bed. He'd also sleep on the floor in front of the TV with me whenever I stayed home sick."

Like her dad, Katie has shown true dedication in her efforts as a dog handler from day one. In fact, you could say she has thrown herself into her work in a most unique way.

"In order to earn my place as a handler, I first had to serve time as a decoy," Katie says with a laugh. "This involved climbing into a bite suit and acting like a big, squeaky chew toy for the patrol dogs. I took a three-day class in which I learned how to properly take bites while protecting myself and the dog. It's a hot, sweaty, and usually painful job, but someone has to do it so we can have properly trained K-9s. It also taught me the patience and grit it takes to be a handler."

After going through an interview process, Katie was chosen to be paired with the

department's newest recruit—a ninety-pound, red-and-black bloodhound named Scout. A fitting moniker for a trailing dog.

"Scout is capable of finding people by their specific scent," Katie explains. "At the beginning of a trail, he's shown a scent article, such as a piece of clothing that only has that person's scent on it. He can then find the person while only following that scent and ignoring any other scent from people who might have walked over that trail."

Katie points out that trailing dogs like Scout differ from tracking dogs, who are trained only to follow the freshest scent. Scout is trained and certified through Search and Rescue Dogs of the United States and currently has a suburban trailing certification.

"Scout is typically used to locate lost children or elderly people with dementia," she says.

Early in his career, Scout was enlisted to help locate an elderly man with Alzheimer's who had wandered away from his home.

"The man had been missing for a few hours, and it was very hot out," Katie recalls. "The challenge with this case was that the man walked his neighborhood with his wife every single day. Scout is capable of following trails up to two days old. So when we started, it was hard to tell if Scout was following the most recent trail or one of the many walks the man had gone on.

"We ended up trailing for five miles in the heat. Scout stopped multiple times along the way to swim in the fountains in the neighborhoods, and the other officers and myself had to stop for water breaks since our body armor is not heat friendly."

Fortunately, the man turned up at a store on Main Street after a few hours, overheated and exhausted from walking so far.

"Scout and I were on his trail about a mile behind him," Katie says. "After the man was checked by EMTs, I was able to allow Scout to 'find' him at the store, which helped give Scout the closure that he was working toward something and that he did a good job."

Bloodhounds like Scout are ideal for search and rescue work. It's been ingrained in their DNA for hundreds of years.

"Bloodhounds have been bred since the Middle Ages to track deer, boar, and people by scent," Katie explains. "When they put their nose to the ground, their long, droopy ears drag along the ground, kicking up scent, which helps them during trailing. Unfortunately, the droopy skin on their face also tends to cover their eyes when their nose is to the

ground. This is terrible for their eyesight but causes them to rely more on their nose, which is what we want. Their excessive amount of drool helps to trap scent as well. Bloodhounds are typically run on-lead because they have a tendency to only follow their nose and may not return if they catch a scent they like."

Katie explains how working together on missions with Scout is an ongoing process of learning from one another and striving to form that all-important bond.

"When Scout came to us, he was extremely shy at first due to lack of exposure," she recalls. "People scared him, fire hydrants scared him, crunchy leaves on the ground scared him. Everything scared him! Since I've had him, I've tried to take every opportunity to socialize him."

A vital part of Scout's socialization has been visiting regularly with the folks who work in the sheriff's office, as well as the people he and Katie meet on the trails, and even the kids whom Scout gets to meet when doing public demonstrations.

"Our relationship is constantly evolving," Katie says. "When I first got Scout, it took some time for us to figure each other out. He struggled for a while trying to understand what I wanted from him, and I struggled to figure out how to tell him what I wanted. I wanted him to get along with my roommate's dog, but he wanted to jump on top of that dog and chew on his legs. I wanted him to sleep on his bed, but he wanted to sleep on my bed. We eventually compromised with the couch. After about six months, we got more comfortable with each other, and Scout matured. I convinced him that I was the alpha, which I think can be difficult with a male dog and a female handler.

"Scout depends on me to feed him every day, provide a warm place for him to sleep, and give him affection in the form of praise and head pats. I depend on him to find that lost child or adult who might be freezing while they're out wandering in the cold. At the end of the day, our canines are tools. We use them for so many different things, and our jobs would be much more difficult without them. But I think most handlers can't help but treat them as a partner and a friend as well. When you spend ten hours a day riding around in a car together, you can't help but to form a friendship."

It's that friendship that helps this pair keep their community of Boulder a safe and happy place, especially when it comes to chasing down the bad guys.

"One time, Scout and I were called out to track a criminal," Katie recalls. "The subject had stolen a car and threatened a citizen with a weapon. He soon rolled the car in a residential

neighborhood and fled on foot, leaving the car on its roof in the middle of the road. Scout and I were assigned to start a track from the car, while another K-9 team performed area searches in the neighborhood.

"There was broken glass, drug needles, and Louis Vuitton bags scattered on the ground around the car. I collected a scent article by carefully reaching into the vehicle while it was upside down and swabbing the driver's seat. Scout and I tracked the subject throughout the neighborhood for about two miles. Scout led us to an open garage and stopped, but we couldn't locate the criminal. We found out we had missed him by less than five minutes. The criminal had stolen a vehicle from inside the garage when the owner had taken some groceries inside the house. Fortunately, Scout was able to give us a direction of travel from the garage because he can still track someone in a vehicle for short distances."

Katie is grateful every day for her big, furry, drooling partner. She's the first to tell you how much her life has been changed for the better in many different ways because of Scout.

"When I was selected as Scout's handler, the department moved me to the parks division," Katie explains. "This means I get to spend my shifts hiking trails with Scout while enforcing county ordinances and enjoying the beautiful summers. It's taken a lot of stress out of my job, and I'm sure it's helped my health by getting me out of the patrol car.

"My homelife has changed as well. I moved into a house with a large yard so that Scout can run freely. I also replaced some of my furniture because bloodhound drool is not friendly to cloth couches. And I've gotten used to wiping drool off the ceiling from his *Beethoven*-like headshakes. Plus, I quickly learned that the sound of his ears slapping his face in the morning means it's time to get up and feed him; otherwise, he'll come into my bedroom and put his nose in my face."

Katie finds herself especially in awe of Scout's unique skills.

"Scout is a hero to me because he's capable of finding lost, distressed people just by being given a scent article," she says. "What an amazing gift it is to be able to 'see' exactly where someone walked just by their scent. And after possibly saving someone's life by finding them, it's all just a game to him. Scout doesn't understand that he might have saved a person's life. All he knows is that he won the game and he gets a treat and praise from me—his most important person."

Bloodhounds by their very nature are a lot of work and can sometimes be a challenge; they are well known for being stubborn and tireless, they can be difficult to obedience

train and to handle on leash, and when they catch a scent, it's pretty difficult to stop them from going after it.

"Scout can and has pulled me off my feet, leaped off small cliffs, pulled me into traffic, and tried to cross deep, fast-moving water while blindly following his nose," Katie says. "And during the summer, they can overheat quickly due to the nature of their coat. So handlers have to monitor them closely while tracking in the heat because bloodhounds will just keep going despite dehydration, burned paw pads, or heatstroke."

Despite all of this, Katie wouldn't change a thing about her partner.

"It's all worth it because he makes me laugh every day," she says. "Every day, I also learn something new about him, such as what certain mannerisms mean or how to train him better or even how to read his body language better on a track. With Scout, life is a constant adventure."

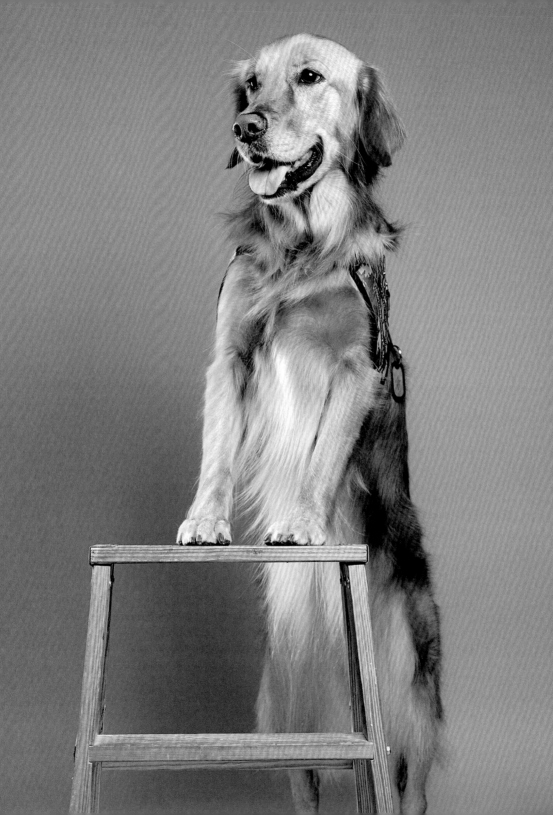

21 SASHA

Hilton Head Island, South Carolina

My wife, Brenda, and I became handlers in order to provide a comfort dog to individuals who were hurting and in need in our local community," Phil Burden says from his hometown of Hilton Head Island, South Carolina.

The Burdens' mission of serving their local community has been fulfilled many times over and has even reached far beyond the Palmetto State.

Members of Island Lutheran Church, the Burdens—Phil a U.S. Army veteran and former owner of a life insurance agency, and Brenda a former public school employee—were paired with a spunky golden retriever named Sasha after a parish family donated funds for the specific purpose of purchasing a Comfort Dog from Lutheran Church Charities (LCC). Now full-time LCC top dogs, they're also the managers of the Comfort Dog program at their church and the caregivers for Sasha, whose official name is Sasha 3 John 1:5.

Sasha has quickly become a beloved member of the parish and larger surrounding community. She's dual vested as both an LCC K-9 Comfort Dog and an LCC Kare 9 Military Ministry dog, the latter duties of which she assumes when traveling with a handler who is also a veteran like Phil.

"We believed deeply in the ministry," Phil explains, "and wanted to participate in a full-time capacity."

Phil easily expresses how he and Brenda feel so honored to be able to serve their fellow men and women and offer comfort, help, and hope to those persons who are lonely, stressed, suffering trauma, hospitalized, or in any type of need.

They also strive to serve military personnel in the same manner.

"We have a great sense of fulfillment," Phil says, "and we feel that Jesus is using us as his representatives to be his hands and feet in service to others. Our aim is to fulfill LCC's

mission of 'sharing the mercy, compassion, presence, and proclamation of Jesus Christ to those suffering and in need.'"

And share they have, selflessly, again and again with Kare 9 Sasha ever at their side.

Sasha and the Burdens visit the Marine Corps Recruit Depot every Thursday to comfort injured Marine recruits in the medical clinic and those receiving services in the dental clinic.

"The recruits often comment, 'I haven't seen a dog in months,'" Phil says. "They'll then add, 'I miss my dog at home.' Numerous times big, tough recruits even tear up. Sasha also meets Marine families who come into town for graduation and other military personnel on base."

The name *Sasha* traces its roots back to a furry, four-legged military hero. Phil explains, "Sasha was named after a British bomb sniffer dog who died in Afghanistan in 2008 along with her handler at the end of their tour of duty. Our Sasha's namesake was awarded the animal equivalent of the Victoria Cross in honor of her heroism in detecting fifteen bombs and saving many lives. The dog and handler volunteered for one final patrol, as replacements hadn't arrived yet, and they were killed that last day by a rocket-propelled grenade."

Kare 9 Sasha valiantly lives up to her namesake's example through her own unique service. On a regular basis, Sasha also visits two veterans' hospital clinics and interacts with veterans of World War II, Korea, Vietnam, the Gulf War, and others.

"Along with Sasha, we listen to the veterans' stories, soothe them, and overall just offer comfort, love, and respect to all of the veterans, thanking each for their service," Phil says. "Sasha is always welcomed with open arms by the staff as well. They consider her valuable for the service and comfort she imparts."

While the work that the Burdens and the larger Comfort Dog team at their parish do with Sasha is important and touches many lives, the true foundation of their deployments is always at the forefront of their intentions.

"We always remember that we're not cure givers, only caregivers, who show love and concern for those who are hurting and in need," Phil says. "The cure giving is left up to God and the professionals. We pray, we serve in the best way we can, and then we debrief with our team and our spiritual advisors."

This divine grounding of faith, comfort, and inspiration was particularly invaluable when the Burdens and Sasha were invited to the site of two high-profile tragedies.

Following the June 12, 2016, mass shooting at Pulse nightclub in Orlando—which left forty-nine people dead, fifty-eight injured, and a city and nation in shock and grief—Sasha headed south to offer a paw of compassion and love to those impacted.

"Once we arrived in Orlando," Phil recalls, "Sasha interacted with shooting victims in the intensive care unit of the trauma hospital, met first responders to the incident, as well as the doctors and nurses who were treating the victims, and she visited with survivors and people throughout the community.

"In the ICU at the trauma hospital, Sasha and I visited one room where there was a female shooting victim whose father was at her bedside along with a nurse. We were accompanied by a pastor, who was our escort and was helping us. The girl was lying flat and couldn't see Sasha, so we continued to better position Sasha until the patient could finally see her and feel comforted by her presence. The girl then began smiling and crying. When the father saw how happy she was with Sasha, he began to cry tears of joy at the sight of his daughter smiling and enjoying Sasha. It was very memorable!

"Later, we met a mother of one of the victims at a memorial for the victims. We introduced Sasha to her. The mother hugged and petted Sasha and spoke of her son for twenty minutes or so and was comforted by Sasha's kind, loving nature and the loving look she gave the mother as the mother petted and talked to her. One of the mother's friends later told us how impactful those few moments were for her friend and how the friend felt a sense of calm and comfort in the mother for the first time since she'd learned of her son's death.

"When we visited city hall, the city commissioner met with us and a group of other Comfort Dogs and their handlers. Sasha made her way through the crowd of dogs and climbed right onto the commissioner's lap. The commissioner said, 'This is the first time I've smiled in five days.'"

Phil points out that golden retrievers are ideal for working as comfort dogs, especially in intense situations involving unspeakable tragedy, because of "their calm demeanor, trainability, love for humans, high energy level, and work ethic."

These innate traits were put to the test once more in 2018 following the Valentine's Day shooting at Marjory Stoneman Douglas High School in Parkland, Florida. One of the world's deadliest school shootings, seventeen students and faculty members were killed, and seventeen others were injured. Again, a community and nation were left brokenhearted and in need of comfort and hope.

"Sasha spent fourteen days meeting with victims, survivors, students, and staff at the high school," Phil says. "She met with a range of students and their therapists, including at the elementary, middle, and high school levels. Because of what had happened, these students were fearful of returning to school. Sasha also spent time at community vigils and memorials throughout Parkland following the shooting."

Thanks to their training through Lutheran Church Charities, the LCC K-9 Comfort Dogs are skilled at both working amid crowds as well as intimate one-on-one interactions.

"Sasha met with an elementary school student while they were asked by their therapist, 'On a scale of one to ten—one being terrified, ten being not fearful at all—how did you feel about coming to school today?'" Phil remembers. "The student responded, 'Less than one.'"

Phil pauses to reflect on this powerful moment, then adds, "The student was petting Sasha during more questioning, and then was asked again by the psychologist how they felt now. The student replied, 'Eleven,' meaning not at all fearful. The psychologist followed up by asking, 'What's the difference?' The student answered, 'The dog makes me feel safe.'"

Sasha encountered another student who also sticks out in Phil's mind.

"We were again working with a group of students and their psychologists," he says. "One student kept coming back to Sasha, petting her, walking away several times, and then coming back. Finally, the student said, 'The bell is going to ring. Are we going to die?' The student later returned and said, 'The bell is going to ring. Is Sasha going to die?' The student then added, 'When the bell rings, people die.'

"On the day of the Parkland tragedy, the fire alarm bell had been ringing when the shooter was shooting. So this young man associated the school bell with the shooting where an older student friend of his was killed. Hearing the bell was a common trigger of fear for the younger middle school students, as they associated the school bell to change classes with the shooting and loss of life. This was also true of some elementary school–age children. Fire drill bells and school bells now reminded these children of the shooting and death. The therapist was with this particular student giving counsel while Sasha was offering comfort. The counselors later told us the Comfort Dogs helped the students verbalize their fears and worries."

Adding to why golden retrievers, and dogs in general, are inspired disciples of comfort

work, Phil says, "Sasha is an example of how each of us should live and behave toward others. She loves everyone unconditionally, she judges no one, she keeps secrets, and she doesn't gossip." He smiles, then adds, "The world would be a better place if we all had those traits. Sasha reminds us of how we should be."

For Phil and Brenda, this has certainly been the case.

"Sasha has completely changed our lives," Phil says. "We work on her ministry full-time as her caregivers and as managers of her program and her social media. She's been an example to us of how we should live our own lives. We've bonded with Sasha particularly because we're her mom and dad and her full-time caregivers. She lives with us, we take care of her daily needs, and she's a real part of our family. She relies on us for everything. Besides working with her, we exercise her, play with her, groom her, and care for all her needs."

Anyone who has witnessed the strong bond that has been forged between the Burdens and Sasha Comfort Dog will also recognize that she takes care of them as well. She provides them with comfort when they, too, are in need of a warm, helping hand, or in this case, a heartfelt paw.

Phil confirms this, saying, "Sasha gives us unconditional love and affection on a daily basis."

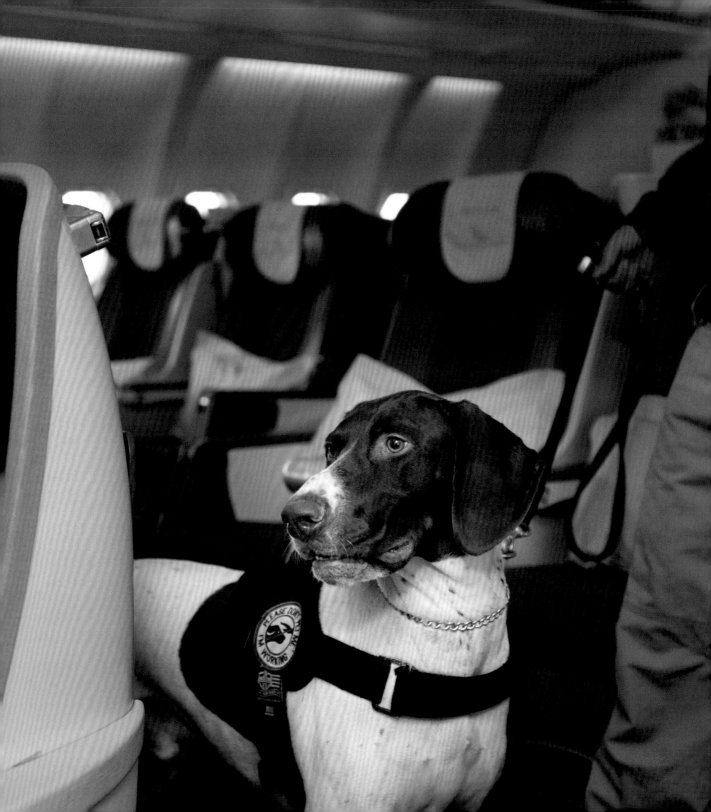

22 ■ HULK

Reston, Virginia

Being a new handler can be intimidating at times, especially when most of my coworkers have years of experience and I have none yet," says Joe Bagnall, TSA explosive detection canine handler at Washington Dulles International Airport. "That being said, being confident is a huge part of the job, and to truly be the best handler one can be, one has to find a way to be confident and take charge of situations or the team will struggle."

A resident of Reston, Virginia, Joe was paired with Hulk by their instructors at TSA's National Canine Training Center—located on the Lackland Air Force Base in San Antonio, Texas—based on their compatible personalities.

"Being new, it was also difficult being sent away for three months to undergo the training course," Joe admits. "I remember being down there, excited to learn and ready to hit the ground running on this new, dream career path. I also remember many times being lonely, especially since I was there from early November to mid-February and couldn't spend the holidays with my family. Additionally, leaving my fiancée, Becca, by herself for three months and not really being able to help with any of the wedding planning or anything else she needed was probably the hardest part of being away. However, in the end, it was all worth it, and I knew that it was a small sacrifice to make. I'd do it all again in a second, especially since I ended up being partnered with Hulk."

Hulk is a handsome dude for sure—a German shorthaired pointer with white body fur and black specks, brown head, and a big brown spot on his right side. But don't let his good looks fool you. This guy is a highly trained explosive detection dog whose job it is to help keep thousands of the flying public safe every year.

"I also remember bringing Hulk home for the first time," Joe says with a laugh. "It was close to midnight, and Hulk and I had just gotten off our flight from Texas. This was after

we'd spent close to five hours at San Antonio International Airport waiting for our flight. Needless to say, we were both exhausted. Hulk was also very confused by and curious about his new surroundings in Virginia. When we finally made it back to my apartment and opened the door and walked in, he was very surprised to see another human in that room watching TV. Becca had waited up for us.

"I don't know if she was more excited to see me or to finally meet Hulk . . . *Okay, okay, who am I kidding?* She really wanted to meet Hulk!

"The first interaction between the two of them was good. When Hulk first saw her, he looked up at me, almost asking me who she was. After I walked him over and greeted her myself, I introduced the two of them, and Hulk leaned against her leg as she petted him. Hulk and my wife-to-be became friends immediately.

"She mostly knows not to love on him too much since he's a working dog and not our pet, and he really doesn't seek too much attention from her. Before leaving for work every morning, I kiss Becca goodbye as she lies in bed, and then Hulk has to say goodbye to her as well. After I kiss her, Hulk knows it's his turn. As she lies in bed, he jumps his front two legs on top of her and leans his head in for a pet. As soon as she pets him and says goodbye, he jumps down on his own and runs to the front door ready for work.

"It can be difficult at times to stay disciplined at home with Hulk and not treat him as a pet, especially since, despite his size, Hulk is so loving and gentle. This is a lesson I constantly have to remind my friends and family when they visit and even myself at times—Hulk is first and foremost a working dog who has to stay focused no matter where he is."

Joe explains that Hulk's breed is a perfect match for this line of work. "German short-haired pointers have a high drive and a very sensitive nose," he says, "both of which are ideal for explosive detection."

On a more personal level, though, while this team is at the beginning of their career, working with Hulk is the fulfillment of a childhood dream for Joe. This dream not only came true, but it also serves a very important purpose when it comes to the security of our country.

"I've always had a passion and have been fascinated by canines, specifically working canines, ever since I was little," Joe says. "Strictly as a handler, I feel my mission is to look after, care for, and meet the needs of my canine as best I can while advancing his training and giving him every opportunity possible during a search to be successful. Then, as a

team, we can work to protect the traveling public by detecting and deterring any potential threats. This mission requires a lot of responsibility, but I wouldn't have it any other way, as I'm very passionate about the canine himself and the people we serve."

A strong bond—so important when it comes to critical work that involves things that could potentially go *boom!*—was forged immediately between these two.

"Hulk and I are a new team, so we're constantly learning new things about one another each day," Joe explains. "I would describe our relationship as a brotherhood. I literally trust him with my life every day as we search for explosives, and I would do anything in my power to protect and take care of him."

This is a sentiment—grounded in a fierce dedication to the work at hand *and paw*—that every visitor passing through Washington Dulles International Airport can take comfort in.

"Besides the personal attachment that grows each day with him," Joe says, "having Hulk means responsibility. Not only is he my responsibility, but having him means we as a team are tasked with the responsibility of being frontline defenders against one of the biggest targets for terrorism. I like to think that when people see us working, it makes them feel a sense of comfort and security."

And when these two partners go home at the end of the day, they cruise along on a high altitude of mutual respect and admiration, grounded in the realization that wishes do come true.

"Hulk has changed my life for the better," Joe says with a smile. "He's given me the opportunity to succeed at a job that I used to only be able to dream about."

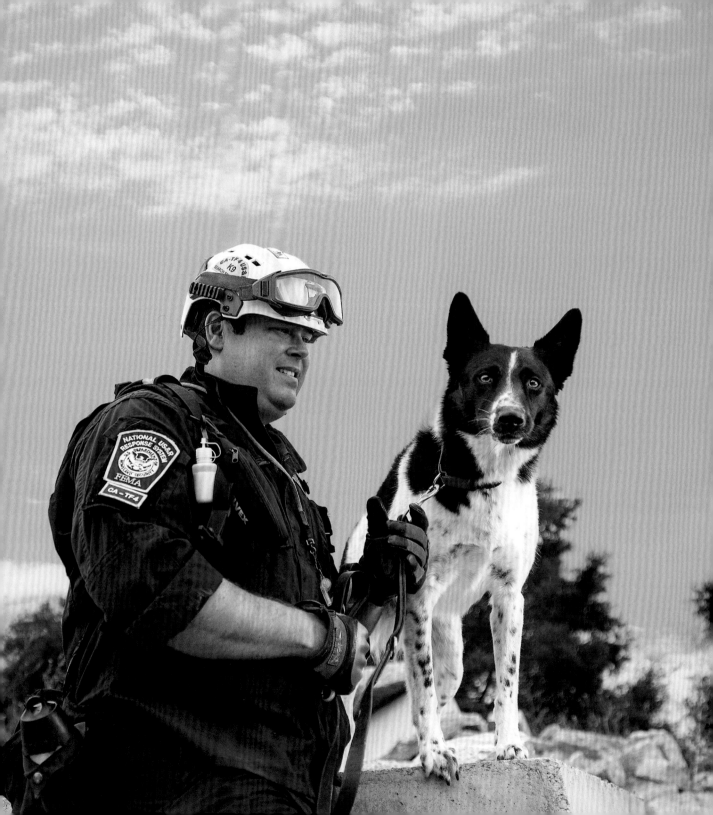

23 ROCKET

Windsor, California

Rocket was one day away from being euthanized. One day!

Because of his high energy, this rescue dog—a fifty-five-pound, black-and-white Belgian Malinois / border collie mix—was deemed unadoptable by a shelter in California—that is, until the National Disaster Search Dog Foundation's (SDF) canine recruitment volunteer Andrea Bergquist stepped in. She had met Rocket a few days earlier and couldn't get him off her mind. She and her husband, Chris, an SDF handler, decided to adopt him themselves. Their four-year-old son, Jack, is the one who named him; his full name is Rocket Booster.

The Bergquists worked hard with Rocket to help hone his searching skills. Chris took him to trainings along with his own search dog, Kari, and Rocket excelled, especially on the rubble pile. He eventually passed his test for search and rescue with flying colors. When they then took Rocket to the SDF's national training center in Santa Paula, California, for evaluation, SDF master trainer Sonja Heritage determined that he had what it took to be a search dog, and the Bergquists donated him to the program on the spot.

Rocket was eventually paired with engineer Mike Stornetta of the Windsor Fire District in Windsor, California. The two immediately began training for their Federal Emergency Management Agency (FEMA) certification evaluation, a requirement in order to be deployed to disaster zones with California Task Force 4 based in Oakland, California.

"Our first deployment was the most emotional one so far," Mike says. "On January 28, 2016, a small private plane crashed in Santa Rosa, which is in the Rincon Valley Fire District next door to Windsor. We heard over the radio that it was a pretty significant crash. Some of the first responders had found pictures of children among the wreckage that was

scattered across almost ten acres. We kept waiting to get the call to head to the scene if they needed us. Finally, the call came.

"The fire crew on scene knew of two adult passengers who had died, but finding those photos of kids really bothered them. They wanted to make sure there weren't survivors somewhere in that huge area, so Rocket was called in to search, and we headed out in the truck with lights flashing and sirens blasting.

"As soon as we arrived, I let Rocket do what he's trained to do. He covered those ten acres in about seven minutes, giving it all he had. It was an amazing feeling to see him in action like this for the first time.

"Ultimately, no survivors were found.

"Later, at the critical-incident stress debriefing, everyone who had responded to the crash was there. The engine company officer said that one of the best things to happen on this incident was Rocket being there to go through and clear the scene so we all could go back to the station and sleep easy. This was an amazing feeling for me."

That mission was just the beginning of what will no doubt be a storied career for these partners. Since that first deployment, this pair has been called into action several more times in just the past few years. Each new disaster and tragedy has been fraught with challenges and devastation, demonstrating why highly trained responders like Mike and Rocket and their colleagues are ultimately among the greatest heroes in our country.

When storms start brewing in the ocean, the National Oceanic and Atmospheric Administration (NOAA) is Mike's go-to source for monitoring the situation and anticipating imminent natural disaster deployments with Rocket.

"We watched as disturbances in the Atlantic and Gulf of Mexico turned into Hurricane Harvey," Mike recalls. "We were one of the first California teams to be deployed. I was at work and got a text telling me I had one hour to get myself and Rocket to the task force warehouse from which we'd head out. We drove for fifty-two hours straight, stopping only for fuel, to get to Texas. By the time we arrived, there was a lot of flooding. This meant that I couldn't really utilize Rocket as much as I would have liked to, because search and rescue operations were being done by boat."

However, as Mike quickly learned, sometimes when you're sent on what you think is the main mission, you suddenly find yourself redirected toward another purpose and the ultimate end goal that fate has in mind.

"While in Texas, and not being able to use Rocket," Mike says, "we started monitoring Hurricane Irma's approach to Florida. Originally, Rocket and I—along with our task force—then started driving back to California, but were soon called by FEMA and very quickly deployed east. We again drove hundreds of miles, first to Georgia where we were pre-positioned with other search and rescue teams at Moody Air Force Base near Valdosta. From there, we headed south to the Orlando Convention Center, where we hunkered down to ride out the storm.

"As the hurricane was literally passing over the convention center, fire alarms and other alerts were going off, the windows were flexing back and forth like they could shatter at any moment, and water was pouring into the center. In addition to Rocket and me, several other task forces and their dogs were inside, so we trained with the dogs, just to keep them occupied and active, and made sure they were safe."

Once Hurricane Irma passed, the real work for this duo and their fellow responders and dogs began.

"Our orders were to drive to the Florida Keys," Mike remembers. "We were the only vehicles headed southbound into the disaster zone, while everyone else was hightailing it out of there in the opposite direction. I'll never forget all the big boats that the storm surge had washed onto the roads. We had to drive around them. And all the leaves had been stripped from the trees, and other vegetation was uprooted and torn away. It reminded me of the scenes I've experienced after a wildland fire. It was all so surreal.

"When we arrived, there was a lot of wind damage and structures blown over. It was our job to search them to find any living victims who might be trapped. Rocket cleared several structures very quickly and made sure that no one was being left behind. We used a special GPS system to map the areas we searched and cleared, and that information was then sent back to a central database that was closely monitored by FEMA."

Mike explains that Rocket is specially trained to only find living people—live human scent. He's conditioned to ignore everything else, including deceased victims, as "distractions." Other search and rescue dogs are trained and then used to detect human remains.

"We worked in the Florida Keys for about a week," Mike adds, "searching in ninety- to one-hundred-degree temperatures, with 95 percent humidity. We were drenched in sweat. Our canines, being from California, aren't used to these conditions, so we had to be really careful with them. We made sure they had ample water and rest."

After having crisscrossed the country for Hurricanes Harvey and Irma, the next series of headlining disasters hit closer to home. In fact, for Mike, the kickoff to the historic wildfire season, and eventual Montecito mudslides, was the Tubbs Fire—recognized at that point as the most destructive wildfire in California history—located smack-dab in Mike and Rocket's home district.

"I had Rocket in the truck with me as I hightailed it to work," Mike says. "We drove through blinding smoke, and with walls of flame on both sides of the highway. It was nerve-racking for sure. My parents lost their home in the fire, and Rocket was with me when we raced to the house to see what we could help them salvage. Rocket is my partner, so it was nice to have him along during all this."

Barely two months later, the Thomas Fire struck Ventura and Santa Barbara Counties. The fire especially impacted the steep mountains, loosening soil and laying the groundwork for the massive mudslides that hit Montecito and other surrounding areas in the middle of the night on January 9, 2018.

A few days later, Mike and Rocket were deployed to the area.

"Because Rocket is a live-find dog," Mike explains, "we, along with our task force, were immediately sent out to search for anyone trapped in homes and other structures. Swimming pools were filled with mud, and when combined with the water, they were like quicksand. The debris flow was a mixture of mud and toxic materials, so we had to be careful, especially with Rocket and the other dogs, at every step along the way. The whole time, Rocket knew exactly what to do and was great. Even while our boots were getting stuck in the mud, he and the other dogs didn't have that problem. In fact, we had to work hard just to keep up with them, they were working so quickly and effortlessly.

"I still remember the odor; it was foul, mud mixed with sewage and other toxic materials that created a really disgusting soup. You could hear jackhammers as large boulders—four and five times the size of a fire engine—were being broken apart and removed from roads. Some houses were completely filled with mud, some had been demolished by the mudflow and boulders, and then there were others just a couple of inches outside the debris field that were untouched. It was nothing like I'd ever seen before, even after being through crazy hurricanes and wildland fires."

Rocket and Mike's work together was hit-the-ground-running, baptism-by-fire from the very start. Considering Rocket was once twenty-four hours away from being euthanized,

this seems about right. For these two brave souls, life is lived on the edge, and every moment is precious.

"No matter what he's doing, Rocket has insane amounts of energy," Mike says. "At work, he's strictly on duty, and he knows it. He does whatever I ask him to, and he's always there for me and the other firefighters when we get back from a critical call. He lets us pet him, debrief our experiences to him, and just love on him. That means a lot to me and the others."

Mike pauses to reflect, then adds, "You know, us firefighters come off a lot of the time as big, tough guys and gals and that nothing affects us. Fact is, we're human beings with emotions. Having Rocket has helped all of us get through a lot of the stressful situations, and he puts a smile on our faces."

Mike laughs and says, "But back home, the switch is flipped and Rocket goes into off-duty mode, and then he's just a goofy, lovable dog."

Mike and Rocket were honored for their service to their community and our country by being asked by the Lucy Pet Foundation to ride on a float in the Tournament of Roses Parade in Pasadena on New Year's Day. They were joined by other four-legged heroes, including a police canine and a cat who had saved a young boy.

Ending up in extraordinary places and doing extraordinary things seems to be this team's trademark now.

"Never in my life did I ever imagine I would someday be on a float in this parade, being watched my millions of people on TV," Mike says. "But as long as I'm with my partner, Rocket, I'll go anywhere when duty calls."

24 ANNA AND EZRA

Toledo, Ohio

The eighty-nine-pound golden retriever known fondly as Lutheran Church Charities (LCC) K-9 Comfort Dog Ezra—full name Ezra Nehemiah 8:10—has been assigned the unique job of working at the Lucas County Prosecutor's Office in Toledo, Ohio. This is a job he owes to his fellow LCC K-9 Comfort Dog Anna—a ninety-three-pound golden retriever whose full name is Anna Psalm 62:8.

While Anna is placed at Trinity Lutheran Church, Ezra is an LCC staff dog who supports the work of the Lucas County Court as his primary responsibility.

"After working with Anna for about a year, visiting hospitals, nursing homes, schools, disasters, and other places," explains LCC top dog Nancy Borders, a retired contract administrator at the University of Toledo, "I was approached by one of our church members who happens to be the county prosecutor. She asked if Anna might stop into her office to visit with the staff. At the time, she was trying to generate interest and find someone who would be willing to house a therapy dog for use in the court.

"The goal was to find a dog who would be trained and then many people would be able to use him or her for their cases. We prepared a presentation for the staff about how Anna works within the community and how she can be deployed to various situations as needed. However, no one in the prosecutor's office stepped up to accept the responsibility of caring for a dog.

"In the meantime, there was a case that was soon going to trial involving young siblings who had been the victims of horrendous abuse and neglect at the hands of their father and another older sibling. These children had been mistreated and were having a very hard time talking about the events that had riddled their young lives. The assistant prosecutor

assigned to this case asked if Anna could come in while the children were being interviewed. I took Anna into the office and sat her down beside the one young girl. At first, the girl was reluctant to engage, but after Anna lay down on the floor, she began to pet her. The girl was then pretty forthcoming with her statements.

"Next was another sibling, who had said very little up to that time. She started petting Anna immediately and, as she petted, she began to talk about the unthinkable things she had witnessed and experienced herself. Anna's presence seemed to give her the courage to tell her story.

"After going through several public defenders, the two male defendants in this case decided to represent themselves for the trial. This meant that they would be allowed to question the children directly in court. The assistant prosecutor filed a motion to allow Anna to sit with the children in court while they had to testify. Of course, the defendants objected, but the judge allowed the request. This was a groundbreaking decision for Lucas County!

"After several months and many additional interviews with the children, with Anna by their side, the time for the trial came. The prosecution called several witnesses before the children were asked to testify. The oldest child was the first of the victimized children to be questioned. The state questioned her for about thirty minutes, but the cross-examination by the defendants—who were representing themselves—lasted for six hours over a period of two days. Anna and I sat with the child who was testifying the entire time. Hearing the child testify was worse than I could've ever imagined. Although Anna laid down most of the time, the girl was able to pet Anna whenever there was a break of any kind. I would have Anna sit up so that this brave girl could pet her.

"At one point, I asked the girl if she liked having Anna with her, and she told me that she felt like Anna was her guardian angel. As Anna sat with the children while they testified, it seemed to give them the courage to speak up to their perpetrators. These children were emboldened! The accused were eventually found guilty."

This trial and Anna Comfort Dog's presence in the courtroom yielded so much publicity that the Toledo Fire Department reached out to Nancy and her team and asked if they could enlist Anna to help comfort the families of two firefighters who had lost their lives in a tragic apartment building fire—an apparent arson.

The owner of the building was being charged with two counts each of aggravated murder and murder, eight counts of aggravated arson, and a single count of tampering with evidence.

"Anna, my husband, Mack, and I first met with the fire department administration to discuss how we could help the families who would have to sit through some graphic and

emotional testimony throughout the course of the trial," Nancy explains. "We were then invited to a brunch where the family members could meet Anna prior to the start of the trial and discuss the trial process. Since the family members would not be testifying, it wasn't necessary for Anna to be in the courtroom. However, because of the publicity this trial had generated, the courtroom would be extremely full, so there would be a private room in the 911 call center that would be used for viewing the trial via closed-circuit TV. Only firefighters, family members, and Anna and her handlers were invited to view the trial from there.

"Anna divided her time between the 911 call center and the hallway directly outside the courtroom as needed. She started the trial at the 911 call center, but as most family members chose to be in the courtroom, it didn't take long to realize that Anna's presence would be most beneficial at the courthouse. Anna and Mack spent nine days in that hallway with other handlers rotating in to assist. As the prosecution was setting up their case, they had many firefighters and arson investigators testify as well as other expert witnesses. Each one sat in the hallway prior to being called to the stand. Anna was there for every one of them, if needed. Most wanted to pet her to relieve some of their anxiety. Some felt comfort just looking at her. One of the deputy chiefs who petted Anna prior to testifying told Mack afterward that every time there was a break or sidebar, he would think about how calm Anna had been, and that would calm him.

"Each day when they would break for lunch, Anna and her handlers were invited to a private lunch with the families in a church across the street from the courthouse. These families looked forward to seeing Anna every day. It didn't take long before the need for Anna extended beyond the firefighters and the victims' families. Eventually, the jurors, media, attorneys, and even the defendant's family looked forward to the compassion that Anna was so willing to give.

"On the eighth day of the trial, information came out in court that the jury wasn't supposed to hear, thus causing a mistrial. The families, the jurors, and most everyone else were devastated. Many cried with Anna. The possibility of another trial was too much for most of them to bear. Since a decision would be made the next day as to how to proceed, the defendant, knowing that it didn't look good for him, entered what's called an Alford plea—not admitting guilt—to two counts of involuntary manslaughter and two counts of

aggravated arson. The judge found him guilty and sentenced him to an agreed-upon twenty years in prison."

These two cases bolstered the prosecutor's resolve even more to obtain a dog for her office. She asked if Nancy and her team at Trinity Lutheran knew of a trainer whose methods could produce a dog like Anna. Nancy was soon in touch with LCC president and CEO Tim Hetzner and LCC director of K-9 Ministries Rich Martin.

"Tim and Rich offered a suggestion that would rock our world," Nancy recalls with a smile. "God had intervened with his own plan. They told me that LCC might be able to provide a dog for use at the prosecutor's office at no charge to them or us. They would have to talk to the prosecutor first, but they thought this would be a great expansion of the Comfort Dog ministry if we'd be willing to spearhead this pilot project. We immediately said yes!"

After navigating many logistics over six months, Nancy and Mack agreed to be Ezra's primary caregivers, and four other handlers from Anna's team would also train for Ezra. In addition, two victim advocates from the prosecutor's office were also trained to be Ezra's handlers. This was something new for LCC, as these latter two handlers were not members of a Lutheran church. Ezra spent the first couple of months getting used to his new home and handlers, often going with Anna on her visits and visiting the courthouse to get familiar with it.

"During this time," Nancy explains, "the prosecutor's office set up a calendar for reserving Ezra's time. He is now in the courthouse two to four times a week in the victim/witness room, helping to calm those who have to appear before a grand jury or in court. It seems that there is always someone who needs Ezra's comfort. The courthouse employees also always find out that Ezra is there, and one can actually feel the atmosphere change.

"Often we're there for the jurors who have to hear horrific testimonies. For many, Ezra provides something to talk about, to ease their stress. As the Comfort Dogs do, he is a bridge to compassionate ministry. We don't ask why people are at the courthouse, but they often tell us. Many are victims of a robbery, domestic violence, or even rape. They're all ages, but Ezra gives them all his unconditional, nonjudgmental love.

"Ezra has also been present for many interviews involving children, most of whom have been sexually assaulted by someone whom they trusted. Allowing themselves to be

vulnerable with Ezra is safe. They know that he won't harm them or judge them. I've noticed that his presence alone makes them feel safe and, therefore, able to talk more freely. It's amazing to watch the transformation in some of these children."

Each encounter that Nancy has witnessed with Ezra Comfort Dog at the courthouse is perpetually etched into her memory. Each experience is one more powerful step forward in their journey together.

Nancy explains that while her career as a university contract administrator was rewarding, it "lacked a sense of service." She yearned to do something more, something that would allow her to further serve God. That opportunity materialized when her pastor at Trinity Lutheran decided to pursue the Comfort Dog ministry, which resulted in Anna and Ezra.

"As Ezra's caregiver, along with my husband," Nancy says, "what I see in him is what I want to bring to the people whom we visit. Ezra loves to work and brings such joy to his job. If it's love and compassion that someone needs, that's what he gives, and he gives it willingly. Because Ezra's primary job is with the court, I've learned that I've led a very sheltered life! Some of the cases with which we've been involved have opened my eyes to situations that I never knew existed in the world. Hearing about the things that people do to each other only proves to me that this world needs more love, especially the love of Jesus Christ. I'm striving to show that love."

That unconditional love was desperately needed involving a case where a serial killer was about to be released after serving a twenty-year sentence. He and his brother admitted to murdering multiple people. At the time of the plea bargain, no one actually thought this guy would live long enough to be released, but he did. Now, the families of the victims, as well as one victim who had lived after being left for dead, had to relive the horrific tragedies of the past.

"Ezra was asked to attend several meetings with the victims' families," Nancy recalls. "At the first meeting, Mack took him into a conference room full of people whom Mack had never met. He gave Ezra a loose leash, and Ezra immediately went to the side of the surviving victim, who had been a pivotal witness that put the serial killer in prison. As she started to pet Ezra, she began to release the tears she'd been holding back. At the next meeting, they were in a small room with chairs and couches, and Ezra proceeded to calmly

move from one person to another, giving each as long as they wanted to help calm their nerves."

Bringing calm into the eye of storms comes naturally to Ezra. "Like Anna and other golden retrievers," Nancy says, "Ezra has a permanent look of compassion in his eyes."

And the lessons she has learned from both of these Comfort Dogs are many. But chief among them, Nancy says, "Anna and Ezra are very free with their love, and they've taught me to do the same. Anna and Ezra have taken me to places that I never could've imagined, and both have handled each situation with professionalism. They make me want to be a better person."

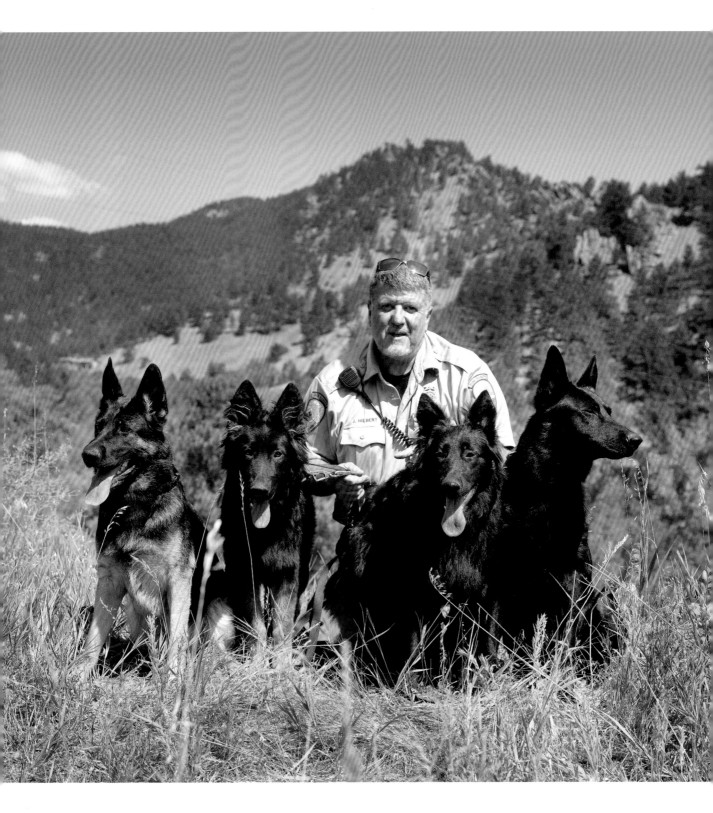

25 DAX, TRINITY, AND NIKITA

Lyons, Colorado

For Jeff Hiebert, a park ranger from Lyons, Colorado, and the president of Search and Rescue Dogs of the United States, working with dogs has been a lifelong passion.

"I started canine search and rescue at the beginning of my career as a park ranger some twenty-three years ago," Jeff says. "I loved the idea of creating a partnership with my dogs with the purpose of helping people who are lost or are missing. Working in nature and in the mountains of Colorado, where many people get into trouble, seemed like the perfect marriage. So in addition to using my canines to find lost and missing people, I utilize them to help protect the resources within the parks where I work."

A fan of German shepherds, Jeff's first three search and rescue dogs were Frisco, Max, and Xenie. Today, his team of working dogs consists of Dax, with black fur; Dax's daughter Trinity, who is black and tan; and Nikita, who is black and red.

"Over the years, my dogs have helped me to find bad guys, people who've entered into sensitive wildlife areas that are closed to the public, and illegal hunters," Jeff explains. "We also look for people who've gotten lost, we look for at-risk people who go missing, we help when there's been an abduction, we work with homicide detectives on murder investigations, we keep the parks safe, and we meet a lot of people who are happy to see us. The dogs are also a great way to break the ice with the public who is out in the wilderness recreating. And they help give presentations on wilderness safety and have been petted by hundreds of kids."

In other words, Jeff and his band of hero dogs have their plates full and their work cut out for them.

"A search and rescue dog is lucky to go a career with one or two finds to their credit," Jeff explains. "For one mission I did with Dax, it was New Year's Eve and a child went miss-

ing in a suburb of Denver. He vanished without any trace as he left home after an argument with a family member. Forty-eight hours later, the FBI called Search and Rescue Dogs of the United States to help with the search. We had area search dogs, human remains detection dogs, and trailing dogs respond to help. Dax and I were assigned to attempt to follow the path the child took to hopefully find him or evidence that might assist in the investigation. Dax is a certified urban trailing dog and had spent hundreds of hours training in urban environments.

"We started from where the child exited from his bedroom window. Once we got out of the scent originating from the house, Dax began to show forward trailing behavior. He led us out of the cul-de-sac and then out of the neighborhood. We crossed a very busy four-lane street and entered into a park about one-fourth mile away from the house. Dax brought us to a frozen pond that had two fountains and pretty colored lights going for the holiday season. The two fountains kept two areas of water from freezing over as they sprayed twenty feet into the air. Dax began alerting on the fountains, and he tried to pull us onto the ice. We then worked the area to see if a scent trail left the area of the pond. We checked in all directions and always came back to the pond. The next day, a dive team was called in to search the pond. They found the body of the child. It appeared that he was drawn to the area by the fountain and pretty lights and just fell in and drowned."

The professional relationship between Jeff and his dogs works so well for a few reasons. Sure, there's the enormous number of trainings and certifications, but even more significant is the tight-knit friendships that Jeff forges with his dogs on and off the clock.

"I spend more hours in a day with my dogs than I do with my husband, Igor," Jeff says with a laugh. "My dogs fill so many different roles day to day. They comfort me during difficult times by giving me a funny look, demanding to be pet, wanting to be taken for a walk, or just being there wherever I go. Working in the emergency response field means we respond when others are in need of help, many times during the worst moments in their lives. There's a lot of stress and trauma that comes from doing law enforcement, and my dogs help me process that stress and trauma.

"You've heard that dogs are good judges of character, right? Well I've found that to be very true; while my dogs aren't trained as patrol dogs, I've been alerted many times by them to be extra wary of bad guys whom I didn't initially know were bad guys. My dogs can sense people's emotions—if they're ready to fight or to flee. One look at my dogs will

tell me a lot. 'Trust your dog' is my motto. These dogs are highly skilled. They understand a world that we barely perceive—the world of scent. 'Trust your dog' not only applies to when they're working. You can always trust your dog to be there for you, and there are no ulterior motives or human frailties that interfere with that trust and bond."

A few years ago in Vail, it was Nikita's turn to put her skills to work.

"A construction project was under way to build a hotel," Jeff remembers. "Soil was being excavated from the site and dumped at two different locations. When one of the dump trucks was emptying its load, one of the workers observed a human skull roll down the pile of dirt. Search and Rescue Dogs of the United States was asked to bring human remains detection dogs to locate the rest of the remains. It was unknown if more human remains were left at the building site, or if they were moved to one of the two locations where fifty loads of dirt had been taken. Nikita was used to search the two areas where the dirt was moved from the site. It was determined that all of the remains, as well as portions of a casket, were located at the original dumpsite. The dogs cleared the second site so yards and yards of material didn't have to be screened through by investigators.

"It was then also determined that the contractors had inadvertently dug up a historic grave from the 1800s. Anthropological analysis and a review of records determined that the clothing and wood found with the human remains dated the site back two hundred years and probably belonged to a family member who owned the land. It was interesting, and remarkable, how Nikita and the other dogs were able to locate and distinguish human remains that were so old."

Jeff's dogs were literally born to do search and rescue work, and at the highest level.

"My dogs all have a lineage going back many generations as proven working dogs," Jeff explains. "As German shepherds, they're from various European lines, in the current case Czech Republic lines, which all have strict breeding programs."

Dax was imported from the Czech Republic, and naturally his daughter Trinity descends from that specific line. Nikita was imported from Austria.

While much time and effort goes into choosing and training his dogs, Jeff also gives careful consideration to their names and nicknames. Dax's full name is Gadax Yucero Bohemia, which is the name he arrived with from the Czech Republic and which nicely lent itself to the fun and hip nickname that Jeff gave him. Trinity is named after a character in *The Matrix,* and Nikita is named after the title character in *La Femme Nikita.*

This attention to detail by Jeff further conveys the love he has for his furry pals. "My dogs are part of my family, and they're my partners in work," he says with a smile. "Thousands of hours have been spent developing a relationship where I can read what they tell me through their behavior. They in turn learn what I want from them, which is detecting and analyzing scent that can lead to saving a life or solving a crime. When you own a German shepherd, they're always at your feet; you're never able to even go to the bathroom by yourself. They're just always there for you."

Jeff's dogs have impacted and changed many lives for the better, but none more than that of their biggest fan. "Since I've been doing this work for so long, it's difficult to think of a time that I haven't been working with dogs," Jeff says. "I suppose in that way they've drastically changed the direction of my life. I run one of the largest search and rescue dog groups in the country. I've worked with hundreds of dog teams, helping to develop them from puppies into certified search and rescue dogs, and I've personally worked hundreds of missions and spent tens of thousands of hours training my own dogs and others."

Jeff's dogs, Dax, Trinity, and Nikita, have collectively earned a number of certifications, such as urban trailing, human remains detection, and suburban trailing.

He adds, "I also started the Returning Soldier Initiative where we match veterans with local search and rescue groups and provide them with dogs to train and mental health support if they need it. In retrospect, all these dogs have completely shaped my life today."

Across the board, folks working with dogs in the search and rescue field will all agree that these animals are heroes in the purest form. Jeff couldn't agree more on this point.

"We look at our dogs as heroes because they give without understanding the potential costs," Jeff says. "They work in dangerous situations, sometimes in peril. The hard work they do probably shortens their life spans, increases wear and tear on their bodies, and exposes them to environmental hazards. They don't get that they're heroes, but these dogs do give so much to others without thought of themselves. They have no idea the importance of what they do; they just do it because we ask them to."

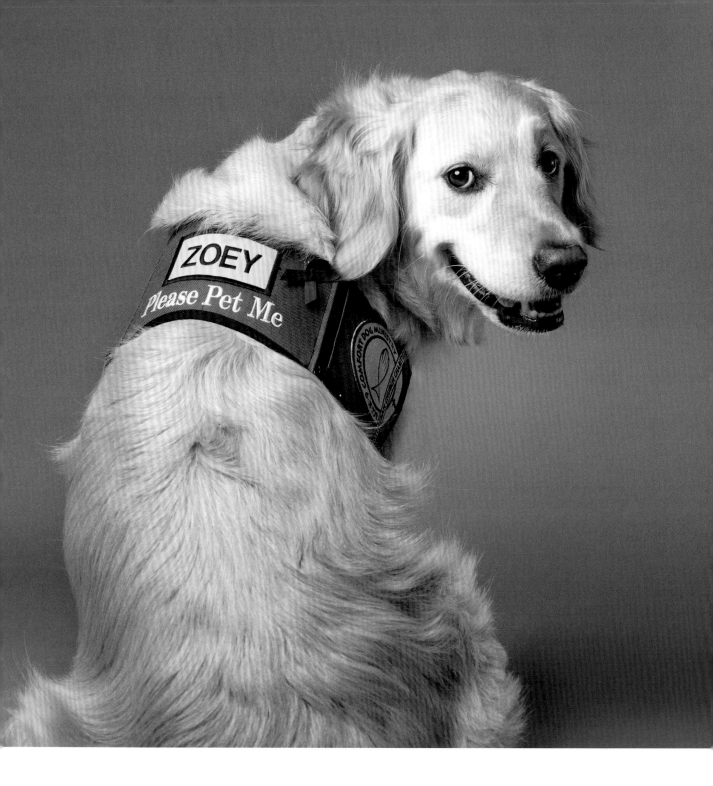

26 ZOEY

Mequon, Wisconsin

Many can claim that they're the big dog on campus, but for Lutheran Church Charities (LCC) K-9 Comfort Dog Zoey at Concordia University Wisconsin, it's literally true in more ways than one.

"To the best of my knowledge," director of counseling services Dave Enters says, "Concordia University Wisconsin continues to be the only university in the country that owns a dog who's highly trained with a specific job description that includes working in the counseling center; working in the classroom, including fieldwork and clinical sites; enhancing the emotional well-being of our students, faculty, staff, and administration; serving the community around us; and who is also available for deployment to national tragedies."

Serving as an LCC top dog handler, Dave has worked with Zoey, a golden retriever whose full name is Zoey Isaiah 66:13, on campus and elsewhere for the past several years. Since coming to campus, this sixty-pound furry bundle of comfort has become a BFF and a blessing to everyone with whom she crosses paths.

Dave has been able to utilize Zoey's unique training as a valuable tool in his counseling office where he works with students who are dealing with a broad spectrum of challenges—abuse, rape, depression, anxiety, addiction, tragedy, and much more. Zoey provides a unique skill set that can't be found in any textbook, and that complements Dave's efforts.

"Working with Zoey in all of these ways makes her feel like my professional partner," Dave says with a smile. "While my relationship with Zoey is different from if she were a pet, there's still an emotional bond that has developed. Her greeting me in my office in the morning is a great way to start any day. When I hear the door of the waiting room open, I get up from my chair and stand next to my desk. Zoey comes running in and sits at my feet

in a 'front' position. As she looks up at me, her eyes seem to be saying, 'What good things are we going to do today?'

"Some days are more difficult and demanding than others, but Zoey always begins the day with an attitude of enthusiasm."

Zoey's enthusiasm and innate optimism allow her to make connections with students who might otherwise never find the hope and solutions they're desperately seeking. For many, these are breakthrough moments.

"What stands out the most to me about Zoey's presence in my counseling office," Dave explains, "is the effect that she has on individuals who have been traumatized or are in an extreme crisis. In my years of professional counseling, I've known individuals to take considerable time, sometimes months, to warm up to and trust a counselor before they can begin talking about their traumatic incident or past. This has been especially true when working with those who have experienced sexual assault or abuse. There have also been a handful of occasions that I've had over the past several years of working with traumatized students. In each case, the student was able to open up about the incident in the first or second session when they were petting Zoey. Needless to say, I was very surprised by this. My observation is that Zoey's presence and the ability to pet her gave these individuals a sense of security, safety, and assurance that things would be okay if they talked about their experience."

The results of Zoey's effectiveness is reaching through the darkness to help these students speak for themselves. Dave counseled one young woman who was in the clutches of depression and anxiety. Again and again, the woman found herself in a very lonely and hopeless rut.

"This woman began with a cautious posture," Dave recalls of their one visit in his office. "Her affect was rather blank and hard to read. Over the course of thirty minutes, she moved from a distancing posture while sitting on a chair to leaning forward on the chair to sitting on the floor to sitting close to Zoey. At one point, Zoey placed her head on the knee of this student and rested it there. The student continued to pet Zoey when I noticed the expression on her face changed; she looked conflicted like she was asking herself, *Should I or shouldn't I?* She then reached down and hugged Zoey passionately. I knew something powerful just took place, but I didn't know what. My guess was that her aching soul was soothed."

In a reflection the student later wrote about the experience, she expressed the happiness she had indeed felt in that moment with Zoey. She wrote of how the heavy burden of anxiety and other troubles melted away, even if only momentarily. Zoey's friendly and non-judgmental demeanor had pulled the student into a safe, comforting zone, allowing her to take a promising step forward in her healing.

"This student had a powerful encounter with Zoey, and it was therapeutic," Dave says. "She was energized and strengthened by the experience and was able to see the light at the end of the tunnel."

For another student, the victim of a dog attack, Zoey had to restore the young woman's faith in her fellow canines and help to banish the paralyzing fear that had gripped her.

"I got a phone call one summer from a young woman who was a student and who had established a close relationship with Zoey," Dave remembers. "She was crying as she explained that she had been attacked by a dog and had injuries from that attack. It was clear to me that she had been traumatized by the experience. I wasn't sure if her crying had more to do with the attack or the fact that she said she would never be able to see Zoey again because of the fear that she now had toward dogs. I asked her if she'd be willing to come in to see me. I told her that Zoey would be in my office area. She agreed to come in. When I heard the door to the waiting room open, I got up from my desk and went to the doorway to my office. Zoey was at my side. The woman had a look of terror on her face. As she slowly entered the waiting room, she hugged the wall with her back, trying somehow to find a sense of safety or security from leaning against it.

"I welcomed her as she finally slid into one of the waiting room chairs about fifteen feet from where I was standing. I could now see that her hands were trembling. I asked her if she would like to come into my office. She shook her head. She looked at Zoey as if she wanted to greet her, but her body wouldn't let her. I asked her if it would be okay for me and Zoey to step toward her. She didn't say no, so Zoey and I took a step forward. This process repeated itself over the next twenty minutes until Zoey and I were within arm's reach of the student. I invited her to pet Zoey, reminding her about how gentle she was. The student finally stretched out her trembling hand and put it on Zoey's head. That touch soon turned to strokes, petting Zoey along the length of her back.

"I invited the student again into my office. This time, she agreed. When we got into my office, I positioned Zoey's mat in the center of the room and directed Zoey to lie on it. I

then invited the student to sit on the floor next to Zoey so that we could talk and she could continue petting her. The student positioned herself on the floor next to Zoey with Zoey lying with her back to her. The trembling hand now stroked Zoey's soft ears. This was the student's favorite part of petting Zoey, her soft ears.

"Suddenly, and for no apparent reason, Zoey lifted her head and looked back at the student while beginning to yawn. The young woman jumped back in terror as she looked at Zoey's open mouth and teeth. I thought, *Zoey, really?* I assured the student that Zoey had just yawned and that it was okay to continue petting her. Within ten to fifteen minutes, her trembling went away again. We then talked about the attack as much as she was willing to share. Most of our conversation had to do with reestablishing her relationship with Zoey. Within an hour of coming into my office, she was in a familiar frame of mind, stroking Zoey and smiling. We ended the meeting with the student giving Zoey a peanut butter treat."

Restoring faith—whether it be in dogs, people, life in general, or God—has become a specialty of Zoey's.

Often, we find ourselves having to make life-altering choices amid unbearable circumstances. Zoey Comfort Dog offers a warm embrace, a leveling of the playing field from which the folks with whom she meets can answer some of the toughest, and most unfair, questions life throws.

Zoey is the calm in the storm for the many people she meets. She provides a respite from whatever trauma they're currently enduring. Such was the case during the summer of 2016, when Dave and Zoey traveled to Orlando with a student handler to meet up with two other LCC Comfort Dog teams to serve those affected by the Pulse nightclub shooting that left forty-nine dead and fifty-three wounded—and a community and nation in a state of utter shock.

"One of the most compelling interactions that we had," Dave recalls, "was at the Orlando communications center where the 911 dispatchers do their work. We were invited to visit with the third-shift crew because the Comfort Dog teams that were there the week before met with only the first- and second-shift crews. We met with several dispatchers who had been on duty the night of the shooting, but the most memorable one for me was the young woman we spoke with about a half hour into our visit. She was pale and weary looking. We walked up to her and asked her if she would like to meet Zoey. She said yes. I

asked her if she had been on duty that night. She again said yes. I asked her if she had been able to sleep well, since she looked exhausted. She replied that she hadn't slept much in the two weeks since the shooting. I could tell that she was drawn to Zoey, as she continued to pet her.

"'I love dogs,' she said. I asked her some general questions about her job—like how long she had been working as a dispatcher. I then made the observation to her that it must have been crazy for her and her colleagues the night of the shooting. She started to tear up as she began to put into words, maybe for the first time, what she'd experienced. She told me how there were tons of calls that came into the communications center that night that reported the shooting. At one point, all of the dispatchers were told to stay on the line with any caller from inside the nightclub. This allowed for the potential of sharing information, either from patrons inside the club to the police or from the police to the patrons. The Pulse patron with whom this young woman was on the phone was hiding out in the bathroom with about a dozen other people.

"The dispatcher then paused and collected herself before telling me the rest of her story. She then said that, at one point, she heard screams, then shots, then silence on the other end of the telephone. It was later reported that the gunman had headquartered himself in this particular bathroom, where the caller was, as he was negotiating with the police.

"The memories of that call had replayed over and over in this young woman's mind since that tragic night. She had been unable to sleep well, eat well, or interact with people. She had experienced secondary trauma—some might even say primary trauma—from having been on the phone with a person who died at the hands of the gunman. I have to wonder if she would've opened up to a stranger had Zoey not been there.

"This has been my experience in working with Zoey. She provides a sense of safety and assurance that enables a person to become willing to share things that are most difficult to share.

"I wish that I could have met with the young woman again after this encounter; a follow-up with Zoey may have helped her process another portion of her trauma. But that's the nature of a deployment after a traumatic event; you get one chance to make a difference. My prayer is that this woman was blessed by our visit."

Being a counselor on a college campus and an LCC K-9 Comfort Dog handler with

Zoey has offered Dave invaluable insight into the human condition, both close to home and across the country. It has also reminded him on numerous occasions that while good will always be the target of evil, with a grounding in faith and compassion—and with the help of a Comfort Dog—good will find a way to triumph in the end.

"Working in the counseling field can be filled with stress, especially when working with college students," Dave says. "Many students make poor life decisions, do not know how to effectively manage their emotions and relationships, they wrestle with depression and suicidal thoughts, and some come from horribly dysfunctional family systems. Petting Zoey, playing with Zoey, and watching her happy-go-lucky spirit helps to put things into perspective and is a steady reminder that life can be good."

And the last several years of working with Zoey have made Dave's life in particular extra good.

"Of all the meaningful ways that Zoey has impacted another person, I've probably been impacted the most," Dave says with a smile. "For example, one of the many unforeseen blessings I've personally experienced from working with Zoey is the elimination of my weekly migraine headaches. This may be a coincidence, but since Zoey has come to Concordia and started working with me, I've gone from having about seventy-five to one hundred migraines per year to about three! Professionally, counseling people and sharing the love of God have been very gratifying for me over the past forty years. I wasn't looking for an extra boost to motivate me in my work. I love my work and am extremely fulfilled. So while I anticipated some of the uses and benefits of working with a Comfort Dog, little did I know that the uses and benefits were exponentially greater than I could even imagine. I imagined that working with a Comfort Dog would make the rating of my job go from an A to an A+. As it turns out, working with Zoey has been an A+++."

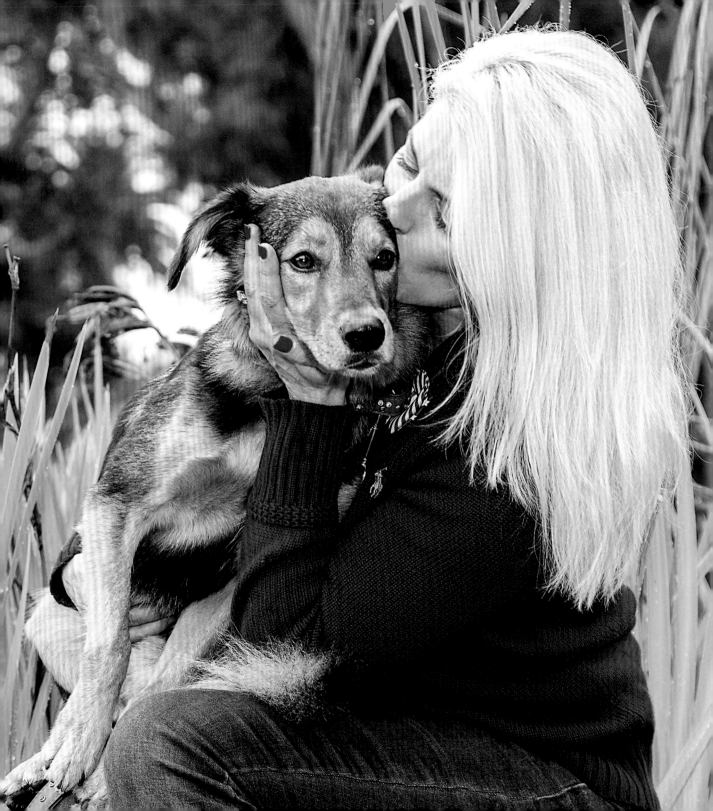

27 BOBO

Brea, California

When Donna Cloughen looks into the spirited brown eyes of her black-and-gold dog BoBo, who is known as Bo for short, and sees only love and hope reflected back, it's still hard for this chiropractor and acupuncturist from Brea, California, to fathom how his precious life started thousands of miles away and in one of the most heinous ways imaginable.

"Bo was rescued off a truck packed with eight hundred other dogs while it was on its way to the horrific Yulin Dog Meat Festival in China," Donna explains. "Dr. John Sessa and his team from the Vanderpump Dog Foundation rescued Bo and others. They had to create makeshift kennels in a field to assess the health of the dogs, but then they were confronted by locals who began slaughtering the dogs in front of them. The rescuers were soon on the move again, running for their own lives. Bo was one of the lucky ones, and rescued for a second time! He eventually made it safely to the rescue clinic. He was treated with blood transfusions and other medical aid. Finally, when he was healthy enough, Vanderpump Dogs brought him to his new home at their rescue in Los Angeles."

After hearing about Bo's harrowing escape on the news, Donna and her husband, Bob MacBurney, felt an instant connection to him. Watching KTLA anchor Lynette Romero cuddle Bo during his television debut as a survivor of Yulin's annual dog massacre, this couple was admittedly hooked.

"We looked at each other and said, 'Wow!'" Donna recalls. "He reminded us of Harley, our beloved golden who had recently passed away. Our eyes filled with tears. He looked so timid and scared, but at the same time so thirsty for love and affection. In our minds, we thought we weren't ready yet to move on from our loss of Harley. However, when we heard Bo's story and where he came from, we decided he was a blessing sent to us and that

we could give him an amazing life. How selfish if we didn't share our love with this innocent pup who was in such need.

"Within minutes, we called Vanderpump Dogs and applied to adopt Bo. We even asked our friend Dr. Paul Nassif, star of *Botched* on E! and a former star of *The Real Housewives of Beverly Hills,* to be a reference and to put in a good word for us since Vanderpump Dogs has a very selective procedure for picking the perfect adoptive parents for their dogs. The rest is history."

And by "the rest is history," Donna means that Bo is helping to now make history. As one of the first dogs to escape the Yulin Dog Meat Festival—where some ten thousand dogs *annually* are rounded up and even abducted from homes, slaughtered, and served as meals—Bo is now taking on the role of stateside ambassador. He is helping to raise grassroots awareness here in the United States about this outrageous mass carnage in the heart of Yulin, Guangxi, China, and about dog abuse and neglect of all kinds. Along the way, he's winning the hearts of everyone with whom he crosses paths.

In 2018, Bo was given the Awareness Ambassador award by the Vanderpump Dog Foundation when he was the guest of honor at the organization's World Dog Day in Los Angeles. Vanderpump Foundation executive director Dr. John Sessa, who originally rescued Bo, and superstar Leona Lewis presented the award to Bo. John expressed his eternal connection to Bo, declaring as he so often has in the past that when he first rescued Bo in China, it was "love at first sight" and that Bo is the ultimate "representation of everything we stand for at Vanderpump Dogs."

On and off the red carpet, Bo was greeted by the hundreds of attendees, including a reunion with Vanderpump Dog Foundation founders and stars of Bravo's *The Real Housewives of Beverly Hills,* Lisa Vanderpump and Ken Todd, and their daughter, Pandora, executive board president for the foundation. He also hobnobbed with several other celebrities, such as Lance Bass, Michael Turchin, and their rescue dogs; Jax Taylor and other cast members from Bravo's *Vanderpump Rules*; and the stars of *Gown and Out in Beverly Hills,* Pol' Atteu and Patrik Simpson, along with their furry costar SnowWhite90210.

It's fitting that Bo's formal name Bobo evolved from *Boo Boo,* meaning "strong and willful" in Chinese. To Donna and his legions of fans, Bo leaves no doubt that with his indomitable and proven strength to survive, he was destined to become a role model of resilience.

Not only did he escape certain death, but he also overcame parvovirus, distemper, anemia, and malnourishment under the horrific conditions he so bravely endured.

After being rescued, Bo was first introduced to the world by Dr. John Sessa, who, while still in China after the heroic mission, posted a heartwarming Instagram photo of himself with Bo and the caption: "It was love at first sight with this sexy boy! He stayed by my side all day ;) #StopYulinForever #WellnessMission #YulinSurvivor."

After Bo was safely back in the United States, the Vanderpump Dog Foundation

followed up with an Instagram photo of a healthy and happy Bo lounging in the grass and a post that read:

> Bobo is one of our Yulin rescues. He is a fighter, survivor & ambassador for the Stop Yulin Forever cause. People are still uninformed and shocked to believe that many countries are slaughtering dogs for their meat, to eat for pleasure, and torturing them both intentionally, and as a product of their treatment along the way. Bobo could have been tortured, sold, cooked, eaten, and forgotten about months ago. Instead, he is lucky to be LOVING life with his two new parents in Los Angeles.

Bo's genealogy is further evidence that he's an original to the core in every way. He's a Jindo mix, which translates to a unique amalgamation of 50 percent Korean Jindo, 25 percent chow chow, 12.5 percent beagle, and 12.5 percent Tibetan spaniel.

"When people meet Bo, they're so impressed with how sweet and cute he is," Donna says. "Because of his sweet nature, so many people are drawn to him. That gives me a chance to tell his story and create more awareness about the evils that are taking place. As he and the other Vanderpump Dogs have brought awareness to me, I can pay it forward and help their cause. I always inform people of where Bo came from and what horrible things are going on in the world. I let them know about the Yulin tragedy, and every little bit helps. Many people have no idea, nor did I. I had my first crash course on Yulin when Lisa Vanderpump took her friends to China during a season of *The Real Housewives of Beverly Hills* so they could see for themselves what she was doing over there to help these beautiful dogs. By using her platform on the show like that, she opened a lot of eyes to this atrocity."

Now with his own powerful platform of being a Yulin survivor to stand on, Bo helps Donna share an empowering message on behalf of all dogs who are suffering. In this way, he's serving as a furry, four-legged activist, educating and inspiring people everywhere he goes.

"Thanks to Bo," Donna says, "I always tell people who are looking to get a pet to *adopt, adopt, adopt*. With Bo at my side, I actually diverted a friend from buying a dog from a breeder, and instead she adopted one from a local shelter. She adopted a six-year-old husky who was on the doggy shelter's version of death row because nobody had adopted him.

The shelter told my friend that he had been there for a long time and his number was going to be up very soon, meaning they were a kill shelter. Like Bo, he would have faced certain death if no one intervened. With Bo's and my help, my friend adopted him, and her family has fallen in love with him. Because of Bo, another life was saved!"

For Donna, Bo has become a sage of sorts, teaching her lessons and guiding her along the pathway of being a champion for dogs. This is further proof that from even the most hellish pits of darkness and horror, hope always floats and inspiration can pave the way to great works of compassion.

"Bo has opened my eyes to the unfortunate circumstances that so many poor animals have endured," Donna says. "This has made me more aware of movements to stop cruelty to animals all over the world. He's shown me and so many others that even when treated horribly, animals can still be forgiving and accepting of human kindness. He's made me want to be more involved in rescuing and saving animals. Because of the motivation I get from Bo, I've been able to have one dog removed from a neglectful situation and placed in a new loving home. I've helped a friend adopt from a shelter rather than purchasing from a breeder. I've since rescued four dogs who were running in the streets and returned them to their owners, who luckily had been looking for them. I'm also helping a lady three days a week to treat her fur baby who has kidney disease. She's afraid of needles and just can't bring herself to do the treatments her cat needs to live. This precious animal can live several years with the proper treatment. Without, she'll die in a very short period of time.

"Bo's story has compelled me to pay it forward in so many ways and to help save other dogs in need because I *can!* The lesson of love and giving what you can is something that can never be overtaught. Every living soul needs love. Bo has taught me, and everyone else who meets him, that nugget of wisdom. He's also instilled in me how one should never give up on love, no matter what the circumstances are."

Despite the great awareness and other good works that Bo has sparked, his astonishing backstory still rips at Donna's heart. "It's very difficult to think about," she says. "I shed tears every time I see posts or documentaries on the Yulin tragedy. I have frequent moments of emotional meltdowns when I watch Bo sleeping so peacefully and just think of what this poor baby has been through and what the other dogs over there are still going through. It just makes me want to do everything and anything for this fur baby to give him the best life ever!"

The goal of giving Bo the best life possible is fulfilled every day, and in return he is doing the same for Donna and her husband. He means the world to them. *Happiness, companionship, hope, dedication,* and *unconditional love* are just a few words that come to mind as Donna gushes over him.

"We've seen Bo transform from a timid pup to a pup who trusts, loves, and depends on us," she says. "He's developed confidence and even guards the house. He gives us such joy. We can't wait to get back to see him when we're away, even for a few hours. We're so blessed to have Bo. He has helped mend our wounded hearts from the passing of our first canine fur baby. He gives us purpose to live the best lives we can, and we give him the best we can offer. We'll never forget our Harley, but she would want us to do what we're doing to save another life. She was also a rescue.

"For us and everyone he meets, Bo has proven that there is always hope in this world. This poor pup, like many others, made it through unthinkable treatment and conditions. His first five months in this world were a living *hell*. But he survived, he was rescued, he was loved!

"Now, from the dedication and compassion of the activists who saved him, he has found his forever home that smothers him in love, affection, and gives him the best of everything. And he's found a new purpose—helping to raise awareness and motivating others to help animals or simply to be more humane in every way. Bo is a hero for not only surviving what he endured but in spite of all that to still be as sweet and happy and healthy as he is. He's still trusting of human kindness after being treated in the most unthinkable circumstances."

It's never too early to think of one's legacy, even when one is only a few years old. Bo's legacy of survival, as well as his encouraging others to embrace their better selves and to help his fellow canines, is merely the pebble tossed into the water. The ripples of his story are many and ongoing.

"Bo gives us hope for humanity," Donna says with a smile. "He's taught us how for every act of evil being committed out there in the world, there are wonderful souls working every day to conquer it and preserve humanity."

28 LYDIA

Lynnfield, Massachusetts

For the thousands of volunteers who are part of the nationwide Lutheran Church Charities (LCC) K-9 Comfort Dogs family, including those who work with the golden retriever named Lydia at her Messiah Lutheran parish in the town of Lynnfield, Massachusetts, each chose to serve in this grassroots ministry for different reasons.

"We had lost our own family dog about five years before," says Kat Bunker, one of Lydia's handlers from North Reading, Massachusetts. "And due to my chronic pain, I can't exercise dogs the way they need to be, so I thought being a handler would allow me to enjoy some part-time doggy time. I'm a fairly organized person and love photography, so I thought that being Lydia's scheduler and social media person would be a contribution I could make. I'm also involved in fund-raising so that we have the means to travel on deployments after tragedies. When pain has kept you bedbound, staring at the ceiling, knowing you can use a phone and an iPad propped against a pillow to arrange visits that healthier people can then carry out with Lydia makes me feel like I'm still a part of the world."

"For me," says Karen Kline, one of Lydia's other handlers and a stay-at-home mom from Peabody, Massachusetts, "it means I'm doing God's work because I'm helping others. There are so many people who need God's love and who need comfort, and these dogs show them *that* love with no judgment or expectations."

Crystal Brown, another of Lydia's handlers and a scientist from Watertown, Massachusetts, explains how working with Lydia fulfills a lifelong goal she had. "Growing up," she says, "I knew I was meant to be a part of something bigger and to somehow minister to those in need. I always loved animals and knew they had a special way to help people heal

and feel loved. I feel that the work of the LCC K-9 Comfort Dogs is a ministry designed for someone like me. I feel that I was meant to be a handler."

These amazing women and the rest of their North Boston Comfort Dog team are indeed getting to fulfill the purposes and intentions that propelled them into this service in the beginning.

"Lydia is a wonderful bridge to connecting with others," Kat says with a smile. "When we visit children—whether a visit to Girl Scouts, Boy Scouts, classrooms, or libraries so the kids can read to Lydia—all these are opportunities for us to do a little dog-safety education. We made up a coloring card depicting how to behave if approached by an angry dog. We talk about the fact that not every dog is trained to be as mellow as the LCC K-9 Comfort Dogs are. We teach the kids how to read the body language of a dog, hoping to avoid situations where a child's exuberance might end in a snap."

While the LCC K-9 Comfort Dogs are often invited to the sites of many of the headline-grabbing national tragedies and natural disasters where local and national media navigate toward them, it's in these unseen, more private moments where their good works are most frequently accomplished.

"One day at a nursing home," Kat remembers, "an elderly gentleman was sitting there just sobbing his heart out. Lydia immediately went to him and nudged her head underneath his hand. It was wonderful to watch the old man's awareness shift from the pain, loneliness, and frustration of aging to this beautiful dog with her liquid, loving eyes. His tears soon dried up, his smile emerged, and he began to laugh! He also kissed Lydia repeatedly on the head. Just for those few moments, Lydia made a world of pain go away and replaced it with warmth and connection.

"Lydia has great empathy; she can seek out those who need her presence. There was an eighty-nine-year-old woman in a nursing home who had never touched a dog in her life. She would leave the room when we arrived. Lydia slowly won her over, and now the woman welcomes Lydia with open arms, full of love and lots of petting. And one of Lydia's favorite people is a one-hundred-four-year-old woman who insists Lydia get up onto her bed and snuggle right next to her.

"She has the same effect on kids. One time during a visit to a class of autistic children, teachers were astounded when a boy who was their most difficult, violent, and hard-to-reach student quietly lay next to Lydia during the whole class."

At the end of the day, Lydia—whose official name is Lydia 1 Thessalonians 1:2—also offers comfort and limitless inspiration to her closest companions. This includes her top dog and handlers who have to carry the awesome burden of the many things—good and sometimes very bad—they witness during their visits far and wide with her.

"Lydia looks deeply into your eyes with such incredible focus and such love," Kat says. "She helps me set my own troubles aside for a while. Even on days when I don't think I can manage doing a visit, being with Lydia helps to distract me from my own pain. Most days, that visit may be the only thing I can physically do, but it makes me feel better emotionally that I've done it. Going on visits with her helps distract me from my own *stuff*."

"Lydia has shown me that there are bigger things in life than all the simple dramas in the world," Crystal says. "If we all just agreed that we're all different and love each other for who we are, then we can become more caring and kind."

Karen agrees with her friend. "Lydia has shown me that there is so much compassion needed in this world," she says, "and we should all try to be more compassionate and caring to others."

"When our pastor asked me to head up this ministry," recalls top dog and handler Joyce Sauca from Wakefield, Massachusetts, "I thought of it as a way to force myself to reach out to others in a way that I could be comfortable. Lydia helps me feel comfortable sharing the mercy, compassion, presence, and proclamation of Jesus to others—something I was not previously comfortable doing. She bridges the gap for me. Because of Lydia and this ministry, I've gone to many places that I would never have dreamed I would go, and I never would have met so many people whom I now consider family. I know that I can go anywhere in this country and have instant friends and family, all because of her and this ministry. Lydia has taught me to focus on others and not on myself, which has resulted in a lot of personal growth for me."

Joyce pauses for a moment, then adds, "Just knowing Lydia is there for all of us is a comfort."

29 ZIELE

Vail, Colorado

So far, all of my search dogs have been named after ducks," Ann-Marie Boness says from her home in Vail, Colorado. "There was Teal, Mallard, Drake, and now Speziele, who I call Ziele for short. I also like how Ziele's name sounds like *zeal,* which he has a lot of!"

She explains how Ziele, a black Labrador retriever, comes from upstanding parents. "I knew a search and rescue canine handler who had a Lab that was not only talented in search techniques but also handsome, smart, and fast. He was bred with a similar, beautiful female. I got Ziele when he was a puppy from that couple's first litter."

Today, Ziele is specifically trained to find missing persons by trailing. "He's scent specific," Ann-Marie explains, "and he also does avalanche rescue."

Ann-Marie, who works in retail, is quick to point out Ziele's key traits that make him perfect for search and rescue missions. "He has drive and wants to please me," she says. "Ziele is able to think through scent puzzles presented when he's following a trail to find a subject. Also, he's strong, and even his fur is easy to manage when we go through brush."

At a solid fifty-five pounds, Ziele is especially persistent and durable. "He's able to withstand a fairly large range of temperatures while still maintaining his razor-sharp focus," Ann-Marie adds.

A longtime member of the Vail Mountain Rescue team, for Ann-Marie, search and rescue is first and foremost about community. "Ziele and the other dogs I've had are the way I serve my community," she explains. "With them, I'm able to help people who are lost or who need to get out of the back country."

Currently, she and Ziele are working on his trailing and avalanche certifications with Search and Rescue Dogs of the United States. While Ann-Marie loves the search and rescue

part of her work, she notes how Ziele is also a part of a healthy living regimen for her. "He's my exercise program," Ann-Marie says. "Keeping Ziele in shape helps keep me in shape for this rigorous work."

Together, Ann-Marie and Ziele have formed a special bond through hard work, as well as respect and trust. "I have in mind the way I want Ziele to work. I want him to cooperate with me but not be coerced for working and obedience," Ann-Marie explains. "I want to expose Ziele to real-life possibilities for missions so when we come across something for real, we're able to handle it together.

"I want mutual respect, and I want Ziele to trust me. This crucial trust comes into play when we're on a real mission and an unusual, and possibly dangerous, situation presents itself. I want Ziele to be confident we can get through whatever it is. It's almost impossible to expose dogs to everything they'll come across, but it's still worth exposing the dog to everything I can think of. If I don't have Ziele's trust, he might react with fear or aversion instead of carefully progressing through the mission. I like to have Ziele be focused and efficient while we're working, and I like him to be calm while we're not working."

So far, Ziele has had a few memorable missions, even though he's new to the search and rescue circuit. Ann-Marie recalls one of their first missions that happened by chance while she and Ziele were out in the field training.

"We were training, and Ziele was following a trail," Ann-Marie recalls. "Suddenly, a frantic mother came out of her house to ask for our help. Her four-year-old son was missing from the family's backyard."

At the time, Ann-Marie and Ziele were with three experienced dog handlers who were shadowing the duo to offer training advice. However, the only dog they had with them was Ziele. Like any superhero, when duty called, Ziele answered!

"I was encouraged to use Ziele as he was progressing well in his training," Ann-Marie says. "The neighborhood we were in was suburban—large houses with medium-sized yards in between. Most of the streets weren't busy. There was one main street with four lanes. It was a very warm day with heavy gusts of wind, and there were Halloween decorations on most houses, some even life-sized models, so we started at the last point where the young boy had been seen, which was his backyard. Without missing a beat, Ziele quickly led us four houses down to a neighbor's yard."

Ann-Marie smiles, thinking about the happy ending they found this time. "There in the

neighbor's backyard, the little boy was swinging, safe and sound without a worry in the world. Both he and Ziele were happy to see one another!"

While this was a simple and fast mission, Ann-Marie notes the depth of what is actually involved with something like this, emotionally and physically.

"There's so much that goes through your mind when a kid is missing," she explains, "but as the handler, you have to clear your mind and look at what the dog is doing without including any opinions or indications as to where the person went. Dogs feed off their owner's emotions. I don't want to have my emotions of worrying about what might have happened to the kid interfere with the work Ziele and I need to do. Worry isn't helpful when trying to find the missing person. My worry will adversely interfere with my working relationship as Ziele is trailing. I want Ziele to do what I train him to do: follow the scent of the missing person as efficiently as possible."

Scenarios like this one remind Ann-Marie why she became a handler in the first place and the important purpose she carries on her shoulders.

Ann-Marie also explains that not every successful mission translates into a happy ending. Sometimes tragedy is an inevitable part of the job she and Ziele do. "Early on in his career, another mission Ziele went on involved establishing the direction of travel for a wellness check on a local resident. The subject's mother called the police and told them that she was worried about her adult son's well-being. Police went to his house but didn't find any leads about where the guy had gone. This was a rural setting. His house was very tiny; there was a loft where he slept, and the rest of the house was about two hundred square feet. There was a horse paddock behind the house and a larger house in the front—what I suspect was the property owner's house. This was on a moderately busy road.

"I started Ziele with a scent article for the missing person, and he led me about a half mile away from the house. The trail to the subject was through the horse paddock, across the road, and through a dry marsh. Three sides of the marsh had recreational trails for hiking or biking. On the way, we crossed over lots of things that could distract a dog while trailing—food garbage, small and large animals, and animal poop. True to his training, Ziele showed no interest in any of that."

Ziele's signal to Ann-Marie that he has found something, what's called *final indication,* is running back to her to bark, and then he takes Ann-Marie to the subject's location.

Eventually, Ziele led Ann-Marie to a body. "Law enforcement confirmed the person

Ziele brought me to was the person they were looking for," Ann-Marie says. "This was the first whole dead body Ziele ever had contact with. Yet he still instinctually knew this was his subject." Sometimes, success for a search and rescue dog like Ziele means bringing a loved one home, even if deceased, to help bring closure and healing to the family.

Reflecting back on her work with Ziele and her other search and rescue dogs, Ann-Marie says, "The amazing thing about search dogs is we aren't really training them with search skills per se. We're only reinforcing skills they already have and know how to use—namely, the ability to hunt better than we ever could."

At the end of the day, search and rescue work for Ann-Marie and Ziele is about keeping each other on top of their game. "I spend a lot of time either training Ziele or working on my own skills," Ann-Marie says. "It takes dedication to find a lost person as efficiently as possible. I want to make sure Ziele is always on the top of his game, and he does the same for me. After all, if either of us let our training slack, we then run the risk of missing the person we've set out to find."

Always an optimist, Ann-Marie has nothing but love and high hopes for Ziele and their future career together. "Even though Ziele has only really just started search and rescue missions," she says, "I expect amazing things from him!"

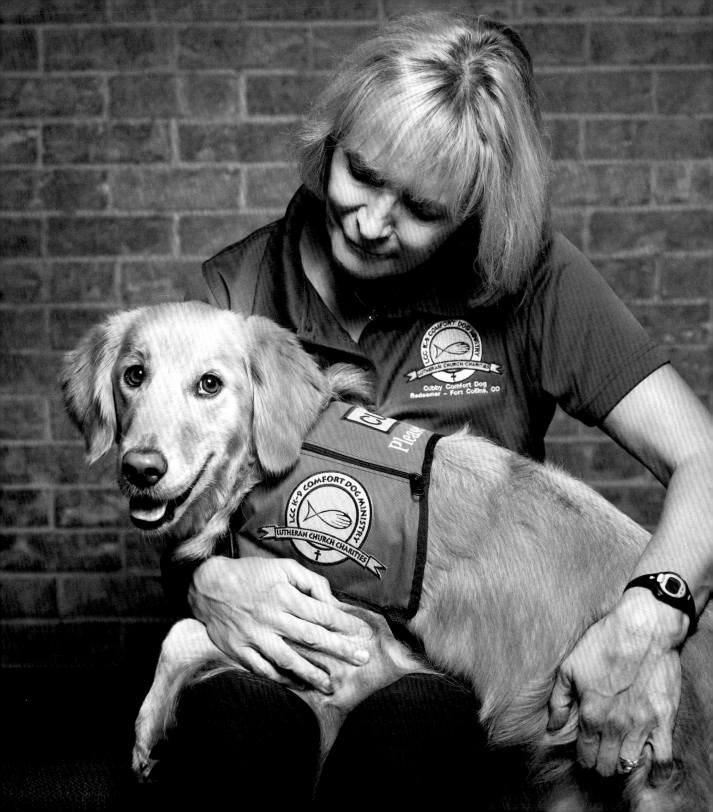

30 ⬥ CUBBY

Fort Collins, Colorado

Out of tragedy and challenge, points of light and inspiration often emerge. This was the case for Bonnie Fear, an independent fitness instructor from Loveland, Colorado, who found her calling to be a Lutheran Church Charities (LCC) K-9 Comfort Dog handler.

"Just by showing up," she says, "Cubby brings conversation and smiles to everyone we meet. It's not always about what they may be going through at that moment; it's a time to perhaps distract them and get them out of that moment of sadness or grief and bring a sense of calmness and peace. My mission as a handler is to bring people that smile, that sigh of relief if they're stressed or sad after petting Cubby; a hug, a prayer, or to say nothing and simply be there in that moment. It personally means that I'm doing what God created me to do, and that's to be there for others who are in need, helping them get past a bad day or a horrible crisis in their life. This work means being there with Cubby, who helps us open that door of knowing someone cares, of knowing someone is praying for them, or of knowing that someone is there with this fuzzy little friend who likes to be petted and loved."

Since being paired together at Redeemer Lutheran Church in Fort Collins, Colorado, LCC top dog Bonnie and Cubby, a fifty-five-pound golden retriever whose official name is Cubby Deuteronomy 31:8, have been deployed on a variety of missions. Their journeys together have ranged from Orlando following the Pulse nightclub shooting in 2016, to Baton Rouge the same year and Houston a year later after those regions were hit with catastrophic natural disasters, to Las Vegas in the wake of the mass shooting at the Route 91 Harvest festival in 2017, to Florida following the Marjory Stoneman Douglas High School massacre in 2018.

Named after a U.S. military dog who lost his life while serving our country, Cubby is

dual vested as both an LCC K-9 Comfort Dog when traveling with Bonnie and other handlers and as an LCC Kare 9 Military Ministry dog when serving with one of the team's two veteran handlers. Along the way, Bonnie has kept a detailed log of her journeys with Cubby—the places they've gone and the folks whose lives they've positively impacted.

"My first really memorable experience with Cubby was our deployment to Orlando after the Pulse nightclub shooting in June of 2016," Bonnie says. "We were the second group of dogs deployed nine days after the attack. I never flew with Cubby before, so I was a little nervous about the whole process of whether the airlines would allow Cubby to get on the plane with me, getting through security, what if she has to go to the bathroom, what if the person sitting next to me doesn't like dogs—you know, all those what-ifs. It was truly amazing how all these concerns vanished once we arrived at the airport and were greeted with open arms by the airline we were flying on. We also met up with LCC K-9 Comfort Dog Eddie and his handlers, Moe and Joan from Grand Island, Nebraska, at Denver International Airport. Just walking through the airport was an experience I'll never forget. People would stop us and ask where we were going. When we told them we were invited to Orlando to help bring hope and comfort to the people who were affected by the shooting, they smiled and had this warm, peaceful look on their faces."

Once in Orlando, there was no resting. "Cubby and I hit the ground running right after we landed," Bonnie recalls.

The pair was in Orlando from June 21 to June 27. While there, Bonnie noted in her log that they first received their schedule for the week from point person Reverend Billy Brath, pastor of Live UCF, Orlando, Florida, while meeting with Lutheran Services Counseling and then headed to a vigil honoring the victims and their families.

While their main mission was to comfort the victims and their families during the coming days, they invariably crossed paths with many other locals whose lives they would also indelibly touch. These folks included a homeless man outside the Orange County government building who revealed he had been baptized only two weeks prior and whose faith was visibly strong. They also visited with the city employees inside—these folks were collectively the "voice of the city"—whose task it was to help victims' families plan memorial services.

One especially heartwarming encounter was with the Pulse nightclub employees. "The owner of Pulse was there and appeared to still be very distraught from the attack," Bonnie

remembers. "Cubby and I sat with the employees outside at a picnic table as they went through bags of letters that were sent to them from all over the world. These employees were all very thankful for the dogs and the fact that we Christians came in and didn't judge them. It was awesome!"

Among the many lives they touched in Orlando, Bonnie and Cubby Comfort Dog also visited with firefighters, police officers, emergency dispatchers, and other first responders. It's often easy to forget the emotional toll these tragedies have on the heroic men and women who are first on the scene and remain actively engaged in these events for days, weeks, and even months afterward.

"At the 911 communications center set up after the shooting, we had a great visit," Bonnie remembers. "Three police officers and two CSI gals made a special trip there at 11:00 p.m. to see the dogs. They were very thankful. Some of the dispatchers at this center had taken calls the night of the shooting from people who were calling them because they were lying on or near dead bodies so the shooter would think they were dead too. We talked to one young woman who was in her first week of training as a dispatcher when this tragedy happened. We also talked to the head of dispatch for the fire department, and he was still trying to sort things out. They'll never forget the chaos and the frantic calls from that horrific night. Cubby put her paw up on the knee of one male dispatcher as he squatted down to pet her. He just loved that and melted into Cubby."

The LCC K-9 Comfort Dogs and their handlers never know where their divinely guided work may take them to next. "We never know where God will be leading us when we go out into the community or on a crisis or disaster deployment out of state," Bonnie says. "So Cubby needs to know I've got her back, and I need and want to know everything about how she reacts to certain situations—when she's stressed, when she needs a break, and if she just doesn't have her game face on at that moment."

A core foundation of this dynamic between dog and handler is good old-fashioned trust. During one unforgettable trip, the unexpected stops along the way included greeting individuals in some of the most famous casinos in the world. Normally places of fun and revelry, following the October 1, 2017, shooting at the Route 91 Harvest festival near Mandalay Bay on the iconic Las Vegas Strip, a heavy darkness enveloped the city. This quickly became a mission for a unique brand of comforting—the furry, four-legged variety. Among the Comfort Dogs and handlers invited to Nevada were Bonnie and Cubby, who were in

Las Vegas from October 3 to October 9.

"For one stop," Bonnie recalls, "we walked through the Cosmopolitan and spent a lot of time with random guests in the lobby. And then we stood outside on Las Vegas Boulevard, where we greeted people by a bus stop. At the Bellagio, we met with the staff in guest relations and random people as we walked through the hotel. They all loved Cubby and the other dogs and thanked us for being there."

Cubby's visit to the Clark County Office of the Coroner/Medical Examiner was especially touching for Bonnie. "While there, we visited with staff members who were tasked with processing all fifty-eight victims' bodies, as well as the shooter's body," she says. "The coroner gave Cubby and the other dogs each a special pin in recognition of their bringing comfort and hope to the coroner's office employees."

The Comfort Dogs were later on hand for the dedication of fifty-eight trees at the Las Vegas Community Healing Garden. Each tree had a white balloon tied to it. After the ceremony, the dogs visited with the people gathered there.

On their last full day in Las Vegas, Bonnie and Cubby found themselves at Mandalay Bay, the site from which the shooting had originated on the thirty-second floor. "We got to visit the front desk and concierge desk staff," Bonnie says. "These were the two areas most active the night of the shooting. Calls were coming in from all over the United States from people asking for information about loved ones who were staying at the resort. It was very chaotic and stressful. These workers loved that the dogs were there."

As mentioned earlier, Bonnie has kept a detailed log with dates, times, locations, and reflections for each of her and Cubby's visits during the past several years. But it's her diary of their deployment from February 26 to March 3, 2018, following the Marjory Stoneman Douglas High School shooting that serves as one of the most significant and riveting documents in her growing archive of good works. Within her diary, Bonnie chronicled that tragedy through the eyes of a humble Comfort Dog and handler in real time.

"We were the second wave of dogs to be deployed to Marjory Stoneman Douglas High School to welcome students and staff back to school two weeks after the shooting," Bonnie wrote. "We arrived in Boca Raton on Monday, February 26, and got settled into our hotel. On Tuesday, February 27, we arrived early at the high school, managing our way through the media frenzy that was present due to staff returning to get ready for the first day of school in two weeks that was starting on Wednesday. We gathered in the open-air court-

yard and waited for staff to stop by and greet us as they collected donated supplies needed to set up their makeshift classrooms. The building where the shooting took place was still a crime scene and would no longer be used for classrooms. Imagine having to basically start over in another classroom or an area set up to resemble a classroom."

Wednesday, February 28, was the first day back to school for the students, and they were welcomed by many very special greeters. "We again arrived early to the school to get through the media frenzy and the heavy traffic into the school," Bonnie recalled in her diary. She continued:

Security was heavy, and all vehicles were stopped and asked a few questions. This was the day the alumni were going to line up along the main street entrance and welcome students back.

We received our assignments for the day. We were assigned to a teacher's room that had two students injured in the shooting. Before the first group of students arrived, we offered up a prayer with the teacher and another staff person from another school assisting the teacher that day. The teaching staff was not holding actual classes where curriculum was being taught.

Kids were allowed to have their cell phones and were free to participate in games and other activities that were provided by the counseling staff to help the students cope with the emotions they were dealing with. We spent most of the day following the teacher to her classrooms.

Each time a new set of students arrived, the teacher greeted them with a hug and a warm welcome, telling them she was glad they chose to come to school today.

There was one student who really gravitated toward Cubby. She just loved her, so Carol—Cubby's other handler that day—and I just sat and let her be and answered any questions she had or just listened to her.

Several students sat on the floor with Cubby and wanted to pet her. The classes were shortened to half days so all class periods were only about fifty minutes. As the last class of the day left the room, we prayed with the teacher before we left.

Bonnie's diary entry on Thursday, March 1, notes that the larger group of handlers and Comfort Dogs met in the school courtyard where they received their assignments for the day.

"Today we were free to roam," she wrote. She continued:

We were not assigned a room. Before the students arrived, we positioned ourselves where the buses were dropping off the students. Just to see the smiles and the "Oh, look, a puppy!" comments were very heartwarming and reassured us why we were there.

Administrators were positioned with clipboards in the open-air hallways to receive requests for a dog in a classroom. We went into several rooms, one of which was a science room. The teacher had a Wii system hooked up, and it was fun for the kids and was just fun to watch. A few kids would get up out of their seats and come over and sit on the floor with Cubby.

When the bell rang, we went out into the hallway and greeted students and staff as they walked by.

We then ended up in a classroom where there was an empty seat—a classroom that lost a classmate in the shooting. We were in the back of the room and positioned Cubby on a blanket and several of the students sat on the floor surrounding Cubby and taking pictures and talking and laughing with each other. We sat down with them and just made sure Cubby was okay and answered any questions they had.

As the morning went on, word of the Comfort Dogs along with about forty local therapy dogs was getting around. We were in high demand. It was a heartwarming thing to see—the hope and comfort these dogs could produce out of such a hurting community.

Nearing the end of their deployment, on Friday, March 2, the handlers and Comfort Dogs were once more asked to visit classrooms.

Bonnie noted in her diary:

One special request that day was from the bus driver who drove the shooter and his brother on her bus to and from school for several years. Two LCC K-9 Comfort Dog teams joined us by the bus stop, and one of the teams and their Comfort Dog were successful in finding that driver and spent a few moments with her.

That day we handed out 400 Cubby military-type dog tags along with Cubby's business cards to the students. Several kids revisited Cubby and asked if she could come to their classrooms. We started a list, and when the bell rang we were on our way.

When the door opened and they saw Cubby, they came running and wanting to pet and hug Cubby. I went into crowd control as Carol protected Cubby. I would ask the students to wait as we got Cubby settled on a blanket and then they could pet her and sit in a circle around her.

Cubby loved the attention, and as they pet her she would very gently extend her paw. They would go "Aw!" and get their phone and take a picture of Cubby's paw. Just to see this moment of love and sweetness was again a reminder of why we were there.

By any measure, the work of the Comfort Dogs and their handlers is heroic, but Bonnie has a different, more modest take on the ultimate purpose that she and Cubby are fulfilling in this life.

"Going into and while on a deployment into a crisis or disaster situation, I know that I can't allow my emotions to get in the way of the ministry we're there to do," Bonnie says. "I've been blessed to be able to do that through my strong faith in Jesus Christ. I know that he is already there, present in the situation we're going into, and that is why we go. We're just following Jesus, and knowing that he is always there gives me the strength to get through the many heartbreaking stories and situations we bring Cubby into to help ease the sadness and pain of people who are hurting. When I get home is when it really hits me. I enter back into my life at home, and I find myself thinking about all the people we met— the tears, the stories, the laughter, the sadness—and that we just returned from a national crisis or disaster and we were there to help. It really sinks in."

As for any notion of being heroes, Bonnie says, "I don't think of Cubby as a hero. I think of her as a gift from God that allows us as handlers to take her into the community and bring smiles, hope, love, and comfort to everyone she meets. The people we meet who survive these crises and disasters are the real heroes. I also think the people we meet know we're part of a Christian organization and that we're doing this because it's what we're called to do—to help others and walk with others through their happy times or sometimes their challenging times in life. What we do is not about Cubby, and it's not about me. It's about serving and loving others."

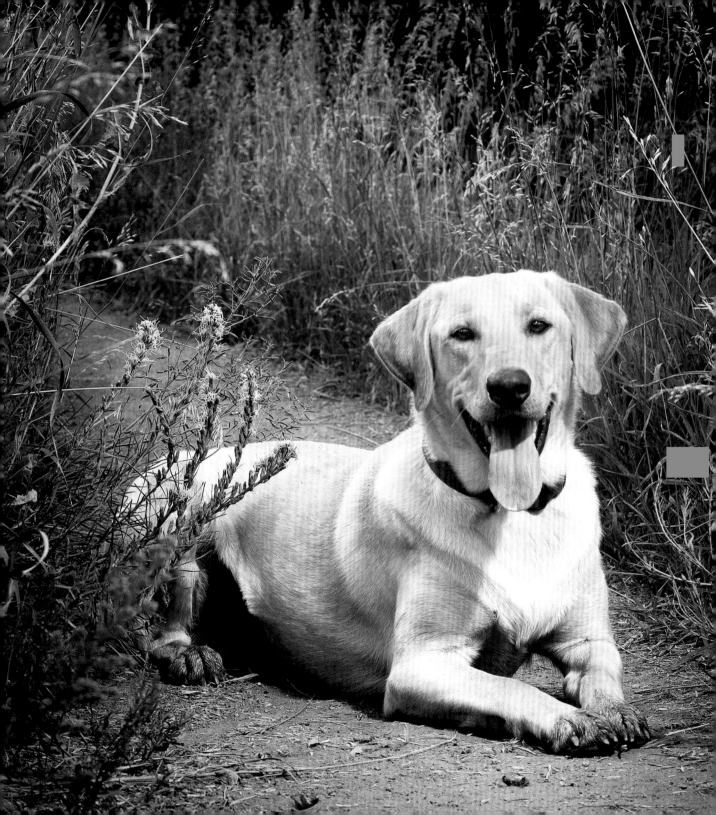

31 JASON AND SAM

Longmont, Colorado

S am picked me, of course," says sheriff's deputy Cathy Bryarly from Longmont, Colorado. "When I first visited the new puppies, I thought they all climbed all over me fairly equally. Then when I got home, I looked at the pictures I took with my phone, and here was this pup with the purple-ribbon collar in picture after picture. There he was, chewing on my pants, my shirt, my fingers."

Later, while driving to pick him up to bring him home when he was nine weeks old, Cathy decided to name her new dog something that had to do with sunshine. She eventually chose a name based on a character named Sam from the movie *Sunshine*; his full name is Jenner's Sunshine Sam. Jenner, a legendary search and rescue dog who had done work at the World Trade Center following the 9/11 terrorist attack, was his great-grandfather.

Sam is currently at the very beginning of his journey in search and rescue, but he already has big paws to fill for sure, both on the law enforcement trail and in Cathy's heart.

"This is a cool story," says Cathy, who became a volunteer handler in 1990. "Jason was my second bloodhound. In 2003, the K-9 sergeant came to me and asked if I would like to handle a bloodhound because of my experience in search and rescue. Our department had never had a bloodhound and never had a single-purpose K-9 before. I immediately said yes."

Cathy's own interest in working with dogs came at an early age. As a teenager and young adult, she loved training dogs and studying canine behavior. Her life's work and pathway soon became clear.

"I was working for a veterinarian, and one of the clients brought her search and rescue dog, a Labrador retriever, to our clinic," she remembers. "In 1987, they were specifically recruiting people to join their volunteer group because they were so busy, and I decided to

go to a training and see what it was all about. I got hooked on the idea of combining training dogs with helping people. For some reason, the idea of search was much more compelling to me than, for example, training assistance dogs. My ultimate career path has since taken me from veterinary technician to animal control to sheriff's deputy.

"Search and rescue continued to be my important hobby until it became part of my job as a K-9 bloodhound handler. When my hobby and passion melded with my paid job, I couldn't ask for anything better. It reminded me of how I once heard an employment counselor say that your job should not define who you are. Well, if you're a K-9 handler, you can throw that little piece of advice right out the window."

Cathy laughs at that piece of advice gone awry, in her life anyway, then adds, "Ann Wichmann got me involved in that first volunteer group, which was called Front Range Rescue Dogs. She later cofounded Search and Rescue Dogs of the United States, which was meant to be a national organization. I was one of its charter members. However, my dog at the time got old, and so I left canine search for a few years, riding horses and doing grid search. Then I got my first bloodhound, Sally. At that point, Jeff Hiebert, a park ranger, wanted to really expand Search and Rescue Dogs of the United States because he felt a lot of the search and rescue groups around here were completely focused on wilderness search and weren't paying attention to urban search, which was becoming a huge deal. Children were walking off, and old people were getting lost and dying of hypothermia in town, and so he and some other people, including Ann and me, thought there was a real need for dogs to be doing urban search.

"The board of directors of Search and Rescue Dogs of the United States developed standards using FEMA's National Incident Management System standards. Around 2005, Jeff and I started beta testing our dogs and other members' dogs. I felt like we really developed a good evaluation system that can be used anywhere in the country and is fair but not too easy. For example, there are four levels of certification in trailing, from a thirty-minute-old trail that is a half mile long to a twenty-four-hour-old trail that is one and a half miles long. There are also three different disciplines: wilderness, suburban, and urban. Each test has to be completed in two hours. Each dog team is required to pass two tests to be certified.

"The human remains detection, or HRD, test uses four areas: wilderness, urban, disaster, and a fourth area that can be similar to one of these or a combination area. Each area is approximately one hundred feet by one hundred feet. There is one unknown blank area

that the dog handler must identify and one to three sources of human remains in each of the other three areas. The sources are buried up to twelve inches, hidden on the surface—such as under objects—or placed up to four feet high.

"Distractions are also placed to check that the dogs don't alert on food, dead animals, or other items that may be in an actual search area. The dog team must find 80 percent of the sources. I would estimate that approximately half of the HRD tests that are taken are passed."

All of this intensive training aside, the story of this handler and her dogs has never been dull. In fact, especially her adventures with Jason have all the makings of a classic Hollywood hit—good guys and bad guys, folks in need of help, and a dashingly handsome furry hero to the rescue.

"Jason, who I got from the Kody Snodgrass Memorial Foundation in Florida when he was eleven weeks old, was part of what was called the Waltons Litter—as in *The Waltons* TV show—and he was originally named after the character of Ike, who was the storekeeper," Cathy explains. "But I was able to rename him as a puppy. When I realized they had used all of the other Walton children's names except Jason Walton, I changed his name to that."

With black-and-tan fur and at 145 pounds, Jason made a positive impression wherever he went. Certified in trailing and human remains detection and boasting a list of other trainings a mile long, he became a skillful searcher who turned out to be the tail-wagging star on many missions.

A part of Jason's knack for conveying a cinematic charm while working was the happily-ever-after endings he helped to ultimately bring about. "One of my favorite finds is what I call Jason's *Lassie* find," Cathy says with a smile. "A suicidal subject had contacted a relative, which led to the person's vehicle being found in the foothills. The person's phone was pinging about a mile away. The vehicle was locked, and I tried to start a track from the outside of the vehicle by having Jason sniff the crack of the door, which is something we frequently trained to do. But Jason wouldn't leave the vehicle, and, in fact, he started jumping on the vehicle repeatedly. That's when I realized how well a person could conceal themselves under a blanket in the hatch. I jiggled the car, and sure enough, I could see something move under the blanket. We eventually pulled the person out of the vehicle, and they were unconscious, but they did eventually recover. Jason surely saved that person's life that day!"

Jason's "most dramatic find," as Cathy refers to it, was a SWAT mission. "About 4:00 one morning, my pager went off," Cathy recalls, "and the SWAT team was specifically requesting Jason. A man had been living in an RV with his girlfriend on a residential street in Boulder. When someone called and complained, it was discovered that there was a restraining order and the man shouldn't be in contact with the woman. One thing led to another, and when the police tried to contact him, a shot was fired. The police were uncertain if the man fired the shot at them or not. When they entered the RV, they found a large amount of blood, and the man had escaped into the dark. The gun wasn't found, and a manhunt ensued.

"Our entire canine unit responded, and Deputy Kelly Boden and her K-9, a Dutch shepherd named Fergie, determined the direction of travel after it was thought the suspect went in the opposite direction. When Jason and I arrived at about 5:00 a.m., the SWAT team was trying to follow an intermittent trail of blood and using the patrol K-9s to search the backyards of a neighborhood that had six-foot privacy fences around each property. The SWAT commander felt this was going too slowly and, although he didn't want to sacrifice anyone's safety, he said we needed to find this guy *now* and that Jason needed to be put in front and he needed to be allowed to track.

"Using Jason's nose and the SWAT team's sharp eyes, we tracked the man through the neighborhood. This was made difficult by the fact that the man was climbing over the six-foot privacy fences, but using Jason to track was much quicker than using a patrol K-9 to search each yard. At one point, I told SWAT that I wasn't sure if we should enter this one yard or the yard next door, but Jason was sure. They found some blood on the gate, and when they opened the gate, Jason almost knocked the SWAT operators over in his excitement to drag me through the gate and into that yard. He ran over to a treehouse but then dragged me out the back gate, and we were on the track again. I heard some SWAT operators yelling; they said that the floor of the treehouse was covered with blood.

"We continued on, and it was just barely starting to get light. We went off on a couple of tangents, with Jason searching a wide area, then coming back to the track. He then discovered another large puddle of blood. By now, it was almost light, and I told the SWAT commander that if there were enough people, they needed to search this entire area carefully because Jason was acting like the suspect was close by. We were along a creek and had come up one side of the creek on a bike path, and now we were going down the other side of the creek between the creek and a subdivision.

"We got to a point where there was the bike path going in two directions, which led to a subdivision, and then an intersection of streets that went in three directions. Jason was circling around and acting like the person was right there, but we couldn't find him, and we couldn't figure it out. Jason clearly didn't want to leave this area, and in the daylight we could see there was no blood trail anywhere.

"Finally, someone said on the radio that there was some blood spatter on the bike path and that it was possible that Jason and I had missed it. I walked over to that area, and there were several SWAT team members surrounding the blood spatter. They parted and let Jason and me through. Jason took me over and sniffed the blood. He immediately turned around and dragged me up a steep embankment on the side of and above the bike path.

"Jason stopped where there was a bush and a fence. I thought he was trying to figure out how to get through the fence. Then I realized he was staring someone directly in the face. I remember thinking this had to be the guy, because he looked like he was wearing a Halloween mask—half of his face was completely covered with blood. He was sitting down, partially obscured by the bush.

"I yelled at him, 'Let me see your hands! Let me see your hands!' I did this because I knew it would both order him not to go for his gun and also alert the SWAT team that we had found him. The man put his hands up in front of his face as Jason continued to stare at him about two inches from his nose. Within a half second, I saw camouflaged figures running past me on both sides, and I pulled Jason out of the way in case there was a gun battle. In the end, the guy gave up peacefully and was transported to the hospital. Apparently, he had shot himself, but he lived."

Sadly, after an amazing tour of duty on the search and rescue circuit, Jason passed away from a twisted spleen four days before his sixth birthday. He was gone too soon and too young.

"The sheriff's office had a memorial service for him, and about 125 people came," Cathy says. "The sheriff gave me the flag that was flying at headquarters the day Jason died."

Jason will always claim a special part of Cathy's heart. Not only were they law enforcement partners, they were buddies to the core. "Jason was a person to me," Cathy reflects. "I built my whole life around him in the time that we were together, and in turn I think that his job and I were nearly his whole world. There's a special bond that's developed between a working dog and handler, and that is intensified when the dog and handler spend 24-7

together. Losing him early was one of the hardest, if not *the* hardest, things that has happened in my life. Jason truly made me who I was at the time. He will always be a part of me. We were best friends."

As for Jason's legacy as a hero, that's a multifaceted and well-earned title. "Jason wasn't just a hero because of what he did," Cathy explains, "but like most heroes, he was a hero because of who he was. He had a distinct personality, and the public loved him. We did many, many public presentations to Girl Scouts, Boy Scouts, school groups, humane society camps, and anyone who wanted a demo of Jason's talents or of search and rescue or of the sheriff's office's K-9 unit. Jason and I had 170 deployments, and I would estimate that one-third of those were public demos."

While Jason will never be forgotten by Cathy or the thousands of people with whom he crossed paths in his life, little Sam, a cuddly Lab with dark eyes and tan-and-white fur, represents the future. He's a reminder that life goes on, and so must the invaluable work that law enforcement and search and rescue dogs do every day—to find people and to keep them safe.

"Sam hasn't replaced Jason by any means—nobody could," Cathy says, "but he certainly is my little buddy, and the things we're doing are different enough, yet the same, to let me know that I've made the right choice of how to continue in search and rescue."

With an eye toward her future with Sam, Cathy says, "Sam and I will volunteer and do human remains detection. I see this mostly as forensic—looking for parts, bones, or evidence—but there's always a possibility that we may search larger areas for a body. Some people have told me they view this as 'sad' or 'gross' work, but to me, working like this with dogs such as Jason and Sam means bringing much-needed closure to families and helping to solve crimes and mysteries in a way that no one else alone can."

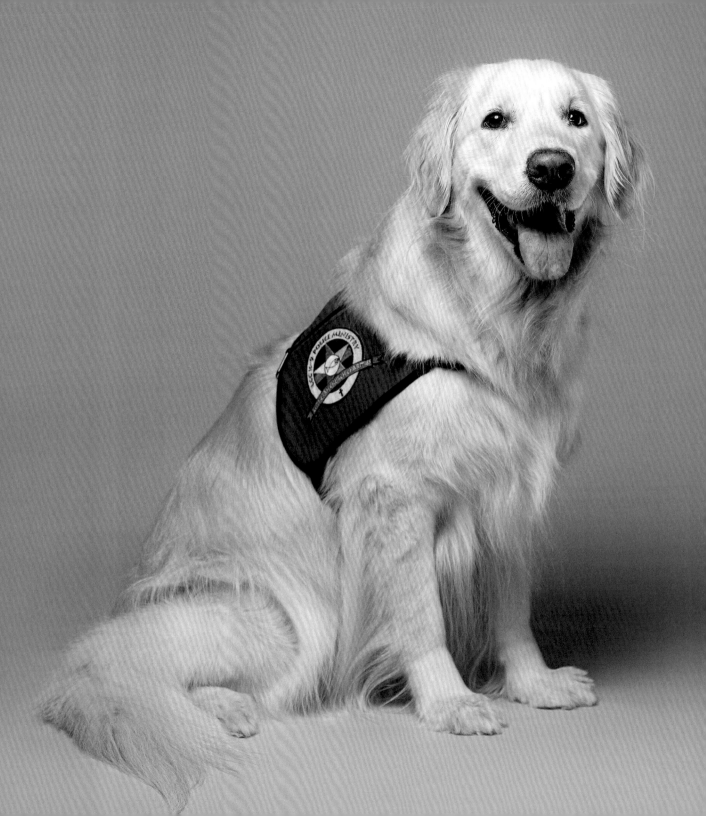

32 | SHILOH

Dixon, Illinois

Everyone who knows the Lutheran Church Charities (LCC) K-9 Police Ministry dog named Shiloh and her top dog handler, retired law enforcement officer Patrick Quinn, recognizes instantly that these two are soul mates who were meant to work together.

"Shiloh's primary ministry focus, from the beginning of our ministry, has been serving the law enforcement community," Patrick explains. "After realizing the need for a specific ministry and observing our work in this area, LCC president and CEO Tim Hetzner asked me to lead a new LCC K-9 ministry, which became known as the LCC K-9 Police Ministry. This was officially launched in July 2017 and has grown to include more than two dozen dogs, with handlers who are either active duty or retired law enforcement officers spread out across the country. This is a peer-support Christian ministry utilizing Comfort Dogs, and it continues to grow."

In 2013, Patrick attended his first LCC K-9 Ministries National Conference, along with his wife, Cherry, to determine if this ministry was something he wanted to pursue. There were many dogs there, but one puppy in particular captured his attention.

"This golden retriever puppy was eight weeks old," Patrick recalls with a smile, "and wearing a pink collar. She was obviously goal driven because she was wearing a little blue vest with a patch on the back that read, 'Future Comfort Dog.' She was the only dog I took pictures of that day.

"The next year at the LCC K-9 Ministries National Conference, several dogs were ready for placement, but our church—Christ Our Savior in Dixon, Illinois—wasn't on the list to receive one yet. But in December, our time came to begin working with a dog, and I was partnered with Shiloh, whose full name is Shiloh Exodus 33:19. Shiloh had been scheduled for placement with another church a few months earlier, but it was determined that she

needed some additional time in training. I was thrilled because I'd been following all of the dogs in training, and I was aware that she had been doing a lot of training with first responders, and this was the primary focus of what I wanted to do.

"After our pairing, I dug deeper into Shiloh's past and reviewed photos from her earliest days. I realized that she was the puppy who had originally captured my attention at the 2013 conference among all of the other dogs there! I have no doubt that the Lord intended for Shiloh to be partnered with me from the beginning, especially to serve law enforcement personnel and their family members. Shiloh went on to become the first official LCC K-9 Police Ministry dog, and I'm the first LCC K-9 Police Ministry coordinator."

Patrick and Shiloh have now served and honored the law enforcement community many times and in many beautiful ways over the years.

"In July 2016," Patrick recalls, "we deployed to Dallas after the ambush on police officers, which resulted in five killed and six injured. We visited the Dallas Police Department and Dallas Area Rapid Transportation Police to visit with as many members as possible. We prayed with many of them there, as well as in the dispatch center at city hall. We attended visitations and funerals for the officers and served their family members to offer comfort. This was the single worst loss of law enforcement since the 9/11 attack, and we were honored to be there to assist.

"A few times already, we've attended the summer C.O.P.S. Kids Camp for the surviving children of law enforcement officers killed in the line of duty from across the country. This camp is held each year in Wisconsin, and it's conducted by an organization called Concerns of Police Survivors. It's a privilege to be there to help the children of our fallen brothers and sisters. Helping to bring them some joy and comfort, while assisting counselors as they work with the kids, is a blessing.

"Also, for the first time in May 2017, we went to Washington, D.C. for National Police Week. While there, we visited the FBI Academy in Quantico, Virginia, to help bring joy to the surviving children of law enforcement officers killed in the line of duty. The kids spend a day there with law enforcement officers doing fun activities. Some of the kids recognized Shiloh from the C.O.P.S. Kids Camp—this day at Quantico was also organized by Concerns of Police Survivors—and it was fun that they remembered her. Shiloh also brought joy to many law enforcement officers at the FBI Academy, as they're all away from home for many months while in training there.

"We spent time at the National Law Enforcement Officers Memorial, where the names of more than twenty-one thousand fallen officers are etched in stone. We offered comfort to law enforcement officers and others gathered there. We even attended the premiere of a film about fallen officers titled *Fallen* and offered comfort to the many law enforcement officers in attendance. Some officers recognized Shiloh from deployments to Canton, Ohio, and Dallas—both times for line-of-duty deaths—and it was wonderful to see them there. We also spent time at the host hotel where a survivors conference was being held, and we offered comfort to many surviving family members of fallen officers, as well as to law enforcement officers from around the country."

While all the missions are emotionally charged, attending funerals is among the most heart-wrenching, even for seasoned pros like Patrick and Shiloh. "My many years in law enforcement have helped me learn to control my emotions while serving," Patrick says, "but these experiences do impact me. I turn to the Lord in prayer for strength and guidance, and I make time for rest so that I can be refreshed and ready to serve again when called upon."

One funeral in particular stands out in Patrick's mind, especially because of the family who was left behind to endure unbearable grief and to go on with lives that would never be fully whole again.

"In March 2017, we were deployed to Wisconsin for a police funeral," Patrick remembers. "A detective had been killed in a gun battle with a murder suspect he was attempting to arrest. We served there to comfort the surviving spouse and their two young girls during the visitation and funeral. The girls stayed by their mother's side to greet the endless line of people expressing their condolences, and they would only step away to pet Shiloh or one of the other LCC K-9 Police Ministry dogs when they needed some relief.

"Before the funeral, the girls were given stuffed Comfort Dogs to hold, since they wouldn't be able to come to us during the service. Understandably, the children cried during the service, but I noticed that they were hugging the stuffed dogs and looking at us— we were seated nearby in the front row of a special law enforcement section. Just the sight of Shiloh and the other dogs helped comfort the girls, and I was grateful for that blessing."

And it's not just the untimely and often-tragic passing of humans that requires Patrick to call upon his faith and his best friend with the cream-colored coat of fur and tender brown eyes to help him get through the experience.

"It's wonderful to live with a Comfort Dog because life includes stressful times for all of us," Patrick says, "and Shiloh is always there for me. It's a blessing to be able to stop and just spend a few minutes with her at any time. Shiloh is often a comfort to me while working too—like the time we attended the memorial service for a police K-9 who was killed in the line of duty while protecting his partner. Law enforcement officers from around the country, as well as many citizens, came to honor this canine member of the police department. It was a very touching service, and there wasn't a dry eye in the place. I was very grateful to have Shiloh by my side."

Patrick believes in his heart that he was divinely called to this special line of service to his community, especially the law enforcement community.

"I believe that I was called by the Holy Spirit to do this work," he explains. "After I retired from law enforcement, I began to feel the need to help my brothers and sisters who were still serving, and their families, in some way. My pastor at Christ Our Savior told me about the LCC K-9 Comfort Dog Ministry, and I began to think about joining the ministry in order to serve first responders, especially law enforcement.

"The law enforcement community is a unique subculture in our country, and they experience many challenges and difficulties that impact them personally. I believe that peer support is important to their spiritual and emotional well-being, and my years of experience can be useful in serving them through this ministry.

"All of us now serving in the LCC K-9 Police Ministry feel a deep sense of honor to be helping those who protect and serve us all, as well as their families. Those we serve often express their heartfelt appreciation to us for being there for them in their time of need. Officers from all around the country have contacted LCC after learning about this ministry. They fully support the concept and want to help. Even private citizens are helping to raise funds in order to support this ministry."

This calling to specifically serve law enforcement and other first responders was on full display following the February 14, 2018, mass shooting at Marjory Stoneman Douglas High School in Parkland, Florida.

"We initially served the community at a park where various memorials had been established for people to gather and mourn," Patrick recalls. "We met many people to offer comfort and prayer. We also served outside the high school, where memorials had also been established, and prayed with some who were there, but the bulk of our work was done at

the Coral Springs Police Department. We also visited the Coral Springs Fire Department and city hall. The dispatchers at Coral Springs Police Department handled most of the phone calls during the incident, and the officers there were the first ones inside the school, so we were glad that the Lord had led us there.

"Shiloh and I, and the other Comfort Dogs and handlers on-site, were honored to serve the men and women who responded to this tragic event, and they asked us to return for several days to visit various shift changes, roll calls, and units in order to meet with as many of their personnel as possible. We offered comfort, thanked them all for their service, and let them know that they were in our prayers."

During the past several years of their partnership, Patrick has viewed Shiloh as much more than a furry, four-legged friend helping other law enforcement heroes and their families at home and across the country.

"Shiloh is a very special animal of God's creation," Patrick says. "She has the ability to help deliver his love to others better than I could ever hope to do without her. Watching Shiloh at work always reminds me of Isaiah 40:1—'Comfort, comfort my people, says your God.'"

And on a humorous note, Patrick's best friend does hold fast to some mysteries of her own. With a laugh, Patrick says, "Shiloh has been trained not to bark, and I've never heard her bark while awake, *but* she occasionally barks in her sleep! It's muffled because her mouth is closed, but I always wonder what she's dreaming about when she does that."

The work Patrick and Shiloh do on behalf of law enforcement continues to thrive and expand. Like that of their colleagues, their résumé together is a glowing testament to self-less service at its best.

"The two of us have been honored and humbled to serve the needs of law enforcement across the country in eleven states and the District of Columbia so far," Patrick says, "and we pray that the Lord will grant us many more years together in his service."

Ultimately, as the first coordinator of the LCC K-9 Police Ministry and as the first dog in the program, Patrick and Shiloh, respectively, are together making history and forging a legacy. All the while, they're spreading love, hope, and compassion everywhere they go. This is a role that these two Good Samaritans take very seriously and for which Patrick is well aware he is only the steward as he passes through this life.

"I'm extremely pleased to know that this work will continue, long after our tour of duty has ended," Patrick says.

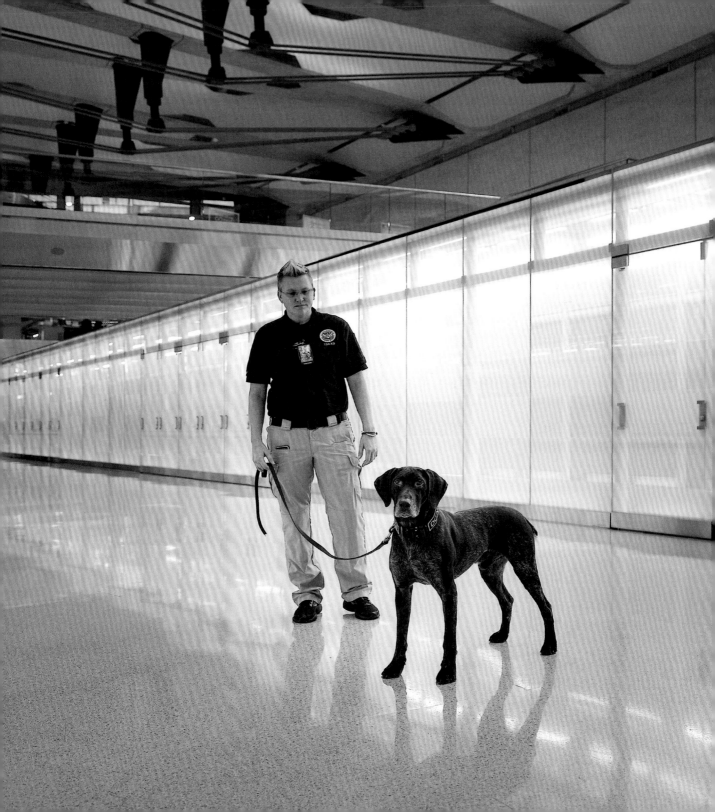

33 ◯ ■ OREL ■

Henrico, Virginia

Both the German shorthaired pointer named Orel—which means *eagle* in Russian—and his handler, Shauna L. Wilson, are among the best of the best that the U.S. Air Force has produced. But it took a while for them to be paired up to work for the Department of Homeland Security's Transportation Security Administration (TSA).

Orel is officially named K9 Orel T713; the T713 refers to the tattoo on his ear that the procurement team at Lackland Air Force Base in San Antonio, Texas, gave him.

"Orel is considered a passenger-screening canine," Shauna explains. "He is vapor-wake trained to respond to the scent of explosive odors that are stationary or being transported by a moving object—meaning a passenger. He screens the passengers as they walk around the canine queue lane prior to going through the TSA screening checkpoint.

"After Orel was trained at the TSA National Canine Training Center located on the Lackland Air Force Base and graduated, he originally accompanied his first handler to Denver International Airport. At first, I was paired with another TSA dog, but that dog didn't work out, which sometimes happens. As luck would have it, around the same time, Orel was being sent back to Lackland Air Force Base from Denver to get a new handler. That's when we were brought together."

Shauna is a two-time graduate of the basic handler course at Lackland Air Force Base, first as a U.S. Air Force canine handler and currently as a TSA handler at Washington Dulles International Airport.

While serving as an active-duty member of the U.S. Air Force, Shauna was a security forces handler, or what she fondly calls her "dream job." She adds, "I'm very honored and proud of my accomplishments in the air force as a security forces member."

Serving alongside military working dogs was, in Shauna's mind, one way that she could have an even greater impact in keeping the world a safe place.

"I became a handler because I wanted to do more for my country and the war on terrorism," Shauna says. "Searching roadways and fields so that supplies can be brought in safely to the troops was a big responsibility. Knowing that you're making a direct impact on the safety and well-being of your fellow troops and the safety of the villagers because of the job you do is a great reward over the hazardous risks. Since retiring from the air force and joining TSA, my mission has changed slightly. I'm still looking for explosives with a highly trained canine, but now solely for the traveling Americans and visitors flying all around the world.

"Being a canine handler at the airport and screening passengers and cargo that are flying all over the world is a great honor. It's nice knowing that the passengers are making it safely to their destinations, but also that all those people who are going about their daily routines on the ground below as that plane passes overhead are safe too. That's in large part because of the job that we do as TSA canine handlers and screeners."

Shauna explains, "Orel is considered a large-breed dog, weighing in at seventy-four pounds. When standing on all four paws, his head height is thirty-five inches, and when he stands on his hind legs, he's five and a half feet tall."

He's a real handsome guy, too, with golden-brown eyes and a brown coat covered with darker brown spots and white speckles, and a blond rectangle on the right side of his neck.

"Orel has natural bird-hunting instincts," Shauna adds, "which make him a great explosive-detection canine."

Orel and his handler eagerly uphold the vision and mission of the TSA as "an agile security agency, embodied by a professional workforce, that engages its partners and the American people to outmatch a dynamic threat."

"He's like my twin, if I were to have one," Shauna says. "We're always together. We can read each other's moods and body language that no one else can relate to. I spend more time with Orel than I do with anyone else. He's my priority and my job, and the safety of the flying public depends on us."

Reflected in Shauna's own words is all the proof you need to know just how precious her bond with Orel and her work as a canine handler are. "Being medically retired suddenly from my dream job as a security forces handler," she says, "it was a lifesaver to get

hired with TSA and continue to live the dream. Orel is equivalent to my own birth child. He makes me proud every day by excelling at his training, and I'm proud simply watching him grow. I'm super honored to be his handler."

It's this kind of comfort and love between two friends that should also give the millions of fliers passing through Dulles a settling peace of mind.

"Orel and I work together to find and locate explosives to ensure that the traveling public get to their final destinations safely and that airport employees get to work in a safe work environment," Shauna explains. "Working with Orel like I do means I can sleep at night knowing that everyone and everything he walked by earlier during our work shift are safe from explosives."

In addition to peace of mind, with Shauna's help, Orel also offers passengers lighthearted moments to help kick off or wind down their travels, such as posing for selfies with kids when asked and giving them his trading card. "The kids always ask if they can ride him because he's so big," Shauna says with a laugh. This is a request Orel politely declines.

Even so, Shauna is always well aware of the risks associated with the job.

"You deal with the challenges and dangers one day at a time," she says. "As long as you're able to learn from mistakes and correct them, it truly hasn't been a bad day. Our job is unpredictable, stressful, and hard, although we make it look as fun and easy as simply walking a dog all day. Being an explosive-detection handler, I am at risk of fatality every day I put on my uniform and go to work. It's just the nature of the job Orel and I do, and I wouldn't have it any other way."

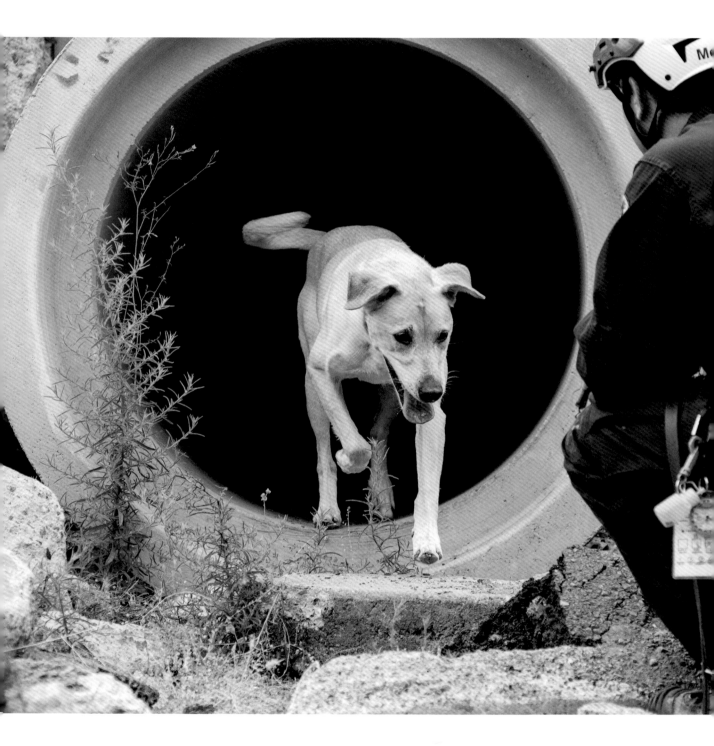

34 GUNNER

Livermore, California

When you're getting a canine from the National Disaster Search Dog Foundation, the normal process is you come to the training center and work with several different dogs to see what type of dog fits you best," explains Alex Mengell, a firefighter from Livermore, California. "My experience was no different; however, when the trainer asked what I wanted in a dog, I replied, 'One who won't quit or give up.' Her reply was, 'Be careful what you ask for!'

"I worked three different dogs that day. Two were very similar to my first dog—very mellow and not a ball of fire. The other one was Gunner! Gunner was impatient with me, anticipated my commands—always correctly—and was all-around obnoxious, in my opinion."

Alex laughs, thinking about that first introduction to his fifty-three-pound Labrador border collie–mix pal with yellow fur who had clearly earned his name.

"Difficult as he may have been with me that first time, Gunner was amazing at whatever I asked him to do," Alex continues. "I didn't find him particularly handsome, though; I thought he had a giraffe neck. After completing the first training session and while on my drive home, I began to replay in my head my interactions with Gunner and decided I wanted another shot with him.

"On my second trip to the training center, I requested to work him first. The trainer giggled and showed me a tally board in the kennel area with a me-versus-Gunner score sheet, and all the tally marks were on Gunner's side from the first training session. The tally marks were on a dry-erase board, and they were based on if I was able to keep up with Gunner while training. He would always correctly anticipate the command I was going to

give him, which is not the correct behavior. If he anticipated my command, then he got a tally. If I was able to give the command before he did it, then I would get a tally.

"I vowed to get tally marks on my side this time. However, it wasn't until the third session that I *finally* got a tally under my name! I never even noticed I wasn't working any other dog until after my third session with Gunner. It was clear he was the canine I was going to be paired with.

"After that third session, I began to actually really like this intense dog who I found obnoxious in the beginning. He and I were starting to work together, and it was amazing. Ever since that third training session, we've been a complementary team. He's now with me 98 percent of the time. He's become part of just about every aspect of my life, and I've relished the last seven years we've spent together."

Gunner is Alex's second working dog. His first was a search dog named Nelson, a yellow Labrador, who retired after an eight-year career with the National Disaster Search Dog Foundation, which is headquartered in Santa Paula, California.

"Originally, Gunner came from a family who donated him to the Dog Adoption & Welfare Group in Santa Barbara," Alex says, adding with a laugh, "and his name at that time was Grumps. The National Disaster Search Dog Foundation renamed him Gunner, which better fits his intense demeanor and the fact that he never gives up.

"The Dog Adoption & Welfare Group immediately realized Gunner's potential and contacted the National Disaster Search Dog Foundation, which later confirmed just how perfect Gunner would be for this line of work. The canine recruiter, Heidi Miller-Mercer, observed and noted that Gunner 'searched tirelessly and never gave up until he found the hidden toy.'"

Alex believes Gunner's mix of Labrador—which enables him to be naturally "forgiving regarding training mistakes on my part"—and border collie—which equips him with a certain innate intelligence—makes him a good match for the work they're doing. In addition, Alex adds that Gunner's "speed and accuracy" continually amaze him, even after fourteen years of doing this work.

This handler's own pathway into FEMA-certified search and rescue work demonstrates that he, too, has a natural talent and drive that fits the job of a hero in action.

"I was inspired to become a firefighter by my Cub Scout leader, who was a fire captain for San Leandro Fire, which then merged with Alameda County Fire Department," Alex

explains. "I had originally worked as a mechanic and with my dad in construction prior to going to the fire academy at Butte College. After the fire academy, I worked as an EMT on an ambulance during the off-season and for Cal-Fire during fire season for two years. Then, after going to paramedic school, I worked six months as a paramedic on an ambulance in Alameda County. In September of 2002, I was hired by South San Francisco Fire Department, and just under six years later, I moved to Alameda County Fire Department, where I am now."

Speaking of good matches, Alex originally was motivated to combine his work as a firefighter with being a handler for the National Disaster Search Dog Foundation because he thought the two go hand in hand, or *hand in paw,* as it were. His intentions also further reveal the generous and kind heart this husband to Stacey and father of two young boys, Logan and Tanner, has.

"I became a handler," Alex says, "because it fit what I was looking for to add to the fire service. It requires hundreds of hours per year on your own time, but it's incredibly rewarding. My mission is to be ready to find someone in any environment. Personally, I believe all firefighters should contribute something above and beyond their normal, everyday duties in volunteer work to better serve their communities. Being a handler is my way of donating my time so that it's beneficial for my community and the nation yet enjoyable for me."

And he's not kidding about the hundreds of hours of work and sheer dedication put into this kind of volunteer service. To say this process is intensive is an understatement, but then, the work they're doing through the SDF leaves zero room for mistakes, so training and certification are of the upmost importance.

Like with many of the great moments in this life, you never forget your first time; there's always a special place in your heart and mind for that initial step you take on a new journey, especially with a new friend. For Alex, his first deployment with Gunner will be one forever etched into his memory no matter where else the road ahead leads them.

"Our first deployment was for a building explosion," Alex recalls. "Gunner and I were deployed to the building to confirm that no live people were still inside. We arrived on scene to find a two-story sixplex with one unit on the top floor totally blown off and the first floor was full of debris from the second floor collapsing in on it. The piles of debris were five to eight feet high in places.

"I was briefed by the operations chief of Contra Costa County Fire Protection District

on what needed to be done. To compound the search, the fire department had used foam to extinguish the building fire prior to my arrival as well.

"Gunner and I began on the outside of the building. There was debris everywhere, and siding and screen doors on surrounding buildings were even ripped off. We then moved to all the less damaged apartments in the affected building. Finding no one, we moved to the collapsed first-floor unit and again found no one.

"We then went to the second-floor unit. This unit was heavily damaged with all the exterior walls and roof on 90 percent of the structure blown off from the massive explosion, leaving slick plywood on the ground surface for Gunner to search on. He had to be placed in a special tracking harness that goes around his chest and a twenty-five-foot-long leash to stop him from sliding off the slick plywood that was sloped to the outside, dropping straight down to the ground. Gunner again had no issues and found no one.

"I eventually came out of the building and reported to the operations chief that Gunner had no indication of live human scent. At that *very* moment, the operations chief motioned to a man in a large backhoe, who subsequently began demolishing the building. The seriousness of the situation hit me like a ton of bricks. I made the final call that no one was left in that building. I was responsible for making that call before they tore down that building. If I wasn't 100 percent confident in my dog, I would have been a mess! That first experience doing this type of work reinforced in my mind the need to be ready all of the time and to trust my dog."

Another time, this pair, part of what's designated as California Task Force 4, was called to an unusual scene in San Leandro. A vehicle had been driven into the building that housed a local business. Alameda County Fire crews originally responded to the call, and Gunner was then sent inside to confirm that other than the driver, who had sustained mild injuries, no one else had been inside the building when the accident occurred.

Thankfully, Alex notes that it is "fairly rare" to find victims, alive or deceased, and that a big part of this job is clearing the area to make sure no one is trapped. "As a firefighter," he explains, "I already have training in how to deal with difficult situations, so for any missions I go on as a handler, one of the important parts for me is to make sure the dog is engaged. It's a game to Gunner, not a job. If he's searching for any extended periods with no finds, we hide a rescuer for him to find just to keep his spirits high. In training or deployments, we never leave without having a successful 'find' for all the canines involved."

As hardworking and efficient as Gunner is, Alex is quick to point out that he isn't perfect. This revelation comes with a laugh. "Like I've said many times before, Gunner really is the perfect dog," Alex says, "but he would be the worst guard dog ever! His friendly disposition toward everyone wouldn't be an ideal trait for protection work."

Perfect or not, these two best buds are together for the long haul. "Training with a live-find canine takes up a lot of time," Alex explains. "Gunner is with me at home and at work. Having a working dog with you all the time changes your life for sure."

This firefighter easily drives home the point of just how much Gunner means to him. The admiration and respect is palpable in this friendship.

"Whether at home, training on basic obedience, obstacles, direction and control, or any type of search," Alex says, "Gunner is willing to please me and will do whatever I ask of him with enthusiasm. Gunner is the best canine partner I could have ever asked for."

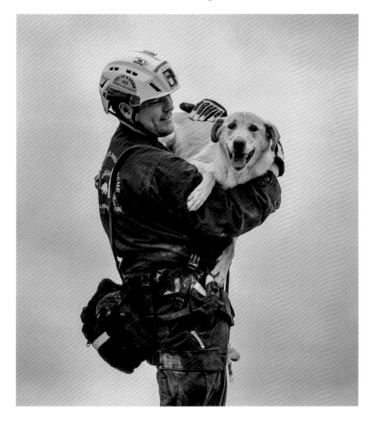

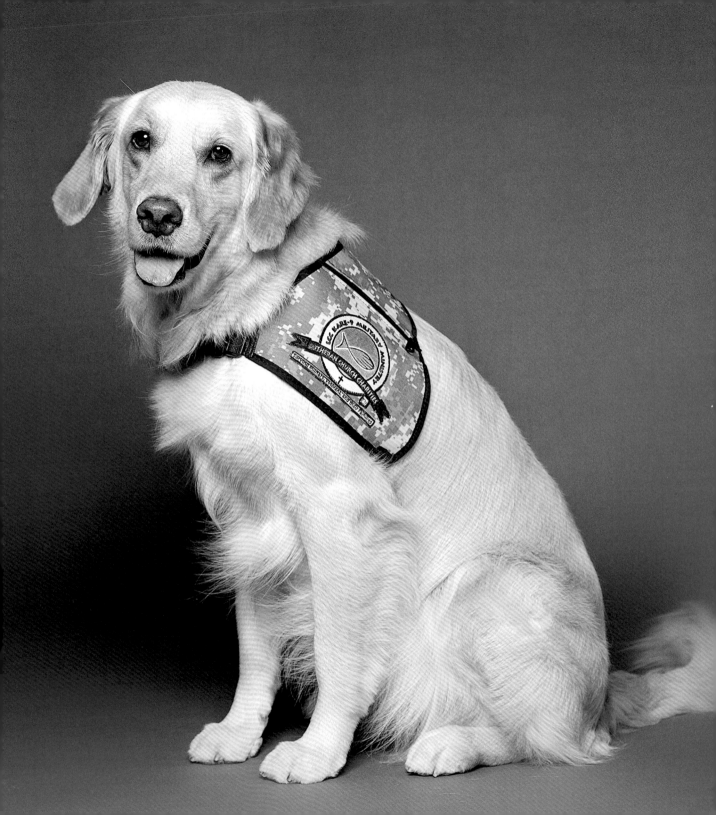

35 MAHLAH

Milford, Illinois

Mahlah has a unique ability to know who's in need of love and comfort," says Reverend Karl Gibbs, pastor of Our Savior Lutheran Church in Milford, Illinois. "Several times, I've experienced her leading me across the room to an individual who was sitting or standing by themselves, but yet she felt a need to be with them. After just a few moments with them, the individuals always begin to open up about how Mahlah's love is 'just what I needed.'"

Lutheran Church Charities (LCC) K-9 Comfort Dog Mahlah, whose official name is Mahlah 2 Corinthians 4:17, is a blessed force of nature indeed.

With more than two thousand training hours behind her, Mahlah is triple vested as an LCC K-9 Comfort Dog, LCC Kare 9 Military Ministry dog, and LCC K-9 Police Ministry dog.

"Mahlah is trained to interact with people of all ages and circumstances who are suffering and in need, whether in schools, hospitals, nursing homes, or disaster zones," Karl says. "She and her team go wherever they're invited!"

While Karl oversees a team of handlers and caregivers who work with Mahlah through his church—a small rural parish with about 130 members—he has also embarked on some extraordinary deployments with her. "Without a doubt, the best part of my job as pastor," Karl says, "is when I can join her on a mission. To see those who are broken by whatever experience or tragedy has happened in their life come to Mahlah with tears but leave with smiles is a joy unmatched by just about anything else in my job."

For him, the most impactful experience so far was their trip together to Las Vegas in 2017. "The most memorable deployment that I've been on with Mahlah was our trip to Las Vegas following the October 1 mass shooting at the Route 91 Harvest festival," Karl says.

"That shooting happened late on a Sunday night, and already by 7:30 a.m. on Monday morning, the invitation for the LCC K-9 Comfort Dogs had been issued, and we were making plans to go. A few hours later, we were on our way. Even now, I still find it extremely difficult to put into words what we experienced that week in Las Vegas. There were so many stories and encounters.

"One story sticks out in my mind from our time in the hospital, and it reaffirms just how effective Mahlah is at building a bridge for compassionate ministry to take place. It was when Mahlah and I and another handler named Dennis were simply walking through the hospital lobby at the end of the day. We were on our way out the door when someone spotted Mahlah. The woman offered the usual 'Oh, look! What a beautiful dog!' comment. She and her friend came over to Mahlah, immediately knelt down to her level, and asked if they could pet her. No sooner had I said yes than Mahlah, on her own and without command, laid down at this woman's feet. At this point, no words were spoken. Here in the middle of the hospital lobby, this woman sat silently, gently stroking Mahlah's head, which was now on her lap.

"Suddenly, as she was petting Mahlah, she began to cry. And not just small tears; we're talking sobs. But still, Dennis and I didn't interject or interrupt. I knew that something was going on and that if I were to interrupt the process with words at this point, she might not be able to get out what she needed to. The sobs continued for a short time, but then the woman began to share. She shared about how she and her daughter were in town to celebrate her daughter's twenty-first birthday. They were not even at the music festival that night, nor were they at the Mandalay Bay. They were walking through a casino lobby a few blocks away from the site of the shooting when it happened.

"However, in the mass confusion that ensued in the wake of the shooting, someone who fled the site of the shooting ran into that particular casino, shouting that there was a shooter coming for them. At that, mass chaos broke out in that lobby, and in the midst of a crowd of people running for safety, this woman's daughter was pushed against and over a buffet table and had suffered serious neck and back injuries.

"After sharing her story, this mother let out a sigh, commented that she felt better, and even cracked a smile. We gave her a hug and were then blessed with the opportunity to answer her questions about who we were and what we were doing there. She then asked us for prayer. So right there in the middle of the hospital lobby, we joined hands with a total

stranger and took her concerns and worries before the Prince of Peace. As a result, this woman left our conversation with a peace in her heart that she didn't have before.

"Again, this experience reaffirmed for me the effectiveness of this ministry. If I had been walking through that lobby by myself, as a total stranger, this woman likely wouldn't have sought me out, nor me her. But in the midst of the chaos and craziness in her life that day, Mahlah provided the bridge to conversation and the sharing of Christ's love and prayer."

While Mahlah has traveled thousands of miles around the country to spread comfort and light to folks who are hurt and hurting in many ways, including at Marjory Stoneman Douglas High School and Pulse nightclub after those shootings, some of her most significant work has been accomplished much closer to home in Illinois.

"Mahlah is very active in our local area," Karl explains. "I remember visiting a local high school following the tragic death of one of the students in a car accident. It was amazing to see how Mahlah provided a safe place for these teens to come and to simply open up and to share their grief, their anger, and their sadness, as well as their cherished memories of their friend. It was at this school that I again was reaffirmed in the effectiveness of the LCC K-9 Comfort Dog Ministry. Many students had spent the day on the floor, circled around Mahlah, but there was one student, who, though in the room where we were, hung off to himself at the side of the room, away from others and from Mahlah.

"At one point in the morning, Mahlah simply got up from the group and walked over to where this young man was sitting. She sat and then placed her head on his lap. At first, he wasn't sure about this, but soon he began to pet her. I made a comment to him about how it seemed that Mahlah sensed that he was having a rough day, and then, in an instant, the gates opened. He began to sob and to share about all kinds of horrible things going on in his life at home and in his family. For more than thirty minutes, he continued uninterrupted in his sharing. At the end of the visit, he commented how much better he felt having been able to share the hurt and the pain that he had been carrying around for so long.

"I remember the school counselor standing there with her jaw nearly on the floor. Apparently, she knew of some of the issues at home and in this young man's life, but in numerous visits with him, she hadn't been able to learn many details. She was astounded how this comfort dog was the necessary tool that allowed him to be able to open up about what was going on in his life. The biggest part of healing is simply sharing. And Mahlah makes that possible."

For Karl personally, Mahlah has been a life-changing breath of fresh air. "Before Mahlah, ministry burnout was becoming a real thing for me," he admits. "As a pastor, especially in this postmodern culture, it's so easy to grow discouraged. I'm in a vocation that requires me to internalize a lot. Day in and day out, I'm inundated with crises and tragedies of many different forms, and I can't talk about most of it with anyone. Mahlah provides a safe place for me to simply share what's in my heart and to unload the stresses of the day. She only listens; she won't repeat what I say, and she'll never judge or correct me.

"She spends quite a bit of time in my office some days, and in a job that can be—and often is—extremely stressful, she seems to instinctually know when I need that comfort and love. Just when the time is right, she'll come over and put her head on my lap or lie at my feet, enabling me to begin to pet her. And, as the doctors have told us happens with other individuals who interact with a comfort dog, the same is true with me. As I pet her, my blood pressure decreases, my heart rate decreases, and the endorphins increase. My stress lessens, and my joy increases."

With a laugh, Reverend Karl adds, "What better friend could there be?"

36 RIOT AND SAKER

Red Feather Lakes, Colorado

A firefighter, paramedic, and FEMA team member from Red Feather Lakes, Colorado, Denise Alvord put a lot of time and effort into finding Riot and Saker, her sixty-pound bundles of furry joy, whom she has trained to be top-notch search and rescue dogs.

"I carefully searched for my own canines," Denise says. "I looked at dogs in shelters and at rescues, as well as dogs from breeders and vendors, even from individuals, until I found exactly what I was looking for each time."

With dark brindle fur and black eyes, Riot was sixteen months old when Denise got him from a friend of a trainer. "His handler was raising him to be a patrol dog," she explains. "The trainer I knew felt that Riot, true to his name, was 'too much' dog for the typical first-time handler and that since they weren't hosting their own canine patrol academy at the time, the dog was mature enough to start formal training, so he talked the handler raising Riot into letting me test him for disaster search work."

Saker, who has fawn-colored fur with a black, pointy mask, was eleven months old when Denise acquired him in Connecticut.

Both dogs are Belgian Malinois, though Riot is also part Dutch shepherd. Denise believes their breed makes them an ideal choice for search and rescue work because of specific traits, such as "high drive, intensity, strong work ethic, and focus," she says. "Also, their size, structure, and natural agility, along with minimal hereditary health concerns, are a big bonus."

Denise is the first to admit that Riot, certified in cadaver and water recovery, is very special in many ways. But to fully appreciate the incredible search and rescue work he does, including the following story, it's all the more significant to learn that Riot is going blind. Always a trooper, though, this impending condition hasn't slowed him down a single bit.

"Riot's first water search was during an early spring," Denise recalls, "when several area lakes were still frozen. Our mission was focused on a small pond on private property where some personal belongings had been located next to the pond. But there were no witnesses to explain why the belongings were there or even how long they had been there. After contacting family, it was determined the individual had not been heard from in several days but also that this was not unusual for that individual.

"Riot and I were asked to search the pond to determine *if* there was somebody in the water. We loaded the boat into the water at an area away from where the belongings had been located, and I gave instructions to the boat driver on our initial search pattern.

"In the first pass, Riot began barking and indicating he was in odor, but I was having difficulty getting a good pattern with the new boat driver to try to narrow down the area to let Riot pinpoint the strongest odor. Partly thinking Riot might just be excited about the water work after a long, cold winter of not working in a boat, I instructed the driver to continue with our original pattern to clear the rest of the pond and we would work back through this area from another direction, with hopefully better wind by then.

"As soon as we left that area, Riot quieted down, indicating he was out of odor, but then he started crawling down to the bottom of the boat by my feet and at one point started biting the aluminum railing and then the carpeted platform at the bow of the boat. These were behaviors I had never seen from him in training.

"I felt confident the rest of the pond was clear and that the only area of odor was the first corner, but by the time we got back there, the battery for the electric motor was drained, so we went straight to shore instead of being able to rework the primary area of interest.

"I was then asked to work the shoreline while the dive team utilized their sonar to check the area where Riot had shown the most interest. While gearing up for the shoreline search, Riot became intent on the shoreline near where the dive team was working their grids with the sonar. Every time a wave washed ashore, Riot would walk deeper into the water, snorkeling several times where he would completely submerge his entire head under the water. I had seen him do that in training before as he got closer to the source.

"He ventured as deep into the water as he could, with the water brushing his chin as the wake came in from the dive boat. Not being inclined to swim, which was preferable to

me with other boats in the water and him not being able to see too well, he also wasn't inclined to be called out of the water either. This was clearly a first search of the season for the dive team as well, as they hadn't brought a battery for their sonar unit, and later I learned they didn't have anybody on scene who was really familiar with the sonar unit either. They were using the spare battery for the boat Riot was working out of and were taking a lot longer to scan the area Riot had indicated as having the strongest odor. But without another battery, I wasn't going to be able to work Riot out of the boat a second time to provide a more pinpointed location.

"And some of Riot's behavior in the boat was still puzzling to me . . . until we later did recover the body, and I realized we had driven over it in that first pass, just as Riot had in-

dicated. This also explained why, given the leak in the boat that had filled it with cadaver-smelling water, Riot was biting the boat in frustration when we drove the boat away from where the body was under the water."

At age two, Riot was first diagnosed with retinal degeneration. At the time, doctors didn't know if he would continue to lose his sight or if he would simply remain with the current reduced level of vision. Denise had originally gotten Riot with the intention of having him do disaster work, but that was soon out of the question, regardless of whether his sight remained as is or worsened.

"I tried to let Riot just be a ranch dog," Denise explains, "but less than two weeks into that idea, it was clear that he needed to work. I researched and asked a lot of my dog friends for advice and really couldn't find a suitable job for him given his vision limitations but also his individual hardheaded, stubborn personality. So I started training him on cadaver work simply because it was an easy way to give him something to do, and it would help me become a better trainer. Plus, I already had all the training aids and everything I needed since I had already trained and certified my first dog in cadaver searching.

"Then, during one of the recertifications of my first dog, while I was working Riot on the test problems after all of the other dogs had tested, the master trainer asked why I wasn't testing with Riot. This got me to thinking, so a couple of months later, I took his advice.

"Today, Riot is still easily the hardest-headed dog I've personally worked, but yet he's absolutely infallible when it comes to his nose. He truly seems to not think at all but simply reacts to cadaver odor, no matter what he's doing or where he is. He knows that cadaver odor equals ball, and he will do anything for his ball."

Riot's eye condition has brought him and Denise even closer together, solidifying their bond. "Since he's going blind, Riot has learned to trust me and look to me as a partner and not just a toy-delivery device," she says. "He'll stop and come back to trail me through difficult terrain or heavy vegetation when we're out hiking, understanding that I'll find a safe path for him. Once we're through the difficult area, he'll venture out again, exploring in his own direction, keeping tabs by sound and smell to keep himself within safe distance from me. He's also learned a small but specific vocabulary so I can warn him from a distance if he's going to run into something or if the ground is going to drop down away from him. He has a better emergency stop than any dog I know, but he always makes me smile

when he responds with a simple pause and then turns in my direction with an almost quizzical expression like he's saying, 'What? I'm just exploring!'"

Together, Denise and Riot are charting some new territory together on the search and rescue circuit. "Riot has probably been the biggest influence on my ability as a trainer to work with a different type of dog," she says, "and because of his progressing blindness, he's a different dog every six months. Also, because of his blindness, none of the trainers I've worked with—prior or since—have ever worked a dog like him, so I'm really forging my own way in developing our partnership. Riot has taught me more than I'll ever realize and continues to teach me how to be a better trainer and partner; how to hold up my end of the deal while letting him do his job; and how to be fair and just, but still clear and unwavering in my expectations."

Because of Riot's condition, Denise decided to add Saker to her team of canines and to the family. Originally imported from Slovakia, Saker shares his name with a type of falcon in Eastern Europe. It's also the name of a lesser-known sports car. "This is fitting since one of the trainers I worked with would refer to him as my 'Maserati,' saying at some point most handlers want to upgrade to a sports car model after their first search and rescue dog," Denise says with a laugh.

"Saker is atypically social for his breed; the Malinois is known for a strong bond with his or her handler and being more aloof toward strangers," she explains. "This is very true of my other two search and rescue dogs. However, Saker is far more outgoing and seems to seek and even enjoy meeting and engaging with strangers over people he already knows and sees regularly. He's naturally independent and confident, which is a big part of the reason why I originally selected him. I've purposely supported and further developed these traits within his search work foundation.

"As Saker's training has progressed, we've developed a closer bond and working relationship. He now sees that I have some value to the team when he's searching. Saker is truly a partner. Of course, there are times when we drive each other nuts—at least his expression tells me the feeling is mutual—but we also simultaneously experience pure joy working together."

Saker's unique combination of skills, personality traits, and a fierce dedication to Denise came in handy when the pair was deployed to the sites of two natural disasters.

"Our FEMA deployment on Hurricanes Harvey and Irma was memorable in part as my

first deployment as a member of Colorado Task Force 1 and because it exemplified why I selected Saker and how our training as well as his personality suited him so well for the job," Denise says. "While we were in Texas for ten days deployed on Hurricane Harvey, we were diverted and re-diverted to several different locations around Texas. "Our longest assignment involved being flown in to Beaumont, on a C-130 with our water rescue boats. While the search operations ended up being less necessary than anticipated in that area, our team set up and ran the airport for several days. The city water system was compromised, so the local evacuation shelters were shutting down, and we flew the evacuees out on military planes.

"Saker actually spent an entire day doing meet and greets and acting as an impromptu therapy dog for many of the evacuees waiting for their flights out. He probably got petted by or played with over 1,500 people during that first day. In fact, I think he was more exhausted from that work than when we were searching during Irma right afterward.

"A day after we got demobilized in Texas and started to drive home to Colorado, we got remobilized and deployed to Florida in the aftermath of Hurricane Irma. This resulted in a full twenty-one days deployed. During Irma, our primary assignment was in the Florida Keys. We started at Stock Island and worked our way back toward the mainland over the course of several days. Due to the heat, the dogs were kept in the vans with air conditioners on while we walked the neighborhoods, talking with residents who had sheltered in place through the storm. When we would come across a partially or completely destroyed structure or an area inaccessible for us to search, we would send the dogs in to search the selected areas. Fortunately, nobody was found trapped during our searches, but we really consider that more a success of the early warnings that a high percentage of residents evacuated, especially following so closely behind Harvey.

"During downtime, Saker would make the rounds, or often the other team members would divert to stop by where I was sitting with him. Saker was always up for a vigorous game of tug or just pets and a belly rub. One of our team members summed up Saker's outlook on life as every day he comes out of the crate with genuine enthusiasm that '*This* is the *best* day of my life!' Taking a full eighty-plus people with *Go do something!* personalities and putting them into the classic *Hurry-up-and-wait!* scenario takes a toll on everybody, so having Saker's enthusiasm every day definitely helped release some of the cumulative stress."

In addition to her career, Saker and Riot have also transformed Denise's personal life with their boundless optimism and energy. "Saker is a *needs-to-work* type of dog," Denise says, "and there are truly no boundaries in his mind of what his work consists of, but it's also genuine and pure joy when he's working. To see such pure enthusiasm for life while working hard, I can't help but be inspired and appreciate what I have in my life just a little more."

As for Riot, explaining why he's a hero is also a no-brainer for Denise. "Even in blindness, Riot lives his life his way," she says. "He has never stopped living and truly experiencing the world simply because he was going blind. He remains his own individual, persistent in his own way of doing things. We often joke that this is Riot's world and we're all just here living in it."

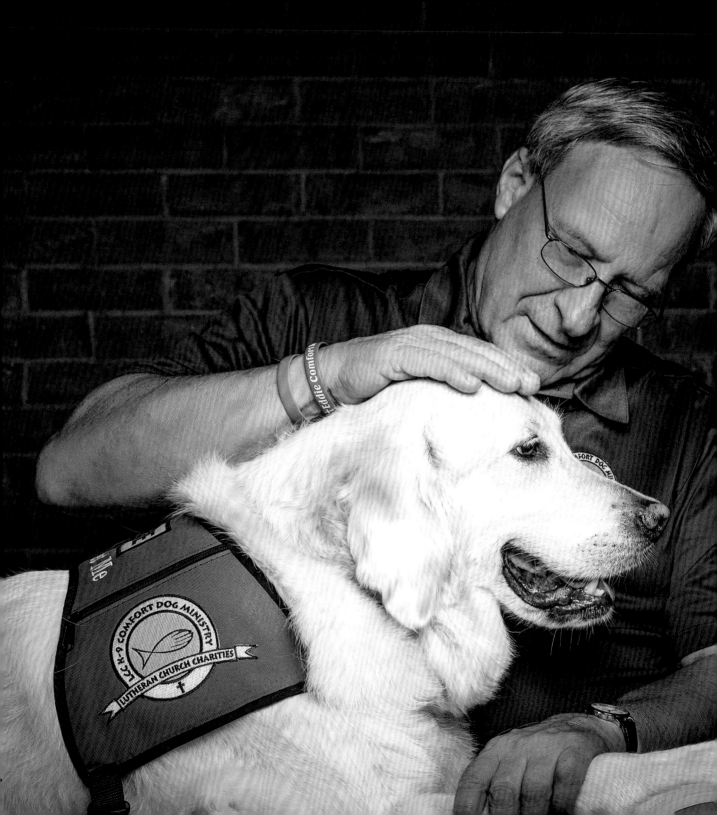

37 ■ EDDIE

Grand Island, Nebraska

Part of our ministry at Peace Lutheran Church in Grand Island, Nebraska, is a prison ministry," says Don "Moe" Moeller, a Lutheran Church Charities (LCC) top dog handler. "We visit inmates, both male and female, and Eddie gets touched, petted, and kissed a lot by many people who he's meeting for the first time, and it could be overwhelming to some dogs. In Eddie's case, he just looks at me and he knows that I'm proud of him and am there for him at all times. Eddie is always ready to do the things that he needs to without expecting rewards and treats for doing a job. He's been a bridge in so many ways for me personally when it comes to meeting, being with, and helping others."

Moe believes wholeheartedly that the prison ministry part of the work he does with Eddie—whose official name is Eddie Isaiah 65:1—has been a "real blessing." And Moe can count those blessings according to each and every extraordinary experience he and his pal have had behind bars. His recollections of these visits with the inmates are inspiring and riveting testimonials of good works service. The encounters only further confirm Eddie and his fellow LCC K-9 Comfort Dogs as much-needed heroes for the modern era in which we live.

In one of their prison experiences, the mental health counselor asked for Eddie and Moe to meet with a drug-addicted woman. "As we went into the counselor's office, the female inmate was sitting on the floor in the corner of the office," Moe recalls. "You could tell she was still high by her eyes and her actions. She appeared to be hitting bottom, and I think the counselor was concerned about suicidal thoughts too.

"When Eddie entered the office, the first place he went was over to the inmate, who began to cry vehemently and talk about how much she missed her dog. She then began to

share a lot of things in her life and how many times she tried to go clean, but she said the 'demon' controlled her totally. However, this inmate, who appeared to be distraught when Eddie came in, slowly changed her attitude as he lay by her with his head on her lap. Eddie was with her about an hour, and during this time, the inmate cried, hugged, and kissed him, and then began to talk more and open up.

"We met with this female inmate multiple more times over the next few months, and she eventually challenged herself to change her life. It's been three years since we first met her in prison, and she's been clean since then after twenty-plus years of drug use. She'll tell you it's been difficult but that she's not going to give up. Presently, she's working as an interviewer at a drug treatment center, and she's working hard toward her goal of being a drug counselor."

Since Eddie has been given access to all of the cell blocks at the prison, he and Moe encounter many backgrounds and reasons for incarceration. Several of the cell blocks contain undocumented immigrants. To help make these interactions as productive and impactful as possible, there's always someone in the group who's able to interpret for them.

"In one cell block, we met several times with a male immigrant," Moe remembers. "He was able to come over to America a number of years ago but had never done all of the needed paperwork or tried to become a citizen. He always had a decent job in a factory but had been incarcerated for an addiction-related problem.

"The first time he met Eddie, the inmate was on the floor petting and talking to him. The inmate said how much he liked animals and what a comfort it was to be able to touch and pet Eddie. Upon future visits to that cell block, the inmate was always one of the first to meet and greet Eddie. In that particular cell block, we met in groups of about five to ten people. Eddie many times sat at this particular inmate's feet as he would talk about his previous or upcoming court appearances and how his life was going. It was very evident that the inmate was worried about being deported. He no longer had any family that he knew of in the country where he was born and was frustrated just waiting to find out what the system's plan was for his life.

"On the last visit we had with the inmate, he was preparing himself to be deported. On that visit, he greeted Eddie like he always did, but you could tell that a lot was on his mind. During the group visit, Eddie spent time lying at the inmate's feet. The inmate asked me to

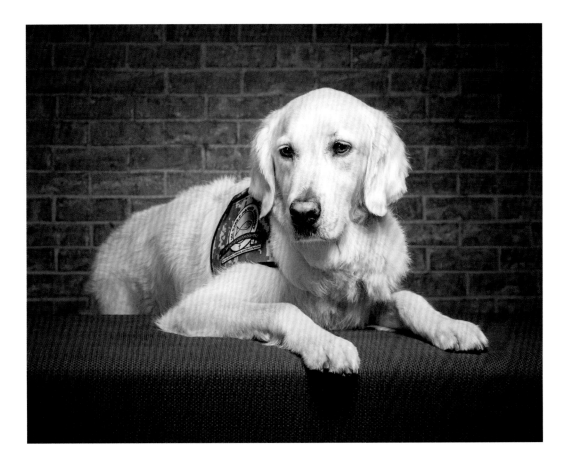

pray for him and also for the others there in detention who were also waiting to see how the system was going to direct their lives. We all prayed that day!

"Then the inmate said that he had something for Eddie. He and several of the other inmates began to get excited and smile. All of a sudden, the inmate handed me a figure he had made for Eddie. The inmate had used pieces of soap that he had somehow molded together and carved by fingernail. It was a statuette he'd lovingly crafted of a miniature Eddie complete with a vest and his name on it. It was a great time, and a happy group

moment. Normally, this statuette would be considered prison contraband and destroyed; however, the correctional officers knew about it and allowed Eddie to take it home with him. This made the inmate smile from ear to ear!"

After every prison visit, Moe and Eddie cap their time there by praying with the inmates.

From the moment Moe stepped into the prison with Eddie, he has approached this pathway of service with humility and grace and self-deprecation. These are traits that will no doubt propel these two pals forward along the many more miles they have to travel together.

"Escorting a dog who has the uncanny ability to touch and help other human lives is what we do," Moe says with a smile. "We handlers are essentially on the dumb end of the leash. Whether it's a simple personal visit or because of a tragedy of some kind, we've been blessed to be able to use one of God's creations—a comfort dog—to do what many times we cannot do by ourselves."

Moe recalls one final, precious and touching story about a very special little girl and the Comfort Dog who loved her with all his heart.

"One of the members in our church is a mental health counselor and also takes children into her home as a foster parent," Moe explains. "One Sunday morning, the counselor, who was called *Grammy* by a little girl, brought the girl to church for the first time. Ironically, it happened to be the Sunday we were celebrating Eddie's birthday.

"On first sight, the little girl immediately went up to Eddie and touched him and loved him like only a young girl could. It was the type of bond that will never break. Every Sunday after that, the child would scope out where Eddie was and ask Grammy if she could be with Eddie during church. Their bond continued to grow and grow.

"Our church was having a father-daughter dance. It was going to be a big event with all types of activities, games, and dancing. The little girl heard about it in the announcements at church and asked Grammy if she could go. Well, since the child's father was not around, what's the next best thing?

"Eddie, of course! She asked Eddie if he would go, and who could say no to a special little girl? Eddie and the little girl had a ball!"

Not a moment passes that Moe isn't grateful for the light and grace that Eddie Comfort

Dog has brought into his life and the remarkable vistas he's been able to experience through his furry pal's eyes.

"Many times," Moe says, "I feel that I'm so blessed just to be there and to have been given this special opportunity of seeing firsthand how the lives of so many people are touched by God through these dogs. This is truly more than what I deserve!"

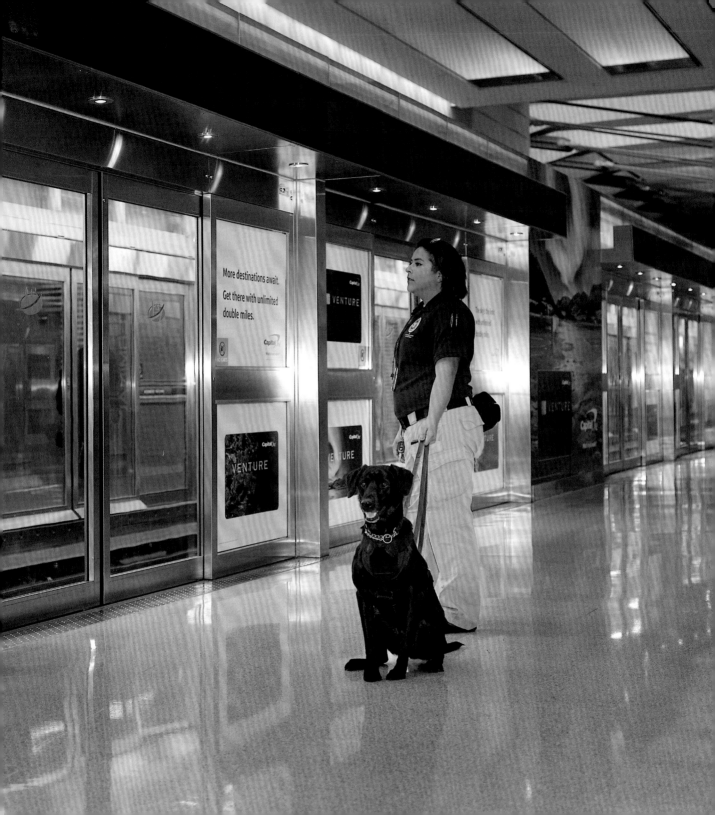

38 BO

Gainesville, Virginia

When I first started as a TSA officer in 2011, I took a vow to do whatever I was capable of to protect the United States from any foreign and domestic terrorist attacks," says Raquel Carrera, a TSA specialist and explosive detection canine handler. "I refuse to let anything like 9/11 happen again on my watch.

"As time passed, I realized there was more for me to do within this agency to protect those who entrust me with their lives to make it to their final destination safe and sound. I decided to become a canine handler because I've seen what the TSA canines are capable of and how they uniquely strive to support the TSA mission of keeping the traveling public safe. Most importantly, I love dogs and know it's a challenging job that requires time and dedication on a daily basis. I pledged my public service to Washington Dulles International Airport because I love to give back to the community."

To fulfill this commitment to her community and our nation, Raquel was partnered with Bo, a black Labrador retriever, who is trained in explosive detection.

Raquel adds, "I now strive to grow as a team with Bo every day by challenging our capabilities through daily training exercises and continuing to screen with excellence."

This team embodies the TSA's core values—integrity, respect, and commitment—both while on duty and at home in Gainesville, Virginia.

"Bo is my hero," Raquel says, "because his passion for everything we go through on a daily basis at work has no limit. His skill sets are so amazing, and I love to see how he works independently. And when I need to motivate him to push through a challenging situation or during a busy day, he gives his all. He's also my hero because he has the phenomenal and natural ability to find explosives through his olfactory system, which is something I certainly can't do."

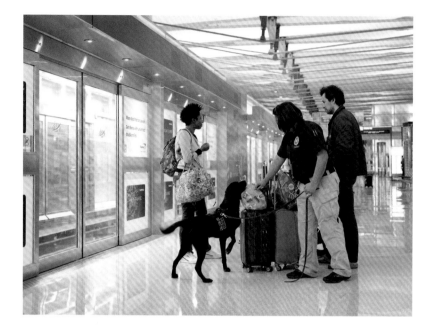

Bo's talents even transcend the language barrier as well and have allowed him to become a multicultural wunderkind of sorts. "After living with my family, Bo is bilingual!" Raquel says. "He tends to respond to Spanish terms spoken to him by my family."

Bo has also shown interest in perhaps a second, more literary career path—becoming an aspiring writer or maybe a journalist or media talking head. Raquel explains, "Bo is always super curious about what's going on around the house. In fact, he tried to assist me in answering the questions for this interview."

Or how about Bo moonlighting as a slapstick comedian? On several occasions, he's exhibited his knack for making people laugh. "Bo is a goofball who loves getting attention from everyone," Raquel explains. "One of the most hilarious things was when Bo and I were running passenger-screening operations one day and this small child was stumbling as he was walking toward us. Bo had no idea which way to pass the child, so he just stopped and tucked his head to brace himself for impact as the child walked right into him. Everyone who saw what happened began chuckling because it was pretty adorable."

But then again, focusing on one career, especially one involving explosives and helping to protect thousands of people in one of the most famous airports in the world, may be enough for this guy. After all, as Raquel notes, in addition to being a furry superhero on the

front lines of national security, Bo values his downtime. "He's a laid-back couch potato who likes to watch Netflix with me," she says with a laugh.

It goes without saying that to Raquel, Bo is very much a member of her family. "He's a huge responsibility, and I view him not only as my partner but as my son," she says. "I wouldn't be able to do my job without him, so I make work the best playtime of his life. Bo has also changed my life immensely as a single individual; it's like being a single parent!" Raquel laughs again. "I usually find myself thinking about him when I'm not at home, and I make my plans around his schedule—for example, his feeding time, bathroom breaks, playtime/work, and daily exercise."

This bond of love and family was forged from day one for these two best friends, who in so many ways complete each other. "The moment I saw Bo's picture on the PowerPoint and learned that he was my assigned canine, it was a reality check that he was going to be my other half," Raquel remembers. "That night, I went to my room and prayed for our bond to be instant and unbreakable. The day I met Bo, his trainer explained to me that it usually takes some time for Bo to trust someone new, but that once the trust is built, he would be a strong, dedicated, hard worker. I felt an instant bond with Bo; I was able to quickly pick up on his mannerisms and what he expected from me as his handler. Since I've been back from Texas, where we both had trained at the TSA National Canine Training Center at Lackland Air Force Base in San Antonio, my whole world revolves around Bo. In fact, I can still remember the first time Bo fell asleep on me on the couch after work. It was like he just melted into me. Every day now, I do my best to make sure he knows that I appreciate all his hard work and that he always feels loved."

This unconditional affection is also evident in the cheerful tone of Raquel's voice as she gushes over Bo, who, while on the job, works fearlessly to protect our nation but off-duty lights up her world.

"He's super outgoing and so silly," she says, "that you can't help but smile, laugh, or just feel an overwhelming joy around him!"

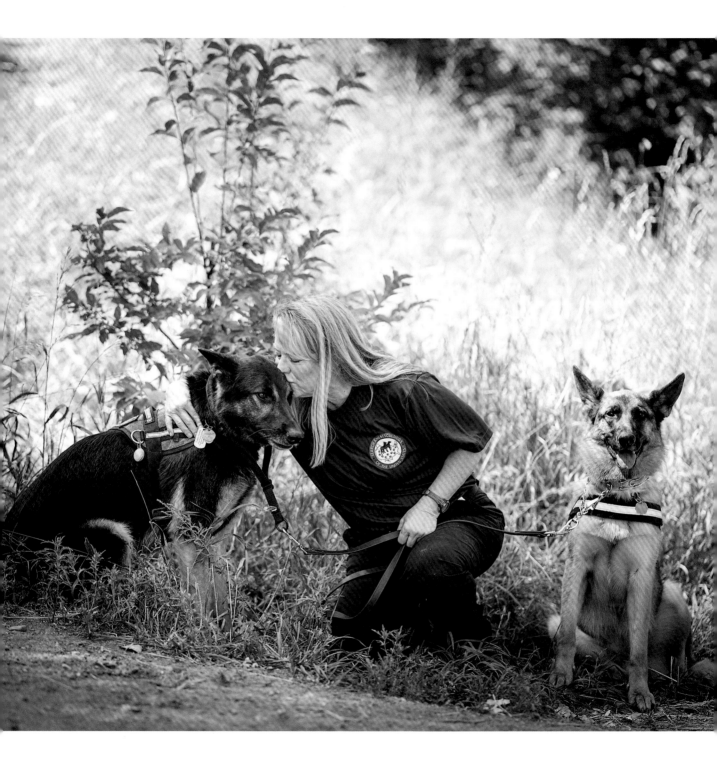

39 DIESEL AND DESSA

Silt, Colorado

Diesel von der Bosen Hundin is a black-and-tan German shepherd with a red mask and goldish-red eyes, and he's extraordinary in many, many ways. "He reminds me of a freight train that just keeps going and going!" his handler, Jody Gruys, says with a laugh.

But then, Diesel could say the same about her.

Together, this pair has a résumé of trainings and accomplishments several pages long. "Diesel has the genetic hardwiring to work and problem solve," Jody, a legal assistant from Silt, Colorado, explains. "I love working with German shepherds because they're so adaptable. They can do any kind of search and rescue work you could ever need, and they love it.'"

To understand the intensely close connection between Jody and Diesel, it's important to first meet Odessa Vom Olympus, a German shepherd who was known more informally as Dessa, or simply Dess. She was one of the first search and rescue dogs to steal this handler's heart.

"Dessa was a calendar girl and very regal, both in her looks and her behavior," Jody remembers. "Very dignified." Even so, Jody adds with a smile, "Dessa had the inner strength to pretty much flip me the paw when I asked her to 'go this way' when she knew I was wrong, and then she would patiently wait for me to realize it and trust her. She was never, ever wrong and would wait me out if she had to until I got it."

Jody recalls a very impactful mission with Dessa that happened in mid-July one year when the local sheriff's department contacted Garfield County Search and Rescue, Inc. to request assistance on an eight-year-old suspected homicide case. They were requesting a certified human remains detection dog and ground searchers to help execute a line search through an area that was considered a crime scene.

The case involved a young woman and her sister who had gone to a party. They had gotten into a fight, and one of them had walked away from the house where the party was being held, in the middle of a whiteout blizzard. She was never seen again.

"The sheriff's department worked diligently to find this woman for eight long years," Jody explains. "All kinds of rumors had circulated about what had happened, and of course there was still a grieving family wondering what had happened to their daughter."

Then, eight years later, a hiker contacted the sheriff's department and reported that he had found what he thought was a human skull. The sheriff's department had called the Colorado Bureau of Investigation to assist with the initial search of the area around where the skull was found. It was located in an area with very tall sagebrush and on a hillside with pinion and juniper trees. There was a creek on the east side of the area, and it was surrounded by thick stands of willows. The recovery site was within a half mile of the house where the party had taken place.

"There was also a very active bear in the area who had a den a short distance above the search site," Jody remembers.

The investigators used their screens to sift through the duff and tried to locate anything else near the area where the skull was found with their techniques and tools, without much success.

"When they called for Dessa and me to assist them," Jody says, "we were briefed that our team would be working under a search warrant and that the scene was considered a crime scene. Our coroner's office had requested a canine. The assistant coroner, who was also a member of Garfield County Search and Rescue, had worked with our dog team regularly and knew how a canine could be used to assist in a search such as this one. Essentially, he recognized Dessa as this wonderful resource with a big nose, who was trained to distinguish human bones from all of the animal bones, dirt, duff, rocks, and sticks that were all over the search site.

"The forensic anthropologist, forensic pathologist, and detectives asked that several searchers work a line search on a grid through the defined search area to see if they could find any clues, clothing, or bones. While we were all standing at the site of the briefing near the defined search area, Dessa very quietly and gently sat down in front of me, facing me, and alerted. Not wanting to interrupt the briefing, I hesitated to say anything at that moment.

"I told the searcher standing next to me what was happening, since I wasn't sure how to handle it. About that time, the anthropologist was describing what the bones could look like. One of the searchers bent over near Dessa and said, 'Oh, like this?' It was a small brown pebble-like object, about the size of a nickel that was near her foot.

"At that time, I told all of them that Dessa was alerting, as trained, to human remains and placed a flag right next to her fuzz butt, since she was sitting directly on top of the location she wanted to indicate. I moved her away from the location of the alert, and the forensic team uncovered a perfect layout of part of a human skeleton. It was buried under about four inches of dirt and duff, and we had almost been standing on it during the briefing. We then started our search in the defined area with the line searchers. I held up the piece of the bone that had been found near her foot during the briefing and told her, 'Find this.'

"Dessa put her nose to the ground and worked the search area for about twenty minutes. Every time she alerted, I'd place a flag next to her. The anthropologist asked me to then search an area below the initial defined area, and I told her that we had already done so. She looked at me with a smile on her face and said, 'Then go do what you do best!' There was still a large area to finish clearing above the defined search site.

"I asked Dessa to go back to work, and she pulled me uphill to an area next to a thick bank of willows that bordered the creek. She alerted in several locations, and I marked them each with a flag for collection. As our team was walking out of the last search area, Dessa alerted and worked her way uphill and out of sight. We followed and found her sitting next to the bin containing all of the collected bags from her alerts. She very clearly communicated that she was ready for her reward for a job well done. The remarkable part of that day was how she had found eight-year-old dry bones—in horrible conditions for a dog to work—*and* she worked with that very angry bear not very far away. In fact, the bear was close enough that we could hear him huffing, and we had a deputy assigned to us with a shotgun with bean bags."

This mission is one Jody will never forget for many reasons. "That day, Dessa proved that a dog is an incredible resource and tool, with her ability to work hard in extreme conditions and give a family a sense of some closure after all those years. It was beautiful to see, and I felt very fortunate to be a part of it. It was a great example of teamwork by everyone there, because of this dog."

Enter Diesel.

"Dessa was so happy when I brought Diesel home as an eight-week-old pup," Jody recalls. "She mothered him, disciplined him, played with him, and mentored him as he learned search and rescue work."

Unfortunately, Dessa was later diagnosed with cancer and passed away. "Many tears were shed, and a piece of my heart is still missing," Jody says. "Diesel has helped mute the hurt with all of his exuberant love, but a part of me went with her. I had her cremated, and she'll be with me when I go someday, just as Diesel will."

The most profound impact Jody and Diesel have had has been on each other. The love and admiration they share one-on-one is palpable. "Diesel is a wonderful blend of working search and rescue dog, best buddy, and caretaker," Jody says. "He's capable of doing any type of search and rescue work I ask him to, both physically and mentally, and then he easily becomes my companion, fuzzy therapist, puppy sitter, and teacher. I swear he can be dead asleep and hear his pack being readied. It doesn't matter how late it is; if he sees my special boots being laced up, he's ready in a mere heartbeat, tail wagging and impatiently waiting at the door, while I'm still trying to get my eyes open and figure out where the door is.

"Personally, I know I need something to nurture, and he lets me. Diesel is full of love and is so exuberant he's overwhelming at times. He's super sweet and snuggly, and often I have a sixty-five-pound lapdog sprawled out over me in the recliner. I love every minute of it!

"It's kind of scary when you spend so much time with your dog that you get to a point where you can communicate with just a look, a touch of the nose, or a breath. Plus, he doesn't care what I look like in the morning or if I'm having a bad hair day or if I'm sweaty or cranky; he loves me just as much. It's a deep bond for me, and I feel so fortunate to have him in my life. I do know my house would be cleaner and quieter, and my life sometimes much simpler, without him, but nowhere near as happy for me. I would rather spend my time outdoors with him or training than be stuck inside doing housework on a pretty day. The housework is not going anywhere, but Diesel is one day older. One of my friends once told me that when they die, they want to come back as one of my dogs. I took that as a compliment."

Jody gives Diesel and her other dogs credit for enhancing her own life and encouraging her to forge ahead despite many challenges.

"In the last five and a half years, I've recovered from a catastrophic illness and am currently recovering from a severe injury, both of which have been life-changing," Jody explains. "I truly believe I wouldn't have recovered from the illness if I hadn't been out 'chasing dogs around' as my mother calls it. When I got sick, I was in better shape physically because of the hard work that had been put in over the prior years. Working a search and rescue dog and being out in the wilderness is a natural high for me and because working a search and rescue dog is hard, it's made me mentally stronger.

"When I was faced with the serious illness and a long recovery, I was able to dig deeper and was much more of a fighter. There's no motivator like a pair of blazing eyes boring a hole through you and a bossy dog telling you to get up and get moving and to never give up. Diesel pushed, and literally pulled, me when I needed motivation to work through bad days and later silently comforted with his steady presence. He's doing that again now. His job is not only to search for and find the lost and missing but to be my constant reminder that you should never, ever quit no matter how painful or hard it is."

Jody easily rattles off the many lessons Diesel has taught her. "In the almost twenty years of working with search and rescue canines, I'm still constantly amazed at the things these dogs can do and the lessons they teach us."

These are universal lessons that have not only motivated Jody but that inspire all those with whom the pair crosses paths. In this unique way, Diesel has become a barking beacon of hope in this world.

"I'm better with him than without him," Jody says. "Diesel gives back to me tenfold what I give to him. He's continued in the footsteps of my other search and rescue canines by continually reminding me that life is to be lived with joy for each new day and that no matter how hard today is, tomorrow we will try again. I never tire of seeing the joy that Diesel has for life and of being the lucky benefactor of all of his enthusiastic love."

A strong and humble work ethic has also come to define Diesel as a role model for Jody and others. "Among many other reasons, Diesel is a hero to me because he's so good at what he does, and he does it all with no ego. He does his job with such joy and doesn't realize how much of a difference he can make in someone's life. He has no expectation of anything other than a pat or a treat for a job well done."

Diesel has nudged Jody out of her comfort zone time and again. "He's taught me that if I can do this much, then I can do even more. Because I know how hard this work is, I also

know that nothing is worthwhile if it comes easy. Being a search and rescue canine handler has given me a belief in myself that nothing else has. It's hard work, period—early mornings, long nights, hot, sweaty days, freezing days, sore feet—it's tiring, and it means time away from your family, but then it all comes together. And nothing beats that connection with a living, independent-minded animal who chooses to work with you to accomplish a mission. A lot of blood, sweat, and tears goes into living with, working with, and loving a search and rescue K-9, but it's all worth it."

Diesel has encouraged Jody to continually dig deeper in her life and learn more about what really makes her tick. "Because of Diesel, my life is richer," she says. "I feel like I've found a piece of myself and better understand who I am because of him."

Over the years, Diesel, just like Jody's previous search and rescue dogs, has embodied a crucial point that bears repeating in the human world as well: we are each individuals with our own personalities, traits, strengths, and weaknesses. So be exactly who you are and respect others for doing the same.

"I've learned to work the dog in front of me and to not judge him or her based on my last dog or any other dogs I know," Jody says. "You can't force a dog to be something he or she isn't. Just like us, each dog is an individual."

To Jody, Diesel, Dessa, and all search and rescue dogs are ultimate goodwill ambassadors, even peacemakers. "I've personally seen trust and mutual respect established between law enforcement, coroners, and search and rescue teams simply by the canine team being reliable and effective on a mission. I've even seen barriers broken down between people who have different beliefs but yet have a mutual love for a search and rescue canine. Several times because of dogs like Diesel and Dessa, I've seen relief on the faces of law enforcement and coroners when they can notify a family that their loved one has been found, even when it ends sadly."

Jody does have one wish, though, which she explains with a laugh. "If only they could talk!" she says. "I would love to hear that conversation. So many times, I thought I knew better and would tell Dessa to go this way, not that way. She would look back at me with her regal face as if to say, 'Ohhhhh, Iiiiiiii looooove youuuuu, but you're just a human. Come with me, and I'll tell you again and again if I need to, until you learn to trust me.' She never let me down."

Even without words, Jody and Diesel have their own language of understanding. "Die-

sel has no limits to his enthusiasm or creativity when he's trying to get a message across to me," Jody says. "He looks at me with his bright eyes, wide smiling mouth, and tongue hanging out of the side of his face as if to say, *Trust me, I've got this!*" And you know what? He always does."

Jody and Diesel's extraordinary relationship can be summarized in a few simple words. "Diesel has given me a great amount of love and trust, and I'm forever grateful for his presence, every day," Jody says. "Diesel is true happiness for me. He's given me an identity to be proud of."

But it's how Jody concludes the description of her dear friend that is most illustrative of their eternal bond. "I trust Diesel with my life!"

The LCC K-9 Comfort Dogs are popular subjects for drawings by the numerous young people they meet, such as this portrait of Newtown's favorite furry resident, Maggie, by Paige Tarpey. Currently in middle school, Paige is a survivor of the Sandy Hook Elementary School shooting—she was in Victoria Soto's first-grade class at the time—and has become one of Maggie's closest friends.

Newtown, Connecticut

In the several years since the mass shooting at Sandy Hook Elementary School on December 14, 2012, Newtown, Connecticut, has continued to heal.

For this devastated community, which lost twenty first graders, all ages six and seven, and six school administrators, including a psychologist, teachers, and the school principal, on that day, a refreshing breath of comfort arrived early on and has never left.

Lutheran Church Charities (LCC) K-9 Comfort Dog Maggie—a golden retriever with reddish-golden fur and soulful brown eyes whose official name is Maggie Psalm 145:21—went to Newtown with other Comfort Dogs after being invited by Christ the King Lutheran Church in the days following the shooting.

"The need here was so great that the Comfort Dogs ended up staying for weeks," says Cathy Reiss, LCC top dog handler for Maggie. "When the Sandy Hook Elementary School reopened its doors in what had been a middle school in a neighboring town, the Comfort Dogs were there daily for the students and staff. Before that, the Comfort Dogs attended memorials, visited survivors, and were at Newtown High School when the students and staff returned to that school, and they remained there for several weeks. Parents still tell me how much the dogs' presence meant to their children.

"After a couple of months, the Comfort Dogs had to go home, but the need for them at Sandy Hook Elementary School remained. LCC offered to leave Maggie and her sister, Addie, on loan with our church to continue their work in Newtown. However, at the time, we were still working through our own grief, helping our children work through their grief and trauma, helping each other and the community, and sorting through the mountains of gifts and cards that were sent to our church, which filled an entire closet, and to our town, which filled multiple warehouses. Our church was in no position to manage a Comfort

Dog ministry at that time, so Maggie and Addie were left in the care of our sister church—Immanuel Lutheran—in Danbury.

"Then, over the summer of 2013, our church decided, what better way to spend the money sent to us from strangers around the world in support of our work to comfort the community than to begin a Comfort Dog ministry. On Labor Day weekend of 2013, we had the Passing of the Leash ceremony from LCC to Christ the King Lutheran Church for Maggie. We invited the public to a celebration at the church to meet Maggie, and she rode on our church's float in Newtown's traditional Labor Day Parade, along with the many other Comfort Dogs who came to celebrate with us."

Since Maggie's official arrival as Newtown's newest resident, she, with the help of her team of handlers and other volunteers at Christ the King, has faithfully carried out her mission of spreading love, hope, and joy throughout the community, especially at Sandy Hook Elementary School where she continues to serve regularly.

Cathy enumerates many ways that Maggie's and her handlers' ongoing presence in Newtown has been called into action: Maggie has helped students and staff after unexpected student deaths, on December 14 anniversaries, on the first days of the new school years, during moments of feeling anxious or uncertain, after the disturbing news of other school shootings, and during regularly scheduled classroom or individual visits.

"In the years that we've been serving those traumatized by the events of December 14, 2012," Cathy says, "we feel blessed to have the opportunity to help provide needed comfort. And especially since this is our community, we also feel blessed to see the emotional healing that takes place over time."

All of the students who were attending Sandy Hook Elementary School when the shooting occurred have now moved up to other grade levels and schools in town. Still, Maggie remains a regular presence there to provide ongoing support to students and staff.

"We continue to bring Maggie to Sandy Hook Elementary for bus greetings, classroom visits, student visits, recess time, and other activities," Cathy says. "To many, she's seen as part of the Sandy Hook School family, bringing smiles to faces, and she's always ready to help those in need. Maggie also regularly visits her former Sandy Hook School friends at the three other Newtown schools serving grades five through twelve."

Throughout these last several years, Maggie Comfort Dog has shared countless unfor-

gettable school visits with students and faculty, as well as members of the larger community. Cathy explains, "One of Maggie's routine jobs at Sandy Hook School is to greet students as they enter the building. Occasionally, students may spend some extra time with her before going to class. Sometimes, I've even let them hold the end of her leash—while I'm still holding it—so they can be an honorary helper. Teachers have told me how much Maggie being in the school has helped students, especially those who may have been more directly impacted by the shooting years ago. I've seen how much little things, like holding Maggie's leash, can give students a little extra comfort and courage to face their day."

Trauma triggers, such as fire, tornado, or evacuation drills, and even school bells, are very much a reality for people who experience a major natural disaster or manmade crisis, such as a school shooting. These triggers can cause anxieties and fears to resurface with a painful vengeance long after a tragedy has happened.

"Maggie was present the first time an evacuation drill was held at Sandy Hook Elementary," Cathy recalls. "Students and staff were to evacuate the building and walk to a nearby school building—a short walk, yet a long journey for these people who had been through so much. Along the way, Maggie provided what we call a 'Maggie Hug' to those who experienced a trauma trigger. As it turned out, a bomb threat necessitated an evacuation about a week after the drill, and after Maggie had left for the day. We'd like to believe that Maggie's assistance during the practice drill helped give everyone the courage and resilience they needed on that day when the threat, at least, was real."

On another occasion, Cathy tells of a touching moment when a student expressed concern for a classmate. "While Maggie was on Sandy Hook School playground duty," she says, "one of her young school friends noticed someone else who was sad. She asked the handler to take Maggie over there. It's heartwarming to see how the children watch over each other and know exactly how to make someone feel better. Plus, a Maggie Hug always helps, as it did this time as well!"

Soon after the shooting in 2012, Newtown decided to demolish the old Sandy Hook Elementary School building and construct a new school on the same property. The new school building opened in time for the 2016/2017 school year.

"During that summer before school started," Cathy remembers, "the new building was opened several evenings for the community to tour. As you can imagine, the emotions

were raw, not only for the obvious reason of the unfathomable loss of life that occurred on those grounds but even for the loss of any vestiges of the previous elementary school building that some older children had fondly grown up in.

"Maggie was there to greet the community, young and old alike, as they arrived. For some of the children, this was their first time back to the school grounds, and they spent lots of time with Maggie, with tears in both the children's and parents' eyes. I often hear how much Maggie means to this community because of the work she's doing to comfort and heal the Sandy Hook School family."

For Cathy and for Maggie's other handlers, every day with the Sandy Hook School community is different, and each one brings unexpected gifts and blessings. "You never know what you might witness when serving with Maggie," Cathy says. "Recently during the school bus greeting, a young student had the opportunity to visit with Maggie alone, as his mother drops him off every day and the buses hadn't arrived yet. It looked like what was going to be a normal visit where Maggie might get a few pats and then he would run off to his class. But instead, the young boy took a few moments to look Maggie square in the eyes. He said to her, 'Maggie, I love you. Remember to be kind and nice to everyone you see today. Have a great day!' The boy then kissed the top of Maggie's head and went off to class. We later learned that those are the words that this student's mother says to him every morning when she drops him off at school. A mother's love and guidance was handed down to Maggie from the heart of a child. And Maggie gladly accepted his words of wisdom and instruction."

And speaking of a mother's love, the parents of Newtown have also drawn peace and serenity from Maggie. "One day while I was on a meet and greet with Maggie," Cathy remembers, "a Sandy Hook School mom introduced herself. She told me about how Maggie's Bible verse—'My mouth will speak in praise to the Lord. Let every creature praise His Holy name for ever and ever.'—had helped her. She described how she was quite anxious one morning because she had to give a presentation later that day. She got her child onto the school bus, came back in the house, and found one of Maggie's business cards that her child had left behind on the kitchen table. The Sandy Hook School students love to collect these cards! The mom saw the Psalm number—145:21—on Maggie's card, looked it up in her Bible, and that verse about speaking in praise of the Lord gave her the strength and courage she needed to give her presentation."

Being a mother herself, Cathy's current work with Maggie is all the more pertinent. After the shooting occurred, she recalls, "Maggie and all the other Comfort Dogs and handlers who visited Newtown came to our church each Sunday morning so we could visit with them after the service. I was concerned about my own children, who lost people they knew on December 14, 2012. My kids loved to visit with the dogs on those Sundays, and as their mom, it was so comforting to see them just be in the moment with the dogs, with smiles on their faces."

This maternal instinct is now conveyed to the whole community by Maggie. Cathy and her fellow handlers at Christ the King—who as neighbors bonded together by tragedy have been called "wounded healers"—work hard every day with their furry messenger of joy to help wipe away sadness and bring smiles to the brokenhearted of their hometown.

"Being at the end of Maggie's leash," Cathy says, "I get to provide comfort to those who are hurting, brighten up the faces of those who are lonely, or even just meet people I wouldn't have otherwise had the opportunity to meet. It's wonderful that I have the chance to help people through whatever troubles they're experiencing, but it also makes me more aware of all the need in the world. In a perfect world, Maggie wouldn't be needed as a comfort dog."

While humility and compassion are the foundation of Maggie's outreach in Newtown, she and her sister Addie are also media stars in their own right. They were featured in the Emmy Award–winning mini-documentary titled *Wags 'n' Tales,* which was written and produced by Ken Fay, one of Maggie's handlers.

This ten-minute film portraying the jobs performed by these two graceful sweethearts has been one more tool through which Maggie and Addie have been able to reach people in need and to share their larger ministry with the masses. Unlike most stars, though, they don't seek applause or fame, for their mission is one of service and mercy.

Cathy perfectly summarizes the true meaning embodied by Maggie and her fellow Comfort Dogs who are all hard at work across the country: "unconditional love."

Speaking of which, Cathy adds with a laugh, "Part of our routine procedure is to play with Maggie and praise her at the end of each visit when her LCC working vest comes off. So Maggie and I always get to end our visits on a high note, and then I get to have some of that Maggie *lovin'* that she's known for!"

ABOUT THE ORGANIZATIONS

Lutheran Church Charities

The mission of Lutheran Church Charities (LCC) is to share the mercy, compassion, presence, and proclamation of Jesus Christ to those who are suffering and in need, and the organization never charges those whom they serve. The LCC K-9 Ministries embrace the unique, calming nature of AKC golden retrievers to interact with people of all ages in the communities in which they are placed, and are also deployed in times of disaster and crisis to bring comfort to all those affected, including first responders and the volunteers who serve them.

The LCC K-9 Ministries include the LCC K-9 Comfort Dogs Ministry; LCC Kare 9 Military Ministry serving the military, veterans, and their families; and the LCC K-9 Police Ministry serving law enforcement officers and their families.

www.LutheranChurchCharities.org

National Disaster Search Dog Foundation

The mission of the National Disaster Search Dog Foundation is to strengthen disaster response in America by rescuing and recruiting dogs and partnering them with firefighters and other first responders to find people buried alive in the wreckage of disasters.

www.SearchDogFoundation.org

Puppy Prodigies

Puppy Prodigies offers canine-assisted programs. It is a grassroots organization that prides itself on pioneering efforts and innovative programs utilizing service, therapy, and emotional support dogs in an effort to empower people with disabilities, kids with special needs, wounded warriors, and veterans with PTSD.

www.SurfDogRicochet.com

Returning Soldier Initiative

In partnership with Search and Rescue Dogs of the United States, the Returning Soldier Initiative supports veterans who want to join the search for lost and missing individuals. It matches veterans with local search groups and then provides puppies for them to train so as a team they can eventually enter the search for those who go missing.

www.ReturningSoldierInitiative.com

Search and Rescue Dogs of the United States

Search and Rescue Dogs of the United States is a national organization that provides training and certification to search and rescue dog teams. It also deploys dog teams to search for lost and missing people and to assist law enforcement with crime investigations.

www.sardogsus.org

Transportation Security Administration

On the morning of September 11, 2001, nearly three thousand people were killed in a series of coordinated terrorist attacks in New York, Pennsylvania, and Virginia. The attacks resulted in the creation of the Transportation Security Administration (TSA), designed to prevent similar attacks in the future.

Driven by a desire to help our nation, tens of thousands of people joined TSA and committed themselves to strengthening our transportation systems while ensuring the free-

dom of movement for people and commerce. TSA's mission is to protect the nation's transportation systems and the sixty-thousand-person workforce (plus about one thousand canines) that goes to work every day to do so.

www.tsa.gov

The Vanderpump Dog Foundation

Based in Los Angeles, the Vanderpump Dog Foundation, started by Lisa Vanderpump and Ken Todd, is a dog rescue organization working on both a domestic and international front to help create a better world for dogs globally.

www.VanderpumpDogs.org

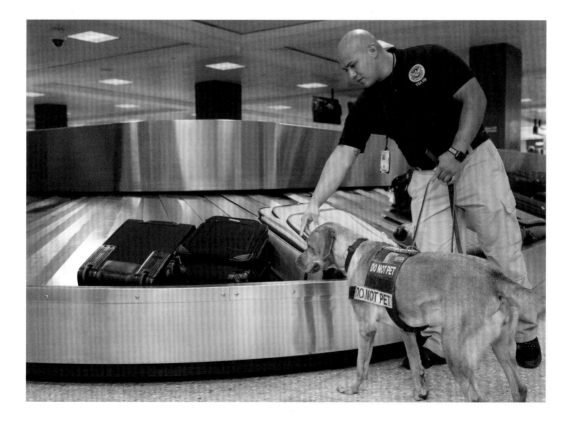

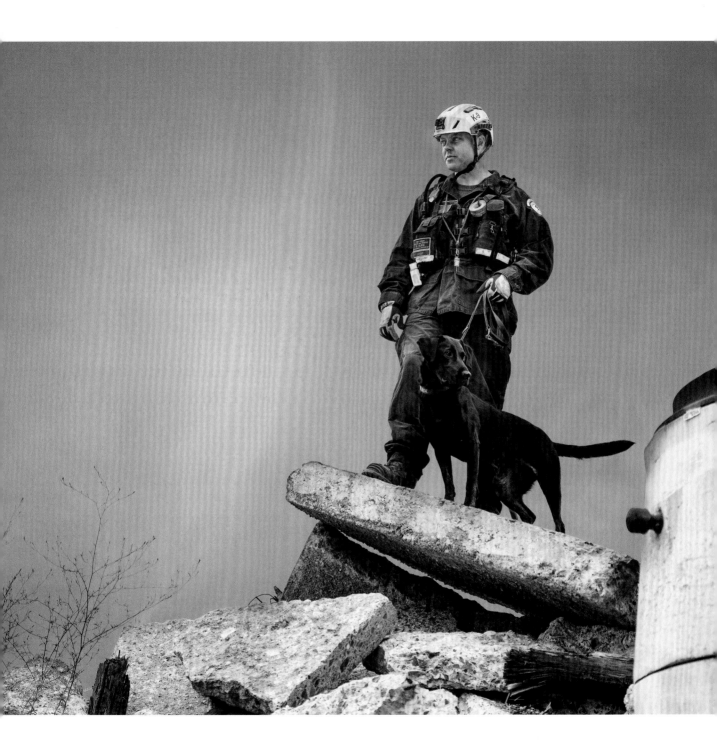

ABOUT THE IMAGES

The images in *Extraordinary Dogs* were captured with the FUJIFILM GFX 50S medium format mirrorless camera.

I chose the FUJIFILM GFX 50S camera to create the images in this book because I'm already in love with the entire FUJIFILM GFX system and X Series ecosystem of cameras and lenses.

With its 51.4 megapixel medium format sensor, the FUJIFILM GFX 50S delivers incredible images that are packed with detail—perfect for making large prints and viewing on high-resolution displays. The sensor's large form factor produces images with a unique three-dimensional look with exceptional tones and advanced color reproduction.

The camera handles beautifully and feels so amazing in my hands. I love the deep grip and thumb rest. Its compact size made it easy to hand-hold the camera when I needed to move around quickly to capture these incredible dogs in action.

Also, the GFX is supported by a range of high-quality FUJINON lenses, ranging from ultrawide angle to fast-aperture telephoto, with zoom and macro lenses too. The GFX system is a complete professional solution for modern photographers like me.

The GFX was able to keep up with all of the extreme paces I put it through while crisscrossing the country for *Extraordinary Dogs,* from low-light conditions to very bright and demanding outdoor locations where I met the various teams I photographed.

The GFX system produces images that capture every hair and whisker, which adds texture, depth, and soul and makes these dogs come alive and practically leap right off the pages of this book.

And using the touch screen on the GFX 50S is the icing on the cake. It enabled me to compose my shots quickly whether shooting handheld or on a tripod.

The ability to produce such beautiful and huge prints from this camera is nothing short of sensational! The GFX system is an exceptional tool.

Learn more about the GFX system at FUJIFILMXGFX.com.

—*Liz Stavrinides*

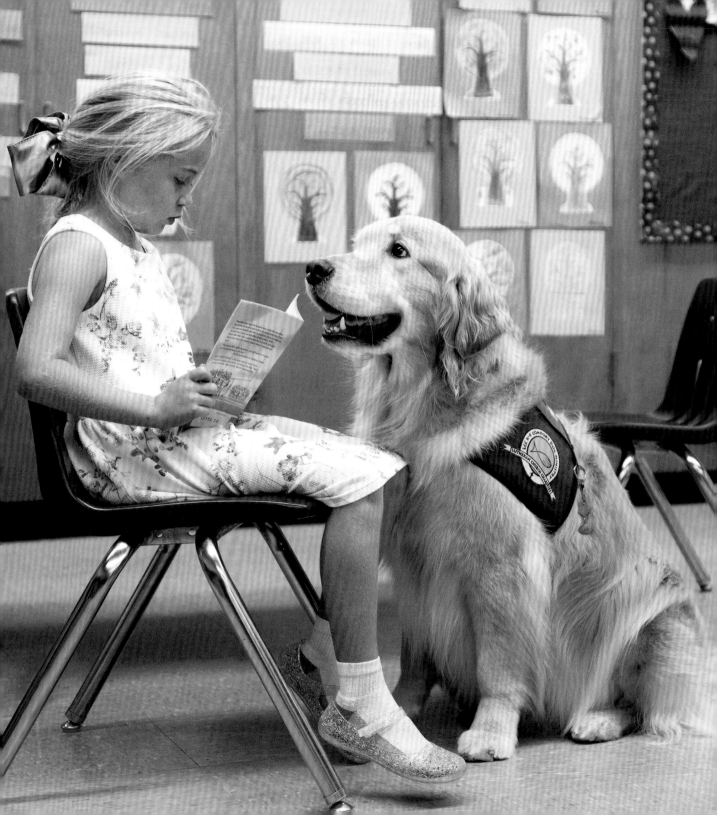

ACKNOWLEDGMENTS

We would like to extend a huge round of gratitude to the following individuals and organizations that helped us to share these extraordinary dogs, handlers, and their stories with the world:

Steve Troha and his incredible team at Folio Literary Management, who believed in the power and mission of this project from the very beginning.

Our editor, Daniela Rapp, and the brilliant team at St. Martin's Press, who graciously embraced this project and dedicated themselves from day one to producing an inspiring and impactful book that will endure the test of time.

Fujifilm, who kindly lent us the FUJIFILM GFX 50S camera so that the dogs and handlers could be immortalized in the most exceptional series of photographs possible.

The organizations, including the staffs, volunteers, and their dogs, who joined us on this journey, and who are single-handedly redefining what grassroots love, compassion, courage, and service look like. These include:

Lutheran Church Charities (LCC), especially Tim Hetzner, Vida Johnston, Deb Baran, Rich Martin, Dana Yocum, David Marks, and the army of other LCC staff and volunteers hard at work across the country.

Search and Rescue Dogs of the United States (SARDUS) and its Returning Soldier Initiative, especially Jeff Hiebert and the extended national SARDUS team of staff and volunteers.

National Disaster Search Dog Foundation, especially Denise Sanders and the many other folks whose dedication has transformed this organization and its work into a nationwide beacon of hope.

Puppy Prodigies, especially Judy Fridono and her team, who are forging new and groundbreaking territory every day with their growing troop of skilled and gifted dogs.

The Vanderpump Dog Foundation, especially Dr. John Sessa, Hannah Bortz, Lisa Vanderpump, Ken Todd, Pandora Vanderpump Sabo, and their fellow crusaders for blazing a

brilliant pathway of compassion across the United States and around the world.

The U.S. Department of Homeland Security's Transportation Security Administration (TSA), especially Lisa Farbstein, Tasha Woody, and everyone else at TSA who works tirelessly 24-7 to keep all of us safe and sound.

And, our most heartfelt love and thanks—truly more than words can ever adequately express—go out to the dogs and handlers who both appear within these pages and the thousands of others across the country and world who are making this planet a better and safer place for everyone.

—*John Schlimm and Liz Stavrinides*

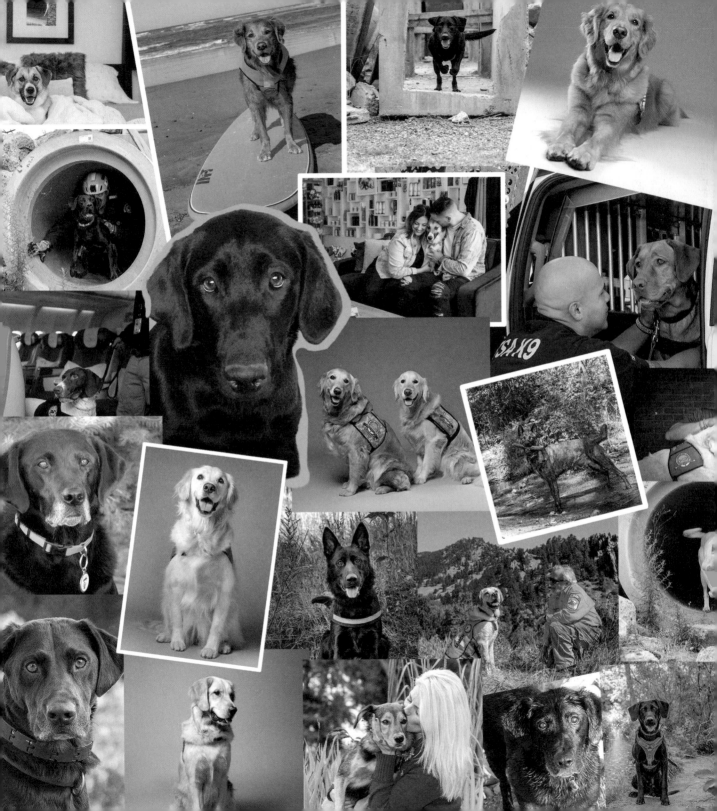